W9-CKR-902

Bill Brandt

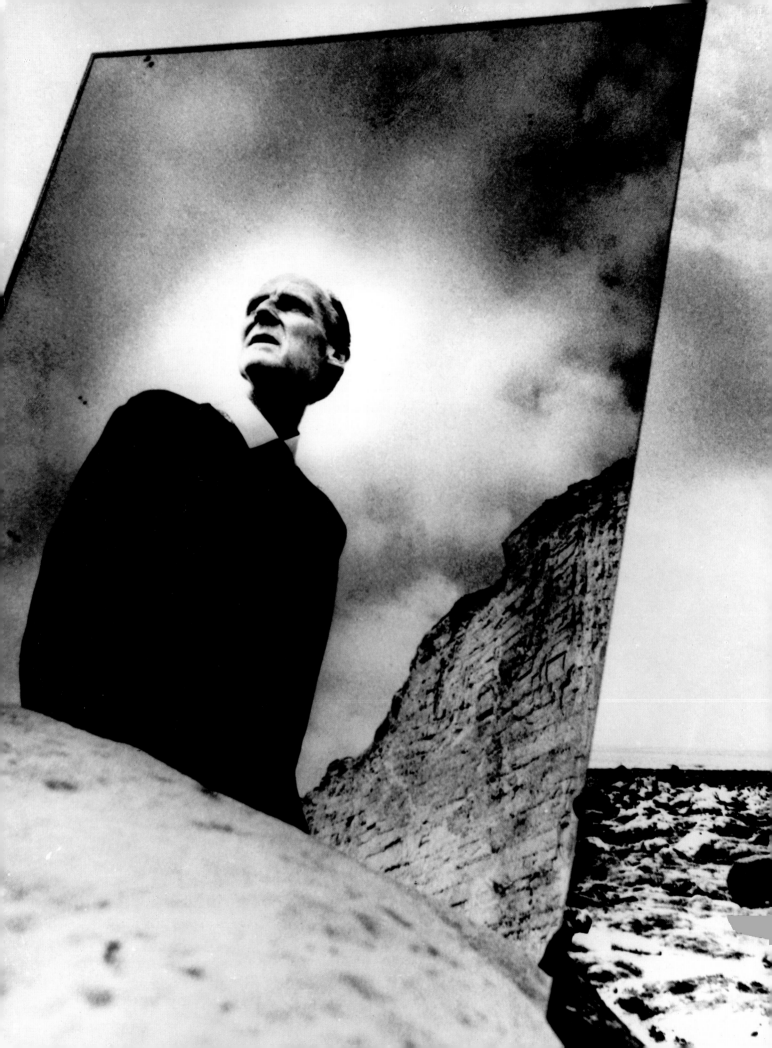

Bill Brandt

Photographs 1928 – 1983

Edited with an introduction
by Ian Jeffrey

Thames and Hudson

This book is dedicated to Dorothy Bohm, for her unstinting work for this project
and British photography in general

Frontispiece: Self-portrait with mirror, East Sussex coast, 1966

Any copy of this book issued by the publisher as a paperback is sold subject to the
condition that it shall not by way of trade or otherwise be lent, resold, hired out or other-
wise circulated without the publisher's prior consent in any form of binding or cover other
than that in which it is published and without a similar condition including these words
being imposed on a subsequent purchaser

Copyright ©1993 Barbican Art Gallery Corporation of London

First published in Great Britain in 1993 by Thames and Hudson Limited in association
with the Barbican Art Gallery, London, on the occasion of the exhibition "Bill Brandt
Photographs 1928-1983," Barbican Art Gallery, 30 September – 12 December 1993

First published in the United States of America in 1994 by Thames and Hudson Inc.,
500 Fifth Avenue, New York, New York 10110
Reprinted 1994

Library of Congress Catalog Card Number 93–60536
ISBN 0-500-27726-5

All Rights Reserved. No part of this publication may be reproduced or transmitted in any
form or by any means, electronic or mechanical, including photocopy, recording or any
other information storage and retrieval system, without prior permission in writing from
the publisher

Printed and bound in Italy

Contents

FOREWORD

When in 1989 we dedicated our 'Through the Looking Glass' exhibition to the memory of Bill Brandt, it was in recognition of his crucial influence upon British photography since the Second World War. As the Barbican Art Gallery has striven over the years to highlight the work of leading photographers, the next step was, naturally, to follow this with a further tribute, a full retrospective of Brandt's work.

We are delighted that it has been possible, through the guidance and support of Dorothy Bohm, to bring together a group of enthusiasts who have set about devising a Brandt selection that is both new and does justice to the work for which he rightly became famous.

We are very grateful to have had the full cooperation of Mrs. Noya Brandt, who not only gave us access to all the photographs in her possession, but also to Bill Brandt's private library and writings, many of which had hitherto not been studied. She has been most generous with her time and her faith that this study would do justice to the work of her late husband has been touching and continually encouraging.

Ian Jeffrey's painstaking research has resulted in a fresh and bold reassessment of Brandt's work, drawing together the facts known about his life and providing a new interpretation of the photographs and their subject-matter. The fact that half the images in this show have not been exhibited before is a measure of the selection's novelty.

An invaluable source of information and work has been the Hulton Deutsch Collection Limited. Brian Deutsch's personal interest in Brandt, combined with the very efficient and friendly help of their staff, notably Sue Percival and the team in the dark room, has enabled the Barbican Art Gallery to reassess the work Brandt did for *Picture Post*, including both well-known images and those that have never been printed since Brandt submitted his nitrate negatives to the magazine's editor in the 1940s and 1950s.

We would also like to extend our gratitude to Anne Woodwood of the National Buildings Records, Paul Kemp of the Imperial War Museum, Stephen Lacey of Reed's Wharf Gallery, and various private lenders for their contribution to this exciting exhibition.

Last, but not least, we would like to thank Levi Strauss, for their sponsorship which has been crucial to the development of this exhibition.

John Hoole, Curator, Barbican Art Gallery
Brigitte Lardinois, Exhibition Organizer, Barbican Art Gallery

Bill Brandt was born Hermann Wilhelm Brandt on 3 May 1904 in Hamburg. His father, L.W. Brandt was head of an import-export firm, and in 1900 had married Lili Merck, from a prominent Hamburg family with interests in the arts. He was the second of four brothers. Rolf, who was born in 1906, became a graphic designer, and was involved with Bill throughout his career. Rolf's memories of their early days, as told to Dr. David Mellor in 1985 for the essay 'Brandt's Phantasms' in the catalogue of that year, *Behind the Camera*, are an invaluable source of information about a relatively undocumented life.

Bill Brandt's childhood included a period at a private school at Elmshorn in Schleswig-Holstein, where he was withdrawn and unhappy, perhaps on account of his English antecedents: his father was a British subject. At sixteen Bill developed tuberculosis and was sent for treatment to Davos in Switzerland. Six years later, in 1927, he moved to Vienna to complete his treatment, which included psychoanalysis by Dr. Wilhelm Stekel. His principal contacts in Vienna were his brother Rolf and a Dr. Eugenie Schwarzwald, who was part of a cultural coterie which included the architect Adolf Loos. Dr. Schwarzwald suggested photography as a career to Brandt and introduced him to Ezra Pound who referred him to Man Ray in Paris.

In 1929 Brandt spent three months, uninstructed but interested, in the Man Ray studio. At other times in the late 1920s and early 1930s he travelled widely, in Germany, England, France, Hungary and Spain, where he visited Barcelona in 1932. The very diverse pictures of this period, of which few survive, have not been collected. In 1932 a picture of 1929, of a second-hand clothes seller in London's Caledonian Road market, was published in the German annual *Das Deutsches Lichtbild*, and in 1934 *Minotaure*, the Parisian Surrealist magazine, published an image of 1929, of two mannequins in a flea market, in association with an article by the writer René Crevel (p. 46). In the *Photographie* annual of 1933-34 three of Brandt's pictures appeared, and other photographs from these early years were published sporadically in *Lilliput* from 1937, and in *Picture Post* from 1938.

He seems to have decided to live in England in 1931, before the trip to Barcelona, where he married his first wife, the Hungarian Eva Rakos. In London they

lived at 58 Hillfield Court, Belsize Park, in a small, first-floor flat. His English days in the 1930s are a puzzle. He was relatively celebrated on the Continent, yet made little impact in his adopted homeland. The best he could do, by 1935, was a tiny photograph in the *News Chronicle* of Saturday, 5 June, of a ship's figurehead taken on Tresco in the Scilly Isles, to mark the opening of an air service to the islands.

Although he was attending very closely to material published in the new *Weekly Illustrated*, founded in July 1934, he may never have meant to become a photo-journalist. In *The English at Home*, his first major book, published by B.T. Batsford in the spring of 1936, there are photo-journalistic images, but as many which relate to art, especially the poster art of the Beggarstaff Brothers, Nicholson and Pryde, whose work he had seen in the Berlin poster magazine, *Das Plakat*, to which his parents subscribed in Hamburg. *The English at Home* was no great success at the time.

Brandt's turning to photo-journalism is undocumented, especially as it involved *Weekly Illustrated*, where photographers were not credited. On 23 May 1936, one of his pictures of a blindfolded 'voyante' standing on a box appears in a Derby Day collage: 'She can see as much of the race as most' (p. 45). The photograph, however, was probably taken in France. Then, on 30 May, *Weekly Illustrated* ran nine of his pictures on 'Opera in a Country House' (Glyndebourne). On 3 June a similar, but not identical series appeared in *The Bystander*, credited to Brandt. Then, on 11 July, *Weekly Illustrated* printed seven pictures on the Eton v. Harrow cricket match, 'Topper versus Boater'. It is likely, too, that he was responsible for other articles and contributions during the same period, such as 'All this to make a hotel Christmas', 26 December 1936, and 'Behind the scenes at Windsor Castle', 19 June 1937. *Weekly Illustrated*'s action on him, one way or another, was to wean him from European notions of outdoor reportage and to recreate him as a British *intimiste*. That was the Brandt who went to work for *Picture Post* in 1938-39.

In 1938 *A Night in London*, his second book, came out. It was meant as a British version of *Paris de Nuit*, Brassaï's (and Paul Morand's) book of text and 60 pictures of 1933. It was published by Country Life, and its sources were legion, including Pearl Binder's (and Thomas Burke's) *The Real East End*, published, with dark lithographs by Pearl Binder, by Constable in 1932. *Weekly Illustrated* also published influential city nocturnes in 1934. In both of these books of the 1930s Brandt seems to have thought in terms of montage, for there are a number of striking interrelationships between paired pictures: a described scene, for example, in the presence of its metaphor, or lovers in each others' arms in relation to a suggestive river scene (pp. 44-45 in *A Night in London*). Montage matured in his *Lilliput* essays of the mid 1940s, and is taken to an extreme in, for instance, 'Over the sea to Skye', *Lilliput*, November 1947.

Brandt had begun to contribute to *Lilliput* in September 1937, and to *Picture Post* in December 1938, at which point the annotation of his career becomes clearer. *Lilliput* credited its artists, who were freelances, and *Picture Post* kept track of negatives and contacts, for its photographers were on the payroll. His major articles for *Picture Post* in 1939 were on days in the lives of an artist's model, a waitress, a barmaid and a parlourmaid. All are continuous with a practice developed by *Weekly Illustrated*, and part of the stock of photo-journalists everywhere. Brandt's stories, though, involved

women: the notably pretty and apparently submissive Lyons Nippy, and the altogether more dominant barmaid (Alice of 'The Crooked Billet', a pub near Tower Bridge) and parlourmaid (Pratt, who worked for the older Brandts in London) (pp. 79, 81, 77). By comparison with the work of precursors, Brandt's narratives are thorough, and even intrusive. They touch uneasily on social boundaries, are in danger of going too far. With the coming of *Lilliput*, *Picture Post* and then of the Second World War the pace of Brandt's career picked up, but he was never a loyal and predictable servant of the times. Take, for instance, his first all-new piece for *Lilliput*, 'Twenty-four hours in Piccadilly Circus', September 1939. Its eight images are photographed from one site opposite Swan & Edgar's, and show passing traffic and a sign for 'Invisible Mending' in the upper right foreground, a sign variously legible and obscured. It is a thoroughly conceptual project, designed to register time dispassionately. He played metaphorically and emblematically with time and the idea of 24 hours at the closure of *A Night in London* which contains a newspaper headline from *The News Chronicle* on Jean Batten's arrival by aeroplane in New Zealand. If the Piccadilly Circus suite has a prototype it might lie, again, in Hitchcock whose stilled figures often register flickering, passing lights.

Photography gave Brandt a chance less to experiment with novelties than to recreate scenes from those arts to which he had been exposed. If there is to be a comprehensive response to Brandt it must somehow involve his relation to other arts: to the posters of the Beggarstaffs and of Ludwig Hohlwein which he saw in *Das Plakat* during the First World War and before, to the photography of Man Ray and of the more workaday German-born reporters who staffed *Weekly Illustrated* in the early 1930s, to the films of Hitchcock, such as *Suspicion* (1941), and of Orson Welles, notably *Citizen Kane* (1941). Photography gave him the means of restaging and of reimagining others' inventions and projections. Through photography he was able to capture, to appropriate anything which caught his eye, any style or motif, that is. There is one moment at the beginning of *Citizen Kane* which stands for Brandt: in it the tycoon collector takes delivery of animals, statuary, all the world's curiosities. Brandt, the photographer, delivered and received such curiosities from the image world: flowers, animals, trees, great houses, back-streets, loitering hoodlums, faithful retainers, ageless geology, quintessential country types, *femmes fatales*, enemy agents (embodied in some of his more glaring portraits of men). Brandt's output was diverse less because he changed direction out of conviction than because of a huge diversity in his favourite things, among those things which he wished to see and to grasp. As a photographer he was unusually promiscuous apropos of genres and subjects, far more so than his contemporary Brassaï, who was a great deal more productive.

How, then, did Brandt function in the hectic 1940s? He appears to have undertaken assignments in all good faith and then to have been engrossed or seduced by motifs. In the back end of 1943, for example, he went to Wales to photograph the Swansea Vale area for a special issue of *Picture Post*, 1 January 1944, 'Valley in Wales'. Five handsome pictures of stark antique architecture were published in the event, but his most striking image from the excursion was a near-abstract perforated wall or ruin which can only have been meant as a found version of Max Ernst's apocalyptic cityscapes of the mid 1930s: *The Petrified City* for example.

The importance of his own concealed agendas made Brandt a poor servant, and his various careers are either intermittent or short-lived. However, he was with *Lilliput* for more than a decade, and *Lilliput* provided the setting for his greatest work: the six-, eight- and ten-piece essays which include 'Bill Brandt visits the Brontë country', April 1945, and 'Hail, Hell and Halifax', February 1948 (pp.122, 126, 127, 135, 138, 140). But his work for *Picture Post* was inconsistent, partly because he was given routine assignments. The humblest projects called on surprising memories, and one of his most challenging pieces, on 'Army Suitability Tests' in 1942, was never published, obviously because it restaged British army life as vaudeville (p. 105). In that case the theatrical director in Brandt got out of hand, just as he promised to do in 'Transport: Key to Our War Effort', *Picture Post*, 26 September 1942, where office work is staged as a dark melodrama (p. 106).

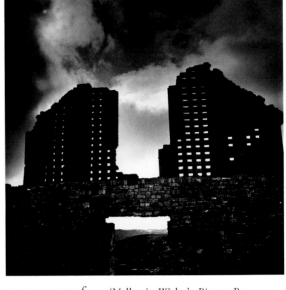

'Valley in Wales', *Picture Post*, 1 January 1944

During 1944 he became a prolific photographer for *Harper's Bazaar*, as a sort of *film noir* cameraman visiting the houses of gentlefolk, notably the Countess of Pembroke and Montgomery and Sir Kenneth and Lady Clark (p.153). He took fashion pictures, and went on to do commercial work for Rima of Bruton Street in London's West End. But the fashion pictures were taken often for the sake of their architectural settings, huge colonnades and London fogscapes. And in his finest 'fashion' work the model was made to look like a Mata Hari, or candidate for *Notorious* (1946). Brandt was keeping very good company in the fashion world – with Hoyningen-Huene, Maurice Tabard, Richard Avedon – but the singularity of his own imagination and the mysterious presence of the model herself always took priority over the product. In the late 1940s he went on to become a fashion photographer for *Picture Post*, in a phase of his career which has always been overlooked. The same over-dramatising, oracular properties are evident in these pictures, which leave them unsettling as 'fashion' photography.

During the war he did a sort of National Service, first of all for the Ministry of Information for which he photographed air-raid shelters during the Blitz in 1940, and then for the National Buildings Record, which put him to work at Canterbury, Chichester, Colchester and Rochester (pp. 90-95, 116-17). The Blitz or Shelter pictures constitute a journey through an operatic Hell, conceived by Tintoretto, perhaps, with iconographic assistance from de Chirico. Bits of Old England survive in the shape of signs for 'LADIES' and 'GENTLEMEN', and the whole has the look of a mythic excursion, having more to do with Dante than with the miseries of the British people under fire (p. 95). When he photographed at Canterbury for the National Buildings Record the results are as melodramatic and wilful, for his pictures are primarily of the figured tombs glaringly lit as if for a pantomime devised by a Sickert of the music halls.

There is no question of explaining Brandt away. Nor is it strictly true to say that he was merely at the mercy of a teeming imagination and memory. There was a centre to his imagination, and it involved desertion, dereliction, the archaic. Absence, it would appear, was the secret, for in absence and void spectres walked more compellingly.

He was, for example, a great war photographer, even if he only became one inadvertently when he went north to photograph 'The Threat to the Great Roman Wall', *Picture Post*, 23 October 1943. At Hadrian's Wall he found, in fact, an abandoned war zone, the epitome of all wars, and at Erthig Hall, in Denbighshire, he found 'The Portraits in the Servants' Hall', 24 December 1943, a complex epitome of the past as picture and absence (pp. 110-13).

Then there is the most imposing of all his essays for *Picture Post*, and the last to be published, 'The Vanished Ports of England', 24 September 1949 (pp. 146-47). It is of Richborough, Reculver, Portchester and Pevensey, of abandoned masonry and installations taken for the sake of a cyclopean geometry, and almost unprecedented in photography. One of France's most discreet photographers of the late 1930s and 1940s was René Jacques, a specialist in geometric cityscapes. The 'forgotten ports' look like Brandt's version of Jacques' geometries, but with a British inflection. Both were photographers who were under threat from the spread and prevalence of humanist action photography, which certainly threatened Brandt's position in the 1940s. In *Picture Post*, for instance, he was at that time reduced to reporting on raincoats, and in *Lilliput* the human figure, in expressive action, was growing in importance by the issue.

It was, however, as a photographer of the female nude that he was finally famous. Nude photography was, appropriately enough, considered a sign of artistic mastery. That was clear enough from the career of Man Ray, and from the work of Erwin Blumenfeld who was the first master photographer to be celebrated by *Lilliput* in 1938. There is no reason to think that Brandt set himself to become such a master photographer, but his fashion work for *Harper's Bazaar* and for Rima, and then for *Picture Post*, put him in touch with models and accustomed him to think of the staging of women – although that had long been one of his interests, from the 'Four Lives' staged

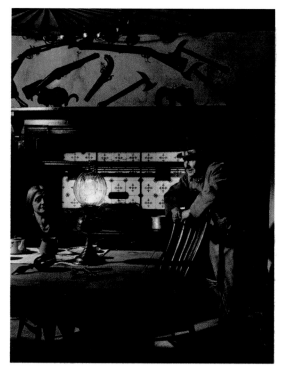

'The Portraits in the Servants' Hall', *Picture Post*, 24 December 1943

in 1939 for *Picture Post*. The first indoor nude, 'The Watcher', appeared in *Lilliput* in June 1946, and three others followed. These mysterious indoor stagings were hesitantly put forward, and excusable in *Lilliput* which catered for male fantasies. At the same time they were challenging figures, far from submissive, even if their connotations were of the brothel. They were the Rima *femmes fatales*, but unclothed and in possession of the site. Again, their source lies in Hitchcock, and their oracular properties stemmed from Brandt's obvious care for exactitudes of staging and lighting which robbed the encounter of all spontaneity.

These nudes, out of Balthus to a scenario by Hitchcock, played a very minor part in *Perspective of Nudes*, Brandt's last great book, of 1961. The photographs in it are a problem in any criticism of Brandt, partly because of their denial of the completeness of the compositions of the 1940s. As the book proceeds, the photographs become progressively more a matter of impersonal fragments of the female nude body and of the photographer's hands, meshed and knitted. It looks rather like a work of denial. During his great phase in the 1940s Brandt's pictures, with their wide tonal range and intact figures, embody closure, although they are, in the late essays in *Lilliput*, interrelated to form

wide, double compositions (as finally in 'Painter's Country', *Lilliput*, September 1948). In *Perspective of Nudes* there are no priorities, no hierarchy, and no identities, neither of place, person nor time. He had been working towards something like that dispassion in 'Over the sea to Skye', November 1947, and in 'Vanished Ports', where landscape and building appear as if in an epitome of all grey days, somewhere between the creation and the dispersion of the world. Born in 1904, Brandt was not exactly old in the 1950s when he was working on *Perspective*, but he had been a diabetic since the 1940s, and was conscious of being in bad health. Thus these late pictures, just like the late landscapes, can be taken as a way of staying or denying time.

Time had, after all, always been one of his topics, even in such a vernacular set as the barmaid pictures, where Alice, no more a maid than Brandt was a youth in the 1950s, is interesting very largely because of her losing but gallant encounter with time. They are, too, a return to origins, to the moment of Man Ray and Paris in 1929 when he came on the scene, and thus they figure, in his career, as repetitions, or denials of the diversity and redundancy in which he had always been involved.

BRANDT'S RETICENCE

Brandt's career, from beginning to end, was the most elaborate and mysterious in the whole history of twentieth-century photography. Ostensibly, he was a documentarist who explored traditional British themes during the 1930s, before becoming a national landscapist and portraitist during and after the Second World War. Finally he gained the standing of an artist, and recognition as Britain's greatest photographer of the modern era.

Brandt was never interested in disclosure and discouraged searching enquiries about himself throughout his life, preferring to be known as an enigma. Whenever some sort of response was called for, he rarely volunteered more than a decent minimum. He considered himself very much a British artist, albeit with Russian and Dutch antecedents; there had, indeed, been a family house in St. Petersburg, a painting of which hung in his London flat.

He generally concealed the fact that he had been born in Hamburg and brought up in Germany during the Great War; German origins were, after all, sometimes a cause for suspicion in a country often at odds with Germany. Brandt, as a documentarist with a taste for mist and darkness, must have easily been taken for a suspicious person, especially with his German accent. It is as likely, though, that he preferred non-disclosure and mystery as a matter of policy. Perhaps he even thought, towards the end, that there was much in his past which should be concealed, and not just his German origins.

We know that he was an active photographer on the staff of *Weekly Illustrated* during its garish heyday in the mid 1930s. *Weekly Illustrated* was no very distinguished address, especially after the foundation, in 1938, of the more responsible and respectworthy *Picture Post*, to which Brandt contributed from the December of that year. *Weekly Illustrated* had itself started quite soberly in 1934, with behind-the-scenes reports, and short stories by Pirandello, but it soon developed a penchant for the vulgar and the exotic. In its great populist days, Brandt's photographs of health centres, for

instance, were outmatched every time by features on popular domestic subjects and by sensational reports from the new front lines in Abyssinia and Spain.

Even the period in Paris, where he had undergone an apprenticeship of sorts in the studio of Man Ray in 1929, had to be treated with caution. Casual researchers in the 1960s connected him with Surrealism and with Man Ray, who had been admitted to the twentieth-century photographic pantheon by then, although largely as a fashion photographer. He had one reason for admitting to Man Ray, however, and that was his own interest in nude photography, which culminated in 1961 in *Perspective of Nudes*. This bold collection was given an acceptable pedigree by reference to Man Ray's album of 1934, *The Age of Light*, in which female nudes figured prominently.

There was not much point, however, in making other Parisian references, which might have been confusing. It seems, for example, that he knew René Crevel in Paris, for in 1934 Crevel wrote a long and fierce article around one of Brandt's photographs in the fourth issue of *Minotaure*, the Surrealist magazine published in Paris by Skira. Crevel, a homosexual and combatant in the struggle around the politicization of Surrealism in the early 1930s, committed suicide in 1935. By the time photographic stock-taking of the period began, in the 1960s and after, Crevel had been filed with the forgotten literature.

Brandt's reticence also extended to a stay in Vienna in 1927. He went there after six years in a sanatorium at Davos, and the visit involved psychoanalytical treatment for tuberculosis. One destination in Vienna was the clinic of Dr. Eugenie Schwarzwald, who suggested to Brandt that he should take up photography. At the Schwarzwald salon he also met Ezra Pound, whom he photographed in 1928 (p.150) and who, as we have noted, gave him an introduction to Man Ray in Paris. At the same time he met, and was impressed by, Adolf Loos, the great Viennese architect and moralist[1]. As a child in Hamburg, Brandt had been trained in drawing by the Czech architect K.E. Ort at the Kunstgewerbeschule, and his interest in architecture was always notable. One of his early photographs is of the façade of Loos' Möller House in Vienna, which was under construction in 1927-28.

His main contact in Vienna was his younger brother Rolf, who had preceded him to the city[2]. His final destination was the Active-Analytic Clinic of Wilhelm Stekel, a busy analyst throughout the 1920s, and a prolific author[3]. Stekel was quoted, admired and denounced by his contemporary, Sigmund Freud. The two were known for their disagreements, which centred on the interpretation of dreams. In later editions of Freud's *The Interpretation of Dreams* Stekel is attacked for his arbitrary readings. Notwithstanding Freud's disapproval, Stekel's many books were translated and republished well into the 1950s. His own work on dreams first came out in 1911, and during the 1920s he published works primarily on sado-masochism and on fetishism. His huge books on these topics are made up of a multiplicity of case studies interspersed with theoretical observations. This involvement with Stekel was first disclosed by Rolf Brandt in conversation with Dr. David Mellor.

The Vienna period was formative, but is liable to misinterpretation. There was even a shadow over Brandt's time with *Picture Post*, which constituted his finest decade. *Picture Post*, for which he worked as a staff photographer, was admirable, but the stand-

ing of *Lilliput*, the associated Hulton magazine to which he contributed as a free-lance, was ambiguous. He may have produced much of his best work for *Lilliput*, which made use of the country's finest writers and illustrators as well as the world's leading photographers, but *Lilliput*, for all that, was *Picture Post*'s slightly dubious *alter ego*: clever and talented, maybe, but not above titillation and exploitation. In its pages photography by, among others, Brassaï, Blumenfeld and Kertész was often reduced to cartoon level by flippant caption writers. It was also known for its nudes: artists' models and chorus girls mainly. In October 1945, its editors, looking back over the first hundred issues, counted around one thousand pictures 'including or concentrating on girls', though not all, admittedly, submissive to the male gaze. But Brandt may very well have found that the association called for silence.

The artist whom he allowed to emerge in the 1960s and 1970s, when he was taking his place in photography's new-found history, was in essence designated by a limited corpus of pictures only slightly attached to specific times or places, and certainly not to places of publication. It was as if they had all been taken, these canonical pictures, in one fabulous excursion through an extended Symbolist twilight. Their relatively large scale and emphatic shadows and highlights declare them to be prints rather than photographic records. They sidestep insistent questions regarding site and time, as they imply a kind of finality. You need look no further, they declare, concluding with a flourishing signature, like certificates authenticated.

BRANDT AND THE THIRTIES

Brandt's early work was very much his own art, to a degree which can be said of none of his contemporaries. Compare his pictures, for instance, to those of André Kertész, who was an established Parisian reporter before Brandt entered the Man Ray studio. Kertész at that time was interested in, and capable of, complete, elegant contemporary figures, tropes in which the social moment is contained. Kertész, though, is no more nor less than contemporaneity declaring itself with a beautiful succinctness. Kertész's art answers to the age, which uses the artist as its medium. The same age could scarcely have recognized itself in Brandt, who was mostly subject to his own preoccupations and memories, making him an anachronism in all directions.

There were options open to him, of which he was well aware. The photographers of the yearbooks were professionals, earning a living from fashion and advertising. Brandt himself contributed to the yearbooks: a nude in the *Photographie* annual of Arts et Métiers Graphiques in 1935 (ill.87), with a successor *jeune baigneuse* in the same annual in 1936 (ill.73). But the professionals were virtuosi who sculpted with light and were impersonally confident, which could never be said of Brandt who eschewed consistency. Man Ray, who was Brandt's 'tutor', was one of those virtuosi and, paradoxically, a Surrealist at the same time. Man Ray's images, which continued to interest Brandt, showed the body burnished and streamlined, as an ultimate contemporary product. But where other photographers set themselves to master contemporary models, Brandt's tendency was to remember until mastery was called for in terms of his own programme. It was only in the 1950s, for instance, that he himself undertook studio nudes in anything like the style of the early 1930s and of the Man Ray studio.

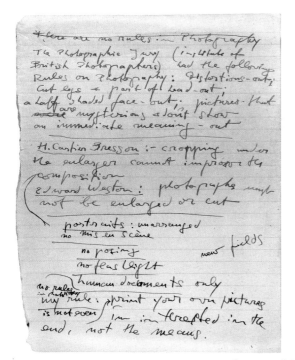

Notes by Brandt on the management and presentation of photographs

At the same time such poet-reporters as Kertész and Cartier-Bresson were in the process of developing an exclusive idiom which depended on wit and lightning reflexes, in the service of compact, instant motifs in which nature and culture, vertical and horizontal meshed. This was a competitive photography with the adjudications carried out by providence, and it was a mode to which Brandt was hostile all his life. This hostility lies behind his insistence on his right to manage the picture as he saw fit, to edit and to reverse and to manipulate lighting to a point where night becomes day. In his longest written reflection on photography, in the introduction to *Camera in London* in 1948, he referred to 'the right moment of action photography', in a passage which separates 'action photography' from his own more mysterious practice.

Then there was the New Photography which, by the time it was codified by Werner Gräff in *Es kommt der neue Fotograf* in 1929, was on the way to becoming archaic. In this mode, which was associated with design and planning, photographers contributed topical fragments to a visionary work-in-progress. It made few allowances for author-photographers, and its ascetic futurism was at odds with Brandt's taste for archaic figuration. Nevertheless, the New Photography was an issue for Brandt because he shared its Modernist interests in institutions and in planning. He was happier, though, with schools, hospitals and the workplace, with any site, in fact, which might be shown to harbour a family or compact peer group: nurses, policemen, or pub-goers.

The implacable Modernism of the New Photography gave way to a more humanist manner, developed in the late 1920s, on behalf of labour everywhere, although especially in the Soviet Union. Margaret Bourke-White represented this tendency in the United States, as François Kollar and Nora Dumas did in France [4]. It was most often expressed in hieratic images of fishermen, factory workers and tractor drivers, and was at the same time both nationalist and democratic, an internationalist mode in regional dress. Brandt put it to no immediate use, although it was added to his stock, and was remembered in Ireland and in the Hebrides in the mid 1940s.

In their turn, the utopian and hieratic manners prompted a kind of disenchanted documentary which was beginning to take hold in Brandt's apprentice years. This new manner was shaped by Germaine Krull in Paris [5]. In it, the values of the 1920s were thoroughly inverted: *clochards* and other marooned street-people took the stage in moments which were always more arbitrary than decisive, and in spaces in no sort of harmony with their inhabitants. This was another selfless idiom, and resolutely contemporary.

One plausible conclusion is that Brandt was simply undecided, and thus free to please himself. He may have been determined to become a photographer at a time when this entailed commitment to a standpoint. Lacking such a commitment he was forced into something like hiding. It cannot be overlooked that he made no very urgent beginning in his *métier*, and that he was never professional, as the term might be applied to Brassaï, for example, who was the closest of all his contemporaries. Brandt

had been active for six years at least before his first collection, *The English at Home*, came out in 1936.

THE SYMBOLIST

Brandt travelled widely in the early days as a photographer: Vienna in 1927-28, London and Paris in 1929, London in 1931, Barcelona in the spring of 1932, and two trips to Hungary in the summers of 1932 and 1933. The pictures from that time include one of a second-hand clothes dealer seated in London's Caledonian Road market in 1929, a night-watchman in Barcelona and a pig in a slough in the Hungarian plain (pp. 48, 53). There are a dozen or so pictures altogether, of which the best known is of a blind beggar kneeling in the sun by a wall in Spain (p.51). He published a number of them later in *Lilliput*, where they were slickly, irreverently captioned.

This peripatetic Brandt was a Symbolist, preoccupied by memories of Munch's *Life Frieze,* which began to take shape in the 1890s. In general, the early figures are afflicted by ambience; they live in extreme and disadvantaged states, impinged on by circumstances which are alien or constraining. The blind beggar in Spain holds his face to the sky and raises a dish which casts a shadow on his cheek. The Barcelona night-watchman is narrowly invested by darkness, and a concierge in a cabin in the same city is hemmed in and labelled: 'PORTERIA'. Where Germaine Krull's personnel exist in an incoherent, disproportioned social milieu, Brandt's appear in relation to the elements: light, darkness, space, gravity. Barcelona's spaces were claustrophobic, and Hungary's horizons were limitless.

The distinguishing feature of the early images is simplicity. In one Hungarian picture the pose of a tottering drunk is mimicked by a crooked tree trunk and mocked by the stable shape of a haystack (p.52). A drunken postman, apparently, is offered as the epitome of disorder. Brandt seems to have been interested in expressing the mere fact of uprightness as elementally human: the presumed postman totters, and elsewhere on the plain a slim boy leans on a stick to make a figure which relates to the poles of a well-head on the horizon. The pig in the pond on the plain is a figure in the process of emerging from a primal, undifferentiated element, and is as clear, if unusual, a symbol as photography has to offer.

The haunted universe of Strindberg and Munch continued to provide Brandt with subject-matter throughout his life; this sequence, 'Nightwalk', was published in *Coronet* (Chicago), January 1941

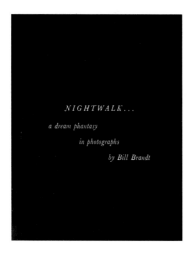 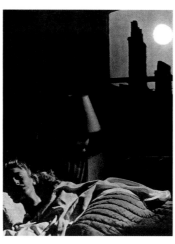 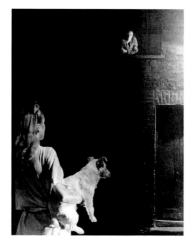 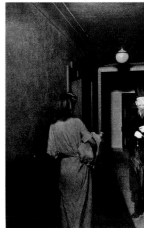

The symbol rings a faint bell. In *A Dream Play*, written by August Strindberg in 1901, a poet enters half way through the action carrying a bucket of mud and glancing at the sky. A nearby quarantine master explains to an officer that the poet, living miles up in space, naturally becomes nostalgic for mud: 'It makes your skin hard like a pig's to roll in mud'. The poet then exclaims, with sardonic asides, on the creation of cultural artefacts from clay. This may be no more than a nice coincidence, except that *A Dream Play* also hosts a collection of figureheads of sunk ships – *Justice, Friendship, The Golden Peace, Hope* – as if in anticipation of Brandt's first published group of photographs, ships' figureheads from wrecks collected together in the Scilly Isles (p. 121).

Brandt's gallery is peopled by Symbolist types, such as the Officer, the Blind Man, the Beggar and the Night-watchman. He did, in some of his latest interviews, admit to an interest in the writing of Knut Hamsun, who was part of that Symbolist coterie which included Strindberg and Munch. Hamsun presents just such figures who scarcely emerge from their typological basis, who remain forever the Boy, the Sailor or the Itinerant.

The Symbolist case can be strengthened, even if never proven. It was during this early period that Brandt first showed a life-long interest in funerary monuments, less because of any innate morbidity than because cemeteries in the major cities provided epic Symbolist types ready made. In Barcelona, for example, he found Death and the Industrialist (p. 49), and in Hungary a figure of the Devoted Husband. Later, in *A Night in London*, a descending Munchian pillar of light pierces the waters of the Thames in a figure which symbolizes coitus.

If the Symbolist theory can be sustained it shows Brandt as an anachronism in the various modern contexts of the early 1930s. Why he should have opted for that road is open to question, but it did grant him access to great, comparatively timeless, themes. Now, one of the questions which will always hover over Brandt concerns what he might have taken from contact with Adolf Loos. If Wittgenstein can be admitted as a spokesman for that coterie in the late 1920s (he returned to Cambridge from Vienna in 1929) it appears that there was an overriding preoccupation with resistance to social epiphenomena: 'Today the difference between a good and a poor architect is that the poor architect succumbs to every temptation and the good one resists it.' Wittgenstein

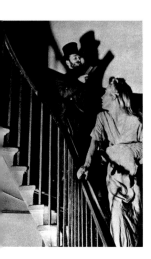
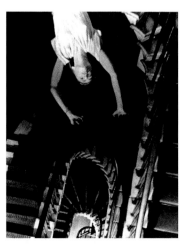

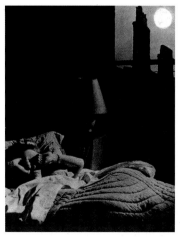

looked back to an age with culture, but saw 1930 as an age without culture peopled by 'a crowd whose best members work for purely private ends'. Brandt, when he opted for Symbolism with all its respect for the immanent, was volunteering for that rumoured 'age with culture'.

VIENNA, STEKEL AND PSYCHOANALYSIS

Brandt's early years as a photographer were marked by conflicting priorities, engendered both by his psychoanalytical experiences and by later cultural encounters in Paris. The meetings with Wilhelm Stekel in Vienna can only have encouraged a Symbolist bias even if, at the same time, they gave it an eccentric colouring.

Stekel's procedures are worth recounting for the light they throw on Brandt's art. His many published case studies usually open with a long narration by the patient of his or her sexual experiences, with special attention to aberrations and anxieties. Once the position has been stated the analysand reports dreams and fantasies and, in the fullest studies, dozens of dreams are narrated. If Freud focused on hesitations and on inconsistencies, and declined to take the dream itself at face value, Stekel had no such reservations, going straight to work to posit meanings. In his book dreams gave up the secrets of their symbols without much resistance. Above all Stekel paid attention to imagery, to the corridors, tunnels, balconies and railway stations which his analysands kept on encountering. His case studies are an iconographic depository from which a history of the Central European imagination could, with time, be written [6].

One of Stekel's main articles of belief was that fairy stories not only made a deep impression but did a lot of damage. Brandt's favourite book from his childhood, and one he cited to interviewers in the 1970s, was *Cherry Stones* ('tinker, tailor, soldier, sailor, rich man, poor man, plough boy, thief') in which the masked thief who brings up the rear of the procession carries a lamp as his symbol, a lamp which looks remarkably like a camera.

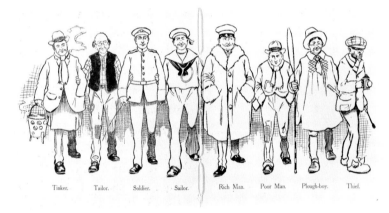

Illustration by Charles Crombie, *Cherry Stones*, c.1900

Stekel's interpretations were often extravagant but perhaps for that very reason, were often compelling. What Stekel did for Brandt, it could be guessed, was to extend the concept of symbolism to the everyday. Once it is pointed out that a three-branched candlestick is a symbol of a life burning and consuming itself, or that a house with many rooms can be read as the inventory of a soul, then there is no end to enchantment. Brandt's art looks, in many cases, very like the dreamwork of Stekel's clients, for like that dreamwork it is as fascinated by significant objects as it is neglectful of context: those Hungarians marooned in infinity; the Spaniards wrapped in shadow.

Not only did analysis in the Stekel mode invest the everyday with symbolic potential, but it also promised first-hand experience of the discovery of meaning. Stekel dealt less with inherited categories, with Love, Despair and Hatred, for example, than with anxieties which had not yet found their proper terms. Analysis was an elaborate event with a revelatory climax, and as such it almost prefigured photography where

preparations and a search might culminate in a conclusive image. The difference lay in the fact that photography's dreamwork was carried out in the absence of the analyst. Without that authoritative voice, speaking confidently of the meanings inherent in balconies and chests of drawers, there could only be delicious surmise.

The whole of Brandt's career amounted to one long submission of dreams to an imaginary analyst, although first of all to himself, who was, as the source, not entitled to speak. It is noteworthy that when he wrote about his own work, which was rarely, or had others write about it, he shrank from references to particular pictures or the circumstances in which they were taken. Analysis would have established a meaning, and with that the life of the dream would be over. Stekel's case studies end either with the analysand fleeing the analyst, or settling down to live happily, and dully, ever after. In terms of the dogma of the Active-Analytic Clinic, Brandt was a paraphiliac, in love with the symptoms of his own condition.

PARIS, CREVEL AND SURREALISM

If Vienna confirmed the oneiric Brandt, Paris added irony and ethics. Apart, however, from that short period in the studio of Man Ray, there is little to connect him with Paris. Some photographs survive, in one of which a figure leaning on the guard-rail of a bridge makes a line and angle which invites comparison with swaying masts of boats and the upright of the Eiffel Tower (p. 42). It is a Kertészian picture. Brandt's Paris output would condemn him to oblivion, except for one picture of two mannequins seen in a flea-market and subsequently published in *Minotaure*, in company with an article by René Crevel (p. 46). The story goes that Crevel saw the picture in the magazine office and was sufficiently taken by it to write his complicated text as a response.

The only item of evidence to suggest a formative connection with Paris is a book which Brandt kept throughout his life: Emile Chautard's *La vie étrange de l'argot*, published in Paris in 1931. What can a photographer have wanted with a book on the slang of criminals and prostitutes, and a scholarly one at that, of 720 pages? It is a suggestive source, almost too good to be true. Although a book of words carefully traced back to their origins, it is intriguingly illustrated in miniature by the Rumanian Eli Lotar, the photographer of Buñuel's Spanish documentary film of 1932, *Los Hurdes* (*Land without Bread*). Lotar's pictures are of street women and their milieu. In addition there are anonymous pictures of burglars' kits on display, and of prison cells, along with a handsome picture by Eugène Atget of a *maison close*, from the collection of André Warnod, the author of *Visages de Paris* (1930), a guide to Paris old and new illustrated by Germaine Krull in the new style of disenchantment. The same very genial, even artisanal, image by Atget was used in *La révolution surréaliste* over the title *Versailles*. Despite Lotar's pictures, *La vie étrange de l'argot* is anachronistic, and quite naturally so, because much of the argot at issue had ancient roots. Many of its older illustrations are by Toulouse-Lautrec. This largely leaves untouched the nature of Brandt's interest in *La vie étrange de l'argot*, which was a specialist study.

In the Paris of 1930 archaism was in the air. A nostalgia for a golden age centred on the years before the First World War, which was the period celebrated in Warnod's *Visages de Paris*. Brandt's *grande mannequin*, admired by Crevel, dated from

that period. Equally, many of the pictures published in *Atget – photographe de Paris* in 1930 originate in the same heyday. Brandt owned a copy of that book, bought in Paris at the time of publication. He also owned a copy of L. Cheronnet's survey of Paris *c.*1900, published in 1932. If the evidence of the *grande mannequin* and of the Nadar pictures of bygone Parisian fashions in Cheronnet's album are to be believed, he was at least as interested in the look and character of Old Paris as he was in Atget's virtues as a photographer[7].

There was a good reason for Brandt to be interested in Crevel, who had also spent time in sanatoriums, and who wrote of the experience in *Etes-vous fous?*[8] He recollected days in the sky-scraper sanatorium or apiary of the ill in relation to a yearning for escape to a Parisian bistro. He dreamed of marbled oilcloths on the tables of these bistros with spectacular veining, wild peninsulas, and every sort of incentive to reverie. Crevel is supposed to have noticed Brandt's *grande mannequin* in the office of *Minotaure*, as if the picture simply happened to be there. Why was it there in the first place? Was it just an odd picture on a desk? More likely than not it was part of a set or series, and Brandt's intention was to catch Crevel's eye – his patience was legendary among subsequent employers and editors. Certainly, Brandt's early work matches the world of Crevel's novels in a number of particulars. The Mac-Louf of *Babylone* had begun as a fake hunchback, selling narcotics, before moving to the evangelical missions in Marseilles and rising in The Society for Protection by Rational Experience. In his early London days Brandt recorded two Mac-Louf figures in London, one on the podium and one behind placards (p. 88). Crevel cherished an idea of victimized children escaping in the gondola of a balloon, and Brandt's best-known picture from the Paris years is of such a balloon rising into an empty sky (p. 47). He was stimulated by artifice, whether manifest in English dress and manners or the wax figures of the Musée Grévin.

Crevel, looking through any submission by the young photographer, would have recognized familiar faces. At the same time he would have recognized his own outlook; and had he not committed suicide in 1935 he might have gone on recognizing it throughout Brandt's career. He was fascinated by the suggestive capacities of words, by their ability to change the play, especially towards the erotic. When, for instance, Brandt found Sailor Cox at the races he was on Crevel's home ground. His Babylon is an eroticized city: 'Its limbs, heavy with clusters of caresses, were the trees, immodest gestures their leaves.' Argot, strongly figured and given to *double entendre*, allowed an underhand approach to taboo subjects especially in *Etes-vous fous?*

Brandt might almost have been Crevel reincarnated, continued covertly by other means or under another name. Crevel's topic, like that of Brandt after him, was lack of identity and its fascinations. Brandt was attracted to mystery, as his editor Tom Hopkinson said. It was a mystery, though, which was predictable and even systematized Crevel foretold much of it in his text around the *grande mannequin*. In the words of analyst Stekel it is a bi-polar fantasy, masculine-feminine. The mannequin is by turns formidable and seductive, mainly a mother, but a warrior too. Jupiter and Minerva open the parade of names, before the entry of Hermes and Aphrodite, and the final coming of 'a new double and total reality'. He then lingers over the romance of trans-

formations, just as Brandt will do a few years on in his *Picture Post* pieces on Pratt the housemaid, Alice the barmaid, and the Lyons Nippy, where in the end the commoner emerges as duchess, empress or princess for the evening. In these pieces of behind-the-scenes access Crevel's visions are re-enacted at street level.

ENGLAND IN THE THIRTIES

From a Parisian and Surrealist point of view England, *c.* 1930, was surreal as it stood – part of the landscape of Surrealism. It was the land of Brandt's father, if not of his mother and it was, it seems, very dear to him following bitter childhood experiences during the First World War. Yet his view of the country was probably that of ironical outsider, for whom the culture, if not the place, was already typecast. With this outsider's cast of mind, reportage in any disinterested sense was almost certainly an impossibility for him, which might explain the fact that when he was finally called on to do his duty, during the Second World War, it was with landscape that he found his touch.

His first major work, *The English at Home*, was published by B.T. Batsford in the spring of 1936. It had been turned down by the publisher Anton Zwemmer, on the grounds that it was not 'erotic' enough. That charge must have been a surprise to the veteran of the Stekel clinic, whose set of 63 pictures was at least as erotic as it was critical. Brian Batsford's confidence may have been vindicated in the long run but, as it turned out, the book was peremptorily reviewed and then remaindered. One reviewer saw it as critical of England: 'Mr. Brandt has hammered his point until it is in danger of being blunted'. The hammering, though, involved no more than three of thirty-one pairings. Oddly enough, Raymond Mortimer who wrote the introduction also gave undue emphasis to social criticism: 'One's pleasure in being English is somewhat modified by knowledge of this unnecessary, this humiliating squalor. And if one insists on referring to it, one is likely to be called a Bolshy.'

The national charade was the true topic of Brandt's book. For instance, one of the ostensibly critical pairings puts 'Travel for the Highest' against 'Rest for the Lowest': on one side a fabulous roadster and royal coach, and on the other sleepers in a Salvation Army hostel. Furthermore, the woman window-gazer at the centre of events, a tidy figure in a trilby, clearly prefers the car to the coach. The trilbied lady, faced with the choice, had gone for chromed headlamps, wire wheels and power under the bonnet. The ticketed hostel-folk, meanwhile, lie low in a torment, a nightmare, of ornamentation. The idea that these tableaux just happened by has to be resisted. Brandt selected his sites and organized their occupants.

The subjects of much of *The English at Home* can be easily traced. His picture of miners returning to the surface after a shift could have been based on Umbo's version of the subject published in the *Photographie* annual of

'Sunday Afternoon'
'Sunday Evening'
The English at Home, 1936

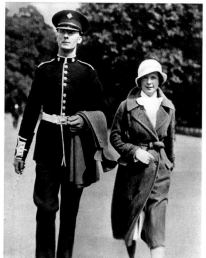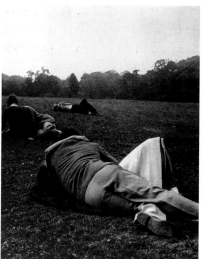

1932. A grouping of two middle-class tailors was taken in Mortimer St. in Soho, according to a memory of his brother Rolf, and was quite specifically based on a scene from *Cherry Stones*, their childhood picture book illustrated by Charles Crombie. A picture of batsman and wicket-keeper by the stumps derives from the same subject in William Nicholson's *Almanack of Sports* (1898). His golf and hunting scenes also owe a lot to Nicholson's *Almanack*, where the seasons are related to particular sports.

Umbo was a strict contemporary, a Berliner and one of the New Photographers of the 1920s, but Nicholson, illustrator of the *Alphabet*, *Almanack*, and *London Types* was from the roaring 'nineties, and an example to Crombie. As a child Brandt had probably seen Nicholson's work in *Das Plakat*, the bountifully illustrated poster magazine published in Berlin, 1910-21, to which his parents subscribed. William Nicholson and James Pryde, as The Beggarstaff Brothers, popularized a kind of simplified realism, which looked as if it could be photographically based. Their influence in Germany was considerable, especially on Ludwig Hohlwein, the Munich artist who became a leader in poster design and a regular exhibiter in *Das Plakat*. Hohlwein's posters were based on his own photographs, and Hohlwein was an influence on Brandt in the 1930s and after.

This influence was twofold, at least. In the first place Hohlwein visualized urban settings in terms of screens and backdrops arranged parallel to the picture plane, which was how Brandt preferred to show London streets. Hohlwein tended to give commercial details along a broad horizontal frieze in a space cleared across a wide foreground – and Brandt left just such spaces ready for occupation, both in London and later, when he turned to landscape. In the second place, Hohlwein liked to people his advertisements with darkened silhouettes, mysterious consumers and agents. Brandt's silhouetted tic-tac men on their Tate & Lyle boxes look back to observers of 1920 isolated by Hohlwein for a Rumpler-Luftverkehr advertisement published in *Das Plakat*'s August issue. When applied to landscape, Hohlwein's deliberated style resulted in the kind of complete composure which is characteristic of Brandt's landscape art in the 1940s.

His ideology at the time, if Brandt's Surrealist credentials are to be given any weight, was one which held stereotypes in suspicion and contempt, and *The English at Home* is an excursion through just such stereotypes. The stereotype was either subverted by means of a disproportionate emphasis on what would normally be subordinated physical features, such as the tailor's bald head, or inverted: three nurses, for example, enjoy a cup of tea and a chat on an infirmary staircase opposite a crowded graveyard.

The most touching of the photographs in *The English at Home*, and one which is repeated on the back of the jacket, almost as a theme picture, is of a miner's family. It may also have its source in *Das Plakat* where, in June 1921, Heinrich Honich's depiction of a striving family was used to exhort German farmers. In Brandt's hungering group a gaunt but elegant mother sits by a self-possessed elder daughter with darkened or dirty hands, as if she had just come from laying a coal fire. This elder girl has a string of beads about her neck. A younger girl, in a white shift, stands by her mother's knee.

Advertisement designed by
Ludwig Hohlwein, *Das Plakat*, 1920

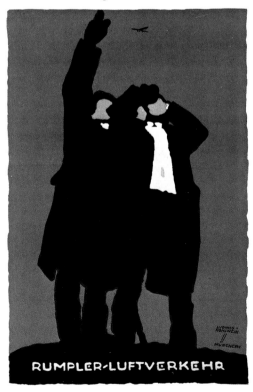

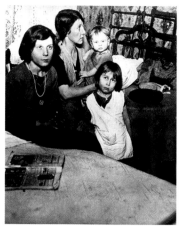 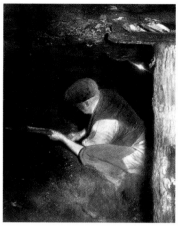

'The Home'
'The Work'
The English at Home, 1936

Next to this exquisitely arranged and slightly cowed family group a man's cap lies on a draped surface. It looks like evidence of the missing man, off to one side, yet within eyeshot of the anxious mother. In 'The Work', on the facing page, a solitary miner wears just such a cap as he excavates in a darkened seam. The pairing, the repeated cap motif, and the huddled, apprehensive look on the female side all suggest that what is at issue has as much to do with a troubled male/female relationship as it has to do with social deprivation in the North. Brandt has invested this scene with potential violence.

WEEKLY ILLUSTRATED

The references to Nicholson, Hohlwein and Crombie support the idea of Brandt as an artist with access to an arcane register of sources. Yet another influence on his imagery lay much closer to hand, but which had none of the exotic appeal of *Cherry Stones* and Nicholson's *Almanack*. Shortly after its opening in 1934, *Weekly Illustrated* ran two major photo-features. In its third issue, on 21 July, a two-page spread recounted 'London by Night' in twelve pictures. Then on 14 August it was the turn of 'Daybreak over London', in fourteen photographs. Neither story is credited to any photographer, and both may be the work of several hands.

Both articles were memorable enough to be recreated by *Picture Post* in its second and fourth issues in 1938: 'London by Night', on 8 October, by Felix Man, and 'In the Heart of the Empire' (Piccadilly Circus), on 22 October, by Kurt Hutton. In *A Night in London*, which was also published in 1938, by Country Life, Brandt clearly drew on the example of the *Weekly Illustrated* articles. In particular, 'Daybreak over London' has a row of five pictures which might almost be by Brandt himself, including two silhouetted policemen in a steeply recessed street, a collection of bottles in a basket, and a hand-operated milk-float in the dawn in Piccadilly Circus. The milkman of 1934 worked for Caroline's of Bedford St., W.C.1, and a successor who posed for Brandt's *Lilliput* article of September 1939, 'Twenty-four Hours in Piccadilly Circus', advertised Express Dairies, of Adeline St.

Conceivably, Brandt drew on both articles for his iconography and syntax. In 'London by Night', for example, an off-duty guardsman, cane in right hand, talks imposingly to a young lady by park railings. Such a guardsman, 'one of the most familiar sights in London streets', also appears in *The English at Home*. Right next to him in that article of 1934, photographer or editor has juxtaposed, over the gutter, 'a motor-café for the homeless and hungry' and 'the vast plate-glass windows of the Savoy', in anticipation of some of the social juxtapositions of *The English at Home*.

Felix Man, who was the author of *Picture Post's* 'London by Night', must have been the part-author, at least, of the prototype in *Weekly Illustrated* – on the strength of a number of near-repetitions. Brandt must have attended closely to that article, and may even have been responsible for some of the frames in 'Daybreak over London',

which also looks as if it carries Man input. Both articles are crucial, and neglected, sources for Brandt's reportage in the 1930s. Both are examples of an outdoor European style, well exemplified by, for example, Germaine Krull who came to England in the autumn of 1935 to report on distress in northern coalfields: 'A Frenchwoman visits the North and asks – Is this your England?', *Weekly Illustrated*, 5 October 1935. And both are social-critical in that they juxtapose social extremes so as to draw attention to inequality.

The *Weekly Illustrated* connection makes possible a Brandtian cross-section for that year. It was the year of his first publication in *Minotaure*, in Crevel's company. It also saw something like a graduation on the European photographic scene, for in the *Photographie* annual of 1933-34 he was represented by three pictures. These were the Spanish beggar (p. 51), the tipsy Hungarian postman (p. 52), and a fountain in Barcelona, which later saw service in *Picture Post* in an article on British weather. At the same time he was attentive to the German-style photo-reportage of *Weekly Illustrated*.

Although Brandt may have been entertaining a variety of options in 1934, England was in the process of calling him in, making him one of her own. His first definite appearance in *Weekly Illustrated*, which was becoming more and more populist by the week, was in a Derby Day collage spread over two pages on 23 May 1936. Among the twenty overlapping and interlocking motifs, expressive of a busy social mix, was the Brandt photograph of a blindfolded voyante, probably taken in Paris long before.

Then on 30 May 1936 there appeared nine pictures over two pages on Glyndebourne ('Opera in a Country House'). A similar article, with slightly different pictures and Brandt's byline, appeared in *The Bystander* magazine on 3 June 1936. Brandt saved some of the pictures which especially intrigued him – which would always be his practice when he worked as a staff photographer at *Picture Post* – and one image of Salvatore Buccalini, an Italian bass from Buenos Aires, brought in to sing Leporello in *Don Giovanni* and Bartolo in *Figaro*, appears much later in reverse in *Lilliput*: 'The voice that breathed o'er Eden'. Apart from a cod-Arcadian piece of three principals in a boat on the Glyndebourne lake under trailing willows there is little Brandtian about anything from Glyndebourne, apart perhaps from a bust of the Commendatore isolated on a lawn. Indeed, the Glyndebourne Brandt looks as complaisant a photo-journalist as *Weekly Illustrated* ever used. In one wicked period piece Aulikki Rautawarra, 'famous Finnish singer', is seen teaching a terrified fledgeling to sing.

A BRITISH PHOTOGRAPHER

Behind-the-scenes in the national home and workplace, spontaneity was impossible, and there quickly grew up an indoor genre in which artisans applied themselves and then relaxed, read, smoked and talked with a stilted informality. Outdoors was the proper domain of the informal. Part of the photo-journalist's task was also to introduce readers to the famous at home, and this too demanded the tact of an itinerant trades-man. On 1 September 1934, for instance, it was 'A "Day Off" with J.B. Priestley', sunk in a large armchair. In this context Brandt, the one-time Parisian wanderer in the city, had no option but to evolve into a British *intimiste*, and it is as such an *intimiste* that he

is celebrated in his stint with *Picture Post*, for which he went to work from December 1938.

During the *Weekly Illustrated* period, which lasted from July 1934 to his leaving for *Picture Post* in the summer of 1938, Brandt was at his most assimilated. He was, in effect, one of the pioneers of indoor documentary and of the decorous, staged shot. There are any number of articles which can be attributed to him during this four-year period, not all of them with absolute confidence, for in many cases the magazine sent a number of photographers on particular missions. Where, for instance, did he find his mining pictures for *The English at Home*? He may, in the winter of 1935-36, have been one of several involved in the preparation of a series called 'Underground Lives', which was published through January and February, with a substantial interruption caused by the death of George V and the installation of Edward VIII. 'Underground Lives' was the most thorough of the magazine's documentaries, and was taken in the Rhondda Valley in Wales by photographers who 'spent several days living among miners'. It is a thorough and compassionate series on home life in mining communities, on the lives of children and on recreation. In the autumn of 1934 James Jarché, who was the magazine's star, had photographed underground for an article of 6 October, 'Coal and the men who get it'. The new series complemented that spectacular excursion. Its most Brandtian scenes are of a dog foraging in a desolate back-to-back street, and of a pub scene on a Friday night, taken from behind the bar.

Brandt may also have been employed on another large-scale, reformist project, published on 17 November 1934, 'Pull down the slums'. In March 1933 a great national scheme for slum clearance had been launched, and a year later still had a long way to go. If Brandt was not one of the photographers, he borrowed the undertaking's iconography: a view down on to a set of chaotic backyards, and a scene of children below street level at the grating or 'front window' of a basement.

In 1934 and 1935 he may have been preoccupied by the idea of *The English at Home* and relatively content to work as a member of the Odhams collective. By the end of the period, however, he was a specialist in indoor documentary, and responsible for articles which are on a par with anything he achieved for *Picture Post*. If his career were to be arranged in phases, the *intimiste* phase begins at some point in 1935 and culminates in 'The Portraits in the Servants' Hall', published by *Picture Post*, 24 December 1943.

The finest, and most unmistakable of these pieces was published on 19 June 1937, in connection with the coronation of George VI, 'Behind the Scenes at Windsor Castle'. In this two-page survey guards patrol the castle grounds, early morning milk arrives and policemen relax in numbers inside the castle's police station. It is a fairy-tale world in miniature, snugly appointed with a lodge-keeper and housekeeper. His gift was for this kind of protected milieu, and it is anticipated in the Barcelona pictures of the night-watchman and concierge. In England, though, it expanded to encompass whole establishments: hospitals, hostels, hotels, schools, colleges and even an ocean liner. In these safe havens the authorities are much in evidence, in the shape of policemen and supervisors. In a three-page piece, 'Night in a Hospital', from 30 November 1935, a policeman questions a witness. In the liner *Aquitania*, 'Ship's quick turn

around', 21 December 1935, bell-boys line up for inspection, as they do a year later in the Cumberland Hotel, 'All this to make a hotel Christmas', 26 December 1936. Nurses abound, nowhere more so than in a campaigning article of 16 October 1937, 'More praise than pay', in which one dreams at a window, some rest on a main staircase, and others take a meal.

The impulse to visualize protective environments was insistent. In 1938, for instance, on 23 April, he seems to have been responsible for a photo-sequence in nine parts on 'The Invisible Cost of a Day Out … It's Budget Week Again'. Ostensibly, the essay has to do with the price of beer, cigarettes and the cinema, but the artist converts it into a reassuring picture of family and social life, with a guardsman, group outing, mealtime and the companionship of a pub.

One aspect of the magazine work which it is easy to overlook is its textual accompaniment. Brandt and his colleagues were practising in a radio age. Radio was news, and a pervasive influence. One of *Weekly Illustrated*'s longest articles ever was headed 'We Spend One Day at the B.B.C.'. It was a day of action and smiles beginning at 7 a.m. in Broadcasting House, and appeared on 11 April 1936. The radio ethos, which put a premium on instruction and entertainment, was, in its own terms, both homely and light. Audiences were good companions, even if worldly-wise, and that understanding of the people was widespread in the media. It was, crucially, an audience to be addressed, an audience of listeners rather than an audience of readers, and the captions of *Weekly Illustrated* are permeated by tone of voice. One characteristic of speech, especially the familiar speech of the streets, is that it moves on. The photography of the time was necessarily deeply implicated in this conversational ambience, and even defined by it. An audience was meant to get the point and proceed to an adjoining frame and phrase. That at least was the case in serious documentary expositions. Where national festivals were involved carnival was indicated by collage and catch-phrase.

Turns of phrase were an understood part of the business, and allowed for by the photographer and associates. In 1943 one of Brandt's most fascinating pictures, of a dancing girl in the street, was used in an article in *Picture Post* and 2 January: 'Are we planning a new deal for youth?' (p. 69). Written on the reverse of the original, as suggestions for use, are these phrases, the last of which is cancelled: 'Oh, mister Wu! I'm you … Joan Whiffin is the Jessie Matthews of Wolverley Street. Grab her Mr Cochran'. Thus a complex image, in which an older girl dances before an audience of younger girls and one embarrassed boy, for her own delight and the benefit of the camera, is slipped into the familiar context of music hall and the chorus line.

Not only did pictures occur in the context of adage, cliché and popular song, but they occurred on an equal footing, writ small enough not to impede the continuum. Thus most of Brandt's work in *Weekly Illustrated* appears in profusion but in miniature, mainly to the size of contact prints. On that scale and in that density, and in the company of friendly chatter, no picture could properly materialize, or develop any implications which might lie too deep for daily speech. In particular, popular venues allowed no scope for the erotic which was and would remain one of Brandt's preoccupations. The books, by contrast, with their discreet captions freed his imagery from the conversational definitions imposed in *Weekly Illustrated*. In both *The English at Home* and *A*

Night in London he was able to return to the point of revelation, the moment just before the dream gave up its reading.

A NIGHT IN LONDON

Brandt's second book, with its sixty-four images, looks like a summation and extension of his work for *Weekly Illustrated*. In fact, it is that world revisited without reference to the utopian hospitals, schools, playgrounds and health centres which had been his forte in 1936 and 1937. London, as interpreted by *Weekly Illustrated*, was more notable for the Middle Park School at Eltham and the L.C.C. School in West Kensington than it was for back alleys and prostitutes' haunts. Thus the author of *A Night in London* was going against a well-lit and well-meaning contemporary ethos, to which his better nature was apparently committed. It is a sign of Brandt as a wilful actor on the contemporary stage, as an artist with another, more cryptic agenda than decent people would believe. One of the unremarked curiosities of his career with *Picture Post* during the 1940s is this very wilfulness, which eventually disqualified him as a documentarist.

A Night in London can be explained in part as a British response to Brassaï's famous picture book of 1933, *Paris de Nuit*. The two books have a topic in common, but very little else. Brassaï was a designer-photographer who excelled in a contemporary style. His Parisian streets are beautifully arranged, nuanced and sectioned. His imagination, however, was that of some of Brandt's caption writers: talkative and topical. Brassaï's jokes and observations are worldly, in the public domain.

Brandt was a true Surrealist – probably the only true one in photography – but his was a curious Surrealism of the prosaic detail, writ large in its innocence. He was a devotee, it seems, of car number plates, such as 'GX 6975', which carries an elderly top hat and blonde bob back to a darkened house. He was attracted by details of London's labyrinthine bus routes and their numbers. Policeman 61 D on the jacket of *A Night in London* is a married man with an incipient moustache, and headlines in the *News Chronicle* on the morning of the new day (the final photograph in the book) show that Jean Batten had just reached New Zealand by air. Any reader of Brandt could hardly help but be turned from the intuition by such cherished, distracting inscriptions: the names on tins and the exact time of night. Nor is it the detailing of Atget, where signs of all sorts abound but keep their place in a hierarchy of the national and quotidian.

There are representative figures in plenty, but their representativeness is qualified. Both include a rag-picker, but Brandt's is watched by a waiter from a restaurant, and the scene revolves mainly around that man's response. Brandt's homeless 'inside a common lodging house' sleep in numbered boxes beyond a chamber-pot, white and intact in the foreground. He relishes disproportion, instability, and sudden changes of vital emphasis.

'Homeless Girl'
'Footsteps Coming Nearer'
A Night in London, 1938

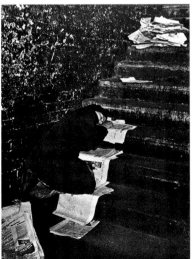
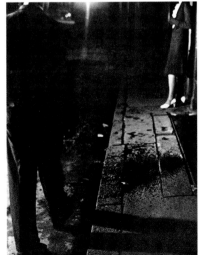

It would be difficult to say what Brandt's subject is, except that it is not London in any strict sense. He is, perhaps, critical of complacency. He consistently achieves disruption of the expected. Although the introverted family might be taken pejoratively, as merely complacent, their situation in the context of the enthralled child invokes countervailing ideas of privacy and of dreaming. Then there is the best known of his pictures from that series, 'Top Floor', in which a couple embrace in a bedroom under a sprig of mistletoe (p. 62). The embrace is based, with very tiny variations, on a motif found on a postcard in the collection of Paul Eluard, 'Le Baiser mystérieux', and published with a range of mainly erotic postcards from that collection in issue 3/4 of *Minotaure* in 1933. The sprig of mistletoe signals licence in winter, and in later versions of the picture, especially in the stabilizing final phase, it no longer appears.

In *A Night in London* its hint of pagan promiscuity is both confirmed and gainsaid by an adjoining river scene which is as complete a symbol of coitus as appears in photography. It is an example of Brandt managing a variety of signs: the mistletoe, an emblem taken from the culture at large; the echoing piers, linking thread, harbour entrance, shaft of light and gulf of deep waters, a symbol which must be half-spoken into action. The other emphatically erotic pairing, close to the 'Top Floor' group, confronts 'Homeless Girl', asleep on a flight of steps, and 'Footsteps Coming Nearer'. In this pairing the short distance separating the prostitute from her client is incarnated, paced out, in the ten steps which rise behind the sleeping girl. Thus, being involved in *A Night in London* entailed less a consumption of ready-made meanings than a creation of meaning from relatively raw materials: steps, deep waters and a mooring rope.

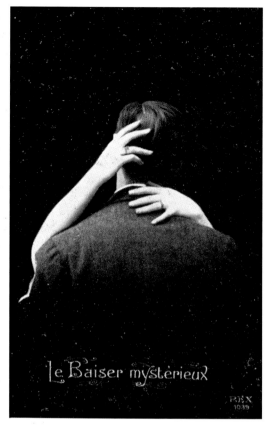

'Le Baiser mystérieux',
Minotaure, 1933

BRANDT IN WARTIME

The history of Brandt in wartime is of a responsible citizen quickly enrolled in work of national importance. His first war work was a traditional piece, 'Blackout in London', carried by *Lilliput* in December 1939. Towards the end of 1940 he was employed by the Ministry of Information to take pictures of Londoners sheltering in the Underground during the Blitz. That work was carried out between the 4 and 12 November. At the same time there was alarm in official circles that adequate records of bomb-damaged buildings were not being kept [9]. In September and October of that year the Ministry of Information was also made responsible for such work, both in London and in the provinces. By 1941 the scope of the project had grown to include the task of recording 'all meritorious buildings', under the title of the National Buildings Record. Brandt was employed on this large project too.

Brandt may have visited Canterbury before the war years, since on 5 March 1938 there were articles in *Weekly Illustrated* on 'Canterbury – England's First Cathedral' and on 'Canterbury's Boy Singers'. He may even have done York Minster in the same year, for 'York – sacked, plundered, fought over' appeared on 16 April. Certainly he was unhesitating about his priorities in Canterbury, which were the

heavily figured tombs of Dean Wotton, Alexander Chapman, Dean Boys and the Thornhurst Family (pp. 116-17). Although images of the Sir Thomas Thornhurst and Dean Boys monuments were published in *Lilliput* over facetious titles, his Canterbury pictures were otherwise unused. They show him bringing the dead back to life, for any implications of family relationships hinted at by the original sculptors are enhanced by the photographer's theatrical lighting effects. Wotton and Chapman, one kneeling and the other in a box, seem narcissistically involved in their devotions. But what drew his attention above all was the interconnection between self-consciously handsome men and worldly, even disenchanted, women: between the outrageously conceited Sir John Boys, for example, and two kneeling handmaidens; between a long-suffering Lady Thornhurst, head on hand, and her armoured husband, lost in devotion and now transfixed by Brandt's camera.

Canterbury was a Brandtian theme park of sexual and architectural motifs. If the cemeteries of Barcelona ten years before had given him Symbolism ready-made, Canterbury returned him to many of his topics of the 1930s, rehearsed by England's finest. While the early work was discreet, at least where it dealt with relationships, the Canterbury pictures are blatant to the point of melodrama. Wotton, Chapman and the rest live more expressively than any of their stunned precursors in the books. It must have been obvious to those in control at the National Buildings Record that Brandt's concept of the national heritage was not exactly theirs.

Brandt retained much from Vienna and Paris, from psychoanalysis and Surrealism, and the war granted him a licence to act without constraint. During the 1930s he had been working for publication, but his new employers allowed him a freer hand, and the result was a carnival and a collapse of stereotypes. Fragments from the old world of social order linger on in the shape of signs, 'LADIES', for instance, and 'GENTLEMEN', in relation to gnarled and slumped survivors (p. 95). England as Arcadia is remembered as a school poster of a country fairground hung above underworld sleepers.

What was novel about both the Shelter and the Canterbury suites was an intrusion of the real into the social order. Canterbury's family dramas are cut in stone, made glaringly present. The sleepers and refugees exist among the smells of slop buckets and unwashed feet, and rest under dripping walls. There is space for understanding still, but it is on the way to being corrupted by an intrusion of the physical.

The Shelter pictures also raise the question of Brandt's knowingness. Was he no more than a natural artist, with the knack of remembering, or was he a sophisticate elaborating an art for an ignorant audience? Despite his taciturnity, this latter option cannot be overlooked. The Shelter pictures, in particular, look like a homage to de Chirico's *Hebdomeros*, the novel – in French – of 1929. De Chirico's montages of simultaneities must have been known to Brandt[10]. In these, the prosaic time of clocks, fluttering pennants and passing locomotives keeps company with the other time of history and dreams. Brandt's temporal differences are less hierarchically gradated. The dome of St. Paul's and Westminster's towers might stand, during the war, for history and tradition, but he was always more intent, as in *A Night in London*, on the difference between inside and out, and on the experience of the classes and generations.

NATIONAL LANDSCAPE AND NATIONAL FARCE

The war, in fact, rewrote Brandt's terms of reference, introducing him to apocalypse. In particular it uncovered the possibilities of history, and made of him one of the greatest of war photographers, even though he never saw the front-line. Or rather, he found another front-line which served his purposes better than any real thing. His principal suite of war pictures was published in *Picture Post* on 23 October 1943, under the heading 'The Threat to the Great Roman Wall' (pp.110-13). The Wall was under threat from quarrying at Housesteads, and C.E.M. Joad's accompanying article was on the topic of preservation. For Brandt, though, it was the front itself, or the embodiment of all fronts and especially those of the Great War, seen as if by History itself. The metaphor is elaborated: the Wall is endless, in terms of space as well as time; empty roads and an apparently abandoned farmhouse speak of the movement of troops and of civilian displacement; an archaeological perspective of a Roman mile-fort confirms the perspective of history; a labourer portrayed, 'What's All the Fuss About?', speaks for the merely contingent, the smaller time with which Brandt, and others, had to cope.

'The Threat to the Great Roman Wall' constitutes Brandt's first major essay in landscape, and provides a key to his understanding of the genre. It shows landscape under the sign of history, of history construed as an absolute, freed from the inter-ference of contemporary voices and attributes. Under these terms the world has been returned to a post- or pre-history inhabited by uncomprehending survivors, 'What's All the Fuss About?'. It is the work of an artist not wanting to be bothered by an impor-tuning present.

Thus burdened, Brandt was in an increasingly difficult position vis-à-vis the work of reportage. Conscious of history's longer perspectives, how could the present be managed? One answer was to stage it as farce, which produced some of the best of his unpublished work. The first of these apparent failures was a *Picture Post* article of 23 August 1941, 'What are all these children laughing at?', an account of children watch-ing the Punch & Judy show of Tom Haffenden (pp. 102-3). Working from home, with a suitcase and portable booth, Haffenden told a contemporary morality in which, for instance, Mussolini is threatened by a crocodile, before being throttled by Uncle Sam smoking a cigar.

The greatest of his failures, taken sometime in the summer of 1942, involved Army Suitability Tests (p.105). Not surprisingly it was killed in its entirety, whereas only the puppets in the Haffenden story were suppressed. Brandt must have begun the piece on Suitability Tests with some idea on a day-in-the-life of a recruit because, at one point, a grocer is seen selling butter before going on to a chest examination. The tests themselves, carried out under elaborate, improvised apparatus, owed more to Heath Robinson than to a modern army, and might have brought about the collapse of national morale had they been published. At first sight it might look as if Brandt, with his inflexible hieratic style, had simply made an awful mistake in this gimcrack camp with its farcical cast. Yet its lampooning of the everyday is consistent with much of what follows. It is as if he was unwilling to go along with propaganda.

In the autumn of 1942 he was sent to Kent to cover the plum harvest, and three of his pictures were used in an article on 12 September, 'Saving Britain's Plum

Crop' (p. 104). The many unpublished pictures, of gipsy families and pickers, amount to a one-man discovery of neo-romantic themes. There followed 'Transport: Key to Our War Effort', on 26 September 1942, in which a secretary appears to wear a lit lampshade as a hat, and demonic planners look set to take over the world (p. 106).

Brandt, seemingly, could only envisage contemporary history as an extravaganza. His imagination, stimulated by the war or forced to work in a new dimension, had discovered a Great Beyond. In Kent, with the plum-pickers, he came across a pagan paradise; at Housesteads he found the site of all wars. Then, on 24 April 1943, he found a local version of God creating the World, in the shape of the Archbishop of York examining 'the model of a New Town of the future' (p. 109).

During the early 1940s Brandt's work went far beyond the English at home to the whole of History. He was endorsed in this and excused by the extreme circumstances in which he was acting. His finest hour, in this omnipotent phase, was 'The Portraits in the Servants' Hall', published on 24 December 1943, and described by Dr. Mellor in 'Brandt's Phantasms' as a masterpiece. Its relevance to the war is obscure, but it does indeed represent the whole of Brandt's career in miniature, and in terms of figures. The few ancient retainers who remain in the hall epitomize that legion of types who figure in his own expositions of the 1930s, and seem even to be sitting in memory of one of his many meal-times. Elsewhere the lady of the house inspects portraits from the past, many of which are inscribed photographs, which are in turn re-photographed by Brandt, so that, in a sense, they become his own photographs. What is at issue in 'The Portraits in the Servants' Hall' is his own past as history.

Just as the abandoned landscapes of the Roman Wall establish an idea of landscape as a figure for a timeless history, so the façade of Erthig Hall, standing non-committal beyond a mighty oak, symbolizes architecture as a closed book – but as a book nonetheless. That façade is just as much a key to *Literary Britain* as Housesteads.

In April 1942 *Lilliput* published a set of eight pictures by Brandt on 'Soho in Wartime'. One of these is of a woman watching the street from an upper window, as if in memory of some of his London pictures of the 1930s (p. 87). The same woman appears in another unpublished picture from the same set, but this time knitting indoors. Brandt's references on the back of the picture establish her as a Greek woman who kept an hotel. What makes Brandt's art uncanny are such references which keep in being some likelihood that what is ostensibly on show is not the whole story, that all those motifs are part of a larger, secret scheme, a private universe to which we are on the point of gaining access. In his last war-time suite, for example, 'The Magic Lantern of a Car's Headlights', published in *Picture Post* on 31 March 1945, he was apparently celebrating the end of the blackout (pp. 114-15). In the process he also took one of the war's most complete pictures, of a cemetery by night afflicted by giant lightning strokes, taken from pollarded trees demonized by the lights. At the same time, the headlamps pick out service men and women, a donkey, a dog, and a damaged rabbit. Among their favourite childhood books, his brother Rolf remembered, was *Peter Rabbit* – and there he is, come to grief in the headlamps, another casualty of wartime. He was telling anything but the whole truth, and once that possibility is insinuated all interpretative certainties loose their footing.

The war allowed Brandt to visualize landscape and its structures as negations. Equally, it must be stressed that the realization was his own, just as those various semiologies of the 1930s, the montage pairings, were also his own. He was not only well armed against contemporaneity and its short-term influences, but confident that providence was on his side, that destiny would provide. He was in a position, experience must have indicated, to take up almost any genre and to make something of it beyond expectation. His relative isolation in the milieu of his own imagination also led him to persist in anachronism, to a point where he courted humiliation. As a photo-journalist, in particular, his loss of touch must have been evident at *Picture Post* when he took so many unusable pictures of the war-time Derby in 1941.

After the war he returned to what might have been thought of as old haunts with a commission to photograph 'The Doomed East End', 9 March 1946. His pictures of Stepney were a triumph in the old hieratic style and one was used on the cover of the magazine, but Charles Hewitt's informality was preferred inside (pp. 82-85). Then, in 'The Forgotten Gorbals' published on 31 January 1948 (p. 75), the lion's share went to Bert Hardy, the most vivacious of all the Cockney humanists, whose informal manner prevailed in *Picture Post*. In the reformist ethos of the welfare state Brandt's archaizing projections were an embarrassment. Where such new reporters as Hardy, Hewitt and Magee submerged themselves in the social and were thus able to show it in process, Brandt with his staged portrayals brought nothing but interruptions. The *leitmotif* of this new age was a child at spontaneous play. Brandt had taken very successful pictures of children, but as actors in traditional types of play. The emblematic child of the 1940s, though, had everything to do with the future, and Brandt's imagination had everything to do with the past.

BUILDINGS AND LANDSCAPES

One of the curiosities of Brandt's career is *Camera in London*, a relatively disappointing book of April 1948, even though his foreword is his longest piece of published writing on his own practice. In it he volunteered a surprising account of his career which, he wrote, began with the photographing of buildings: 'Yet they lacked something, some quality which I could not name and only vaguely felt would have given me pleasure. So I turned to landscape.' What was he referring to? There are no traces in his surviving work of any architectural phase, nor even of any purely landscape phase. Perhaps he was doing no more than setting the scene for a development for which there is a great deal of evidence: 'Almost without realising it stone-work began to encroach upon my landscapes. Little by little – a milestone, the tombs in a churchyard, a distant house in a park – until there was a fusion, not consciously sought by myself, of the subject that interested me and that indefinable something which gave me pleasure – aesthetic or emotional, or call it what you will. I began to feel that I might produce good pictures.'

He may have been re-telling, in brief, his story of the 1930s and of the early 1940s, when he was a photographer of London and then, very tentatively, a landscapist. There were some woodland pictures published in *Lilliput* in October 1940, 'Autumn in a forgotten wood', although with rimed fir trees and a toadstool they owe more to Arthur Rackham than to nature. Then there was a very romantic tree and moon, also in

Lilliput, January 1942, alongside a verse by Dylan Thomas (p. 134). Certainly this phase, if it was such, came to very little. As he recalled in 1948, stone-work encroached, and by 1943 it was well established.

Encroaching stone-work was a preoccupation until, roughly, 1951 when its aesthetic was summarized and obscured by *Literary Britain*. The story of stone-work in landscape began in earnest with eight pictures from Edinburgh, 'The Northern Capital in Winter', *Lilliput*, February 1942 (p. 132); and more than a year later was taken up in another *Lilliput* article, 'The Garden of England', September 1943.

It is tempting to look at all of Brandt's stone-work pictures as merely impressive compositions in their own right. Many of them have been subsequently republished in isolation. They are, however, oddly composed, often in relation to an asymmetrical axis, with a main feature occupying the foreground to left or right. It might even be said that there is something disquieting about his compositions in landscape and architecture. For instance, when *Literary Britain* came out it was, of course, well reviewed although with reservations.

Literary Britain is, for the greater part, taken from six- and eight-part essays published in *Lilliput* during the 1940s, and these constitute some of Brandt's greatest achievements. Now, photographic connoisseurship invests in the priority of the single image, in an idea of photographers producing like painters or graphic artists. Yet in the 1940s, at the height of his powers, Brandt's basic unit of account was far less the isolated picture than the montage pairing. In the 1930s these pairings had involved semantics: description in the presence of metaphor, for instance. In the 1940s, on the other hand, his attention was drawn to spatial play, to surprising conjunctions of deep, steep spaces.

In his foreword to *Camera in London* he remarked that he was 'not very interested in extraordinary angles', which remark has only an element of truth in it, for there are many very extraordinary angles in the *Lilliput* essays. He meant perhaps that he was not interested in imposing such angles. What happened in the paired pictures, almost from the beginning, is that coulisses collide where the pages meet, and white stone, for example, rhymes with dark foliage. In itself each image is conspicuously incomplete, lop-sided. The trick was to find a counterpart which might make a completed unit.

It looks as if the procedure was implicit in his compositional strategy from the beginning. He had, very early in his career, taken photographs in the Scilly Isles, some of which – of ships' figureheads – were published in *Minotaure* in the winter of 1935 (p. 121). Other pictures from that visit were published in *Lilliput* in July and August of 1943, and one, of a stone head in shrubbery gazing out towards the sea, constitutes an early landscape

'Over the sea to Skye', *Lilliput*, November 1947

SKYE has probably not changed much since Dr. Johnson's visit in 1773. It has no aerodrome, no railway, and roads are few and bad. Atmospheric effects of strange, unearthly beauty make up for the island's misty climate. After the rainy season of August and September the hills and moors are a dripping sponge. But October always brings a brilliant Indian summer before Skye disappears behind the clouds and darkness of the long island winter.

PORT NA LONG is the village of the weavers and spinners in Skye. The most suitable wool for spinning comes from the poorest type of sheep that live on the barren moors of the Outer Hebrides. While spinning yarn during long winter nights the women of Port na Long sing traditional weaving songs. Some curious taboos are still found in Skye. You should not give a woman a needle without a thread in it for fear it would render her barren.

(p. 143). In it Brandt remarks on pictorial depth as a sight-line, as space to be actively traversed, rather than as any mere representation of depth. In later enactments of this sort of composition the point of deepest recession touches often on the edge of the picture, as if that edge were more literal than conventional. Then in the *Lilliput* essays it is the furrow of the gutter itself which is treated as real space. Many of his *Lilliput* townscapes play on an idea of disappearance into that infinite fold, as if he were some kind of photographic sculptor attentive to the point where the representation meets and slips into a shadowy reality.

Many of Brandt's urban sites appear to have been chosen for the sake of spatial differentials. Edinburgh is, notoriously, a city assembled on a steep site. Bradford-on-Avon which he presented in an article of December 1944, 'A small town in autumn sunlight', is also projected in terms of dipping and curving streets. Then Hampstead was pictured in February 1946, 'Hampstead under snow', and the interest there was all in the interaction of façades, grills and swooping deep spaces. In March of that year he applied the same process to the curtain walls and alleyways of Wapping in 'Below Tower Bridge'. The most outstanding of these spatial extravaganzas was 'Hail, Hell and Halifax', of February 1948, where he found something like perfection in the conjunctions of plunging waters and precipitous streets which he was able to bring into abrupt interplay (p. 126-27).

The spatial montages were at their purest in Hampstead and Halifax. The system may, in fact, have been developed to take advantage of the cramped conditions which obtained in *Lilliput*, where photographs were traditionally bled on three sides. In *Picture Post*, with its greater scale, Brandt developed a type of flat, banded landscape, which looked back to the poster designs of Ludwig Hohlwein in the 1920s and beyond. Their poster potential was obvious, and one was used as such on the front cover of *Picture Post*, 19 April 1947, to advertise a special feature on Britain in crisis (soaring prices, slumping quality). It was of Stonehenge. A comparable picture, of Barbury Castle, on Marlborough Downs, introduced 'The horizon of Richard Jefferies', 6 November 1948 (p. 136).

The most comprehensive, and the most surreal, of these landscape montages, the one with the most unsettling changes of scale, is 'Over the sea to Skye', November 1947, for which he also, and unusually, prepared the commentaries. The final image in this set is of a gull's nest, of isolated eggs against a large background of sea and sky (p. 133), and in an afterword to a republication of *Literary Britain* in 1984 Mark Haworth-Booth remarked on its affinities with Herbert List's 'Goldfischglas, Santorin', published in *Photographie 1940*. In List's picture, goldfish swim in a bowl on a ledge with the sea beyond, and Brandt's pairing was almost as anomalous.

In March 1947 some of the tactics used in 'Over the sea to Skye' had been rehearsed in 'The beauty and sadness of Connemara'. In one folkloric image of an elderly woman and a child at the half-door of a cottage there is an unsettling detail, which looks no more

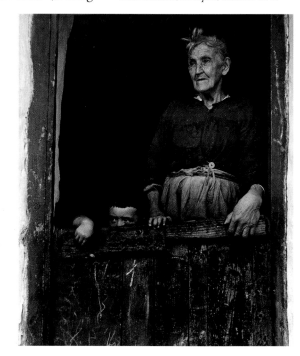

'The beauty and sadness of Connemara', *Lilliput*, March 1947

than an accident. Brandt's own caption begins paradoxically, as if in anticipation: '"I have no English", said this old woman, standing with her grandchild at her cottage door overlooking Galway Bay.' At first sight, the scene looks commonplace enough, like an exercise in the style of the great French folk photographer Nora Dumas. The woman, though, rests her hands on the ledge of the door, or appears to. What looks, at a glance, like her right hand is, in fact, the left hand of the child, but it seems to be attached to her wrist. Appearances are anomalous, suspect. The opening frame in the set is of a view through a divided sash window, arranged like the opened pages of a book, on to a nearly symmetrical market scene blurred by rain – or readable only in general.

LITERARY BRITAIN

The watcher in front of any of the extraordinary *Lilliput* articles of the 1940s moves vertiginously between spaces, scales and registers, from the touch of a hand on wood to an idea of a people. Ideas are interfused, interrupted by memories of particulars, and by evidence to hand. Yet all the same Grigson only gave him 35 out of a hundred. More than likely Grigson misunderstood, and he can hardly be blamed, for some of Brandt's literary sites are bleak indeed, especially when seen in the isolation of *Literary Britain*. Brandt's contemporaries, most of them subject to *horor vacui*, cluttered their literary sites with friendly paraphernalia, with summer clouds and wicket gates. Brandt and his tenants put the shutters up – literally in some cases – and the result is a landscape of exclusion and negation, a landscape of absence.

Although only four of *Literary Britain's*[11] sixty-five images are of graveyards the overall effect is commemorative, but commemorative of the childhood of literature. What is on show are the unfilled spaces of infancy and youth, the bare spaces into which the phantasms of British literature are delivered. Brandt had been down that road before, as the author of *The English at Home*. In 1951, though, he was considering creation itself, and emptiness was its figure. That idea of the empty space as a site of desire and dreaming is admitted by John Hayward, who put the book together, in his juxtaposition of one of those early Roman Wall pictures with Kipling's imagining of the Wall as a battle zone in *Puck of Pook's Hill*.

Brandt hardly had to know anything of the work in question, for he already knew enough of the workings of the imagination. Even so, it is likely that he started out with specific phantoms in mind. There were the front-lines, camps and military roads called up by the Wall in 1943. Then the impressive landscape of absence series of May 1945, 'Bill Brandt visits the Brontë country: Wuthering Heights', was the setting for Balthus's illustrations for *Wuthering Heights*, published by *Minotaure* in 1935. Balthus' hallucinated Cathy of the drawings looks like the prototype for Brandt's own fascinated nude sitters of the 1940s. There are seven Brontë pictures altogether in *Literary Britain*. The principle of completion never depended on proximity, and where there was proximity – as in the essay montages – the results were intentionally discrepant.

If 'Over the sea to Skye' is as metaphysical as this account implies, why does Brandt give no hint of its meaning anywhere? The captions are those of a romantic

traveller. Nor in *Camera in London* does Brandt present himself as a programmatic metaphysician alert to any mythic resonance in spinning wheels and primaeval kine. The reason is that the enunciation of anything of this sort would re-define the whole as a contrivance, part of a symbolic order already well understood. As it is, whatever meanings rest under the surface appear to be endorsed by the natural order, a part of how things naturally are.

He invested heavily in this ideology of the real. Just how heavily can be seen in 'The Vanished Ports of England', which looks like a record from an era of gigantic post-minimalism. In 1943 at the time of his Wall pictures he, like George G. Carter in his text for *Picture Post*, might have chosen to remember vanished traffic. In 1949, however, he chose to show space systematically charted by gross matter, by ragged walls, heaps and towers, as in some unfinished cyclopean rebuilding of a de Chirico townscape. This most sculptural of his essays combines the brutish and the schematic.

THE PORTRAITIST

The Brandt who wrote in *Camera in London* said something about his method: 'See the subject first. Do not try to force it to be a picture of this, that or the other thing. Stand apart from it. Then something will happen. The subject will reveal itself'. In this case, the standing apart also meant the calculating and registering of space, a task which could be attended to without forcing the picture. It is no accident that he became a successful portraitist, and a portraitist of nudes, as he began to attend to buildings in landscape.

In November 1948 he was asked to participate in a project in *Lilliput* which demonstrates his procedures in portraiture. Five photographers, Rosemary Gilliat, Michael Peto, Laelia Goehr, Bill Brandt and Angus McBean, were asked to photograph the actress Josephine Stuart, who had played the part of Oliver's mother in *Oliver Twist*. Brandt commented: 'André Breton once said that a portrait should not only be an image but an oracle one questions, and that the photographer's aim should be a profound likeness, which physically and morally predicts the subject's entire future'. It was his most grandiose published statement on art, and the sitter does look like an oracle, if one could be imagined. At least she appears to be gravely wrapped up in herself, like so many of her precursors, clothed or not. The others in the group made staged portraits, but Brandt's is calculated, to the degree that all its interest lies in the background, in the lighting on a pair of pictures hung on either side of a chimney breast, and in the relation between a domed clock stood on the mantelpiece and the dome of Josephine Stuart's forehead.

Evidently in the time taken to arrange the picture, and in the presence of an artist attending to physical circumstances, any notion of the portrait as an encounter vanished. Left to her own devices, but still under a contract of sorts, the sitter easily became an 'oracle'. A number of Brandt subjects, including some of the 'English Composers of Our Time', taken for *Lilliput* in September 1946, act as staffage in calculated architectural settings which plunge and align around them.

It would be naïve to act as if any of Brandt's new practices of the 1940s – portraiture, fashion, and the nude – were uncontentious. Nor were they, in their funda-

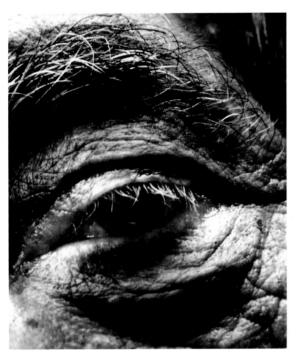

Giacometti's left eye, 1963

mentals, new, but they did involve him more completely than before in the problem of power. During the 1930s his actions were endorsed by his public role. Like his colleagues, he was acting on behalf of the national interest as interpreted by his employers, and that was even more the case when he worked on social issues for *Picture Post*. But in the topics which greatly involved him – Pratt, Nippy and Alice of 'The Crooked Billet' – he exceeded his role. Both Pratt and Alice were dominating figures, and are shown from a child's, supplicant's or dependant's point of view. Nippy, on the other hand, is envisaged as a vulnerable harem girl: under apparent threat from an older pipe-smoker on the upper deck of a bus, and as one of a number of submissive operatives under the gaze of a brilliantined maestro. The three essays stage fantasies of domination and submission in the presence of women. All three centre on an idealized woman. Only in Nippy's case do men appear – to act oppressive parts. The male role he seems to have associated with violence and disproportion: in the figure of the guardsman, and that of the prevailing male in his several scenes of love on the grass.

His vision of male dominance, threat and violence was mediated in the 1930s by the motif of the figure in uniform – guardsman or policeman. Thus the destabilizing male role was kept at arm's length, in the realm of fable. From December 1941, when he photographed 'Young Poets of Democracy' for *Lilliput* he was called on to undertake portraiture, and this inevitably raised the problem of staging the male. It did so in an especially acute way, because he was asked to photograph celebrities, which involved the issue of relative status. He may have been apprehensive, because he did not become a portraitist all of a sudden. He took Henry Moore in his studio in December 1942 and then the English composers in September 1946. There followed 'Six Artists' in *Lilliput* in June 1948, a series on film producers in February 1949, 'Nervy Birds in a Gilded Cage', and eight writers in November 1949, 'An Odd Lot'. In the meantime he had been working, mainly as a portraitist, for *Harper's Bazaar*, for whom he began with five London designers in October 1943: Edward Molyneux, Norman Hartnell, Peter Russell, Charles Creed and Hardy Amies.

He depended on a plain conceptual manner in which Charles Creed, for instance, is accompanied by an unclothed tailor's dummy, and Peter Russell by a bale of cloth. Among the musicians, though, in 1946 he was less accommodating: Michael Tippett stands endangered by a collapsing roof and Bernard Stevens is diminished by a disproportionate trumpet. Norman Douglas, in 'An Odd Lot', is outshone by his shoe, and Graham Greene, in one of the most frequently reproduced of Brandt's pictures, acts as a cipher in a complex architectural abstraction, where shoulder and head rhyme with the lines of a building.

Thus the subject becomes an unwitting participant in Brandt's own composition, or in a milieu which is more absorbing pictorially than the face in question. Artists and writers gave him the greatest trouble because they, like himself, were creative but, unlike himself, honoured in the culture. Henry Moore, with whom he had once

shared double billing apropos of the Shelter project, was photographed against a background which gave him the look of someone with the ears of a donkey or hare. Then, in the 1960s, he photographed the eyes of an international cast of artists, published in his retrospective *Shadow of Light* in 1966. Close-ups of eyes are a commonplace in modern photography, especially in that of Erwin Blumenfeld who was much used by *Lilliput*, but Brandt's emphasis on fissured and puckered lids was a novelty, for it proposed the real rather than the imaginary of the artist. Equally, they were images which were in his gift, for he was possessor of the names, without which the pictures made no sense.

THE NUDES

Brandt's nude photography is more complex. He may have undertaken nudes because they formed an accepted genre with a ready and steady market in *Lilliput*. His first published art nude of this last phase came out in February 1942 in *Lilliput*. Photographed through muslin, the body is presented chastely. Decorum was expected of named photographers of the nude, who were students of beauty. The best known of these students in England was John Everard who, in the fourth issue of *Lilliput*, in April 1938, stressed impersonality and chastity as ideals. Everard's art nudes act as if entranced by ambience. They luxuriate in light and in ocean breezes. Profane beauty, of the kind connected with chorus girls, was provided by Wide World and Keystone.

Brandt, graduating from muslin and chaste impersonality, restored the gaze to nude photography. His subjects of the mid 1940s either return the camera's stare or act disinterestedly, indifferent to the role of 'nude'. With Everard's chaste figures, and those of Berko who appeared regularly in *Lilliput*, there was never any question of a response to figures who were, according to the conventions of the genre, engrossed by their own luxuriating response to ambience. Brandt's nonchalant sitters offer, by contrast, a challenge to male apprehension. At least that was the case in 1946, 1947 and 1948, when single nudes appeared in *Lilliput*.

Few of the portrait nudes of the mid 1940s were used in *Perspective of Nudes*, the retrospective of 1961. The Hampstead blonde of 1945 (p. 166) was no.1 in that series and isolated as she is on the jacket of *Behind the Camera* in 1985, and is again secluded in the nudes section of the same book. There is something about her bearing which does not tolerate company, which might be characteristic of all the nudes of the mid 1940s. Those in *Lilliput* are also isolated, and this isolation might be a key to their meaning.

Their staging for a heterosexual fantasy is clear enough, although how that fantasy might unfold is doubtful. Pratt may be authoritarian and Nippy submissive, but more importantly they play parts, which means that they can be framed by the whole – of the working day, or of the institution itself. But their successors, such as 'The Watcher' of June 1946, are self-possessed, which condition is supplemented by the coherency of the rooms they occupy. They are relatively closed images which allow a challenged access to one gaze only.

Why, then, did he turn from these sequestered oracles to the gargantuan fragments of the latter days? Remember that the bulk of the *Perspective of Nudes* was never

rehearsed in miniature, as was everything else before then. Nor, although the pictures in *Perspective* go two to an opening, is there any strong implication of mutual interaction. Instead, there is some loose sense of sequence, and of a sporadic return of a sense of touch, given in the shape of interlaced fingers and clenched hands. But on the evidence of these motifs, it is a sense rather of touch thwarted. At the same time flesh has been transposed or sublimated as light, which means that the promise of proximity is also thwarted, baffled. *Perspective* is also a history of sorts, stretching from an encounter with the Hampstead gaze of 1945 to harmonic fragments from the present of 1961. It is, though, a history without dates, and marks the first ten years of the photographer's attempts to dissociate himself from the categories of time and place with which he had been involved since his days in Vienna.

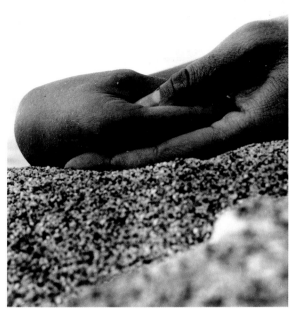

From *Perspective of Nudes*, 1961

What happens afterwards, in the shape of the so-called collages and such nature fragments as the 'Caligo Moth' of 1963, is an attempt less to attach Brandt's art to some neo-romantic iconography, than to incorporate a primal nature symbolism, more oceanic and geological than local. It is consistent, this identification with an increasingly wide concept of time, with his late reprinting programme in which contingencies are dissolved and the deadlines and crises of the social past blurred and forgotten. *Shadow of Light* of 1966, although a retrospective, is notable for its lack of differentiation, as if it had all happened in a dream.

Brandt the adult gives the impression of an artist working with childhood recollections, and even from a child's point of view. He worked like someone confident of the sanctity of such a viewpoint. Given any sort of a chance, he preferred to envisage the most routine assignment as an opening into fable. On 14 November 1942, for instance, *Picture Post* published a story on 'Fire Guards in the House of Commons' (p. 107), where the members on duty look like trolls or spooks in pantomime, or grotesques by Mervyn Peake – one of Brandt's colleagues at *Lilliput*. The 'fire guard' story is typical of his dramatizing for an audience devoted to fabulous narrations. As the photographer he was the inventor of these tales; but, at the same time, as the printer he was also their first consumer. Photography thus gave him the chance to be once again like the child he had once been, as if still inhabiting a childhood where the fantastical still held sway, or could still exercise its power and charm.

In the properly psycho-analytical account there was once a threatening moment which is then ceaselessly renegotiated, and there is what might be evidence of that in his several versions of a scene of sleep, death and coition. In general, though, it appears to be the very idea of childhood which is most important to him, and that any motif that looks evocative enough will serve his turn, from surrealist-approved statuary, such as he found in the Scillies, to the gnarled roots and trunks of his early landscapes. Childhood, in fact, meant keeping in touch with origins, and stood opposed to ideas of dispersal and loss. One repeated scene in his documentaries of the 1930s is of a sitter writing letters in the calm of the evening. Chorus girls, barmaids and cooks all recollect

in the tranquillity of time off. It is easy to imagine that they are writing home, keeping touch, reporting back, and that they function as metaphors for an art which was a means of contacting or even of reliving childhood imagining, as some ideal scene where phantasms were invested with a force denied them in the quotidian culture in which he was, as an adult, obliged to operate.

In two of his most poignant images he appears to have staged that division between the social continuum and childhood as a moment apart. In 1941, for example, he reported on the war-time Derby and was taken by several scenes of children climbing and tumbling on a sandy track winding up a slope topped by a frieze of preoccupied adults (p. 100). In Wales in 1943, in pursuit of planning, he found more lost boys in a hidden, almost a subterranean landscape, under another continuum of spectral houses.

The evolutionary track through Brandt even helps to throw light on the phantasmic and its meaning. It has been noted here and elsewhere that he took from childhood sources, indeed from almost any sources that came to hand, and that he took literally: that kiss from Eluard's postcard is stolen intact, and the Nicholson derivations are unconcealed. He also took again and again from earlier articles; he had a reliable template and used it: relaxation, for example, is signalled by a showcase with cinema stills, and conviviality by mealtime at a table. Originality, by definition, meant novelty and thus a break with the past. Brandt seems to have wanted to guard against the break, to claim even that time stood more or less still. He re-shot similar scenes with minor alterations from year to year: invisible mending. He re-used earlier work as if it were still relevant in an extended present. His tactic was often to reverse the print, as if that minimal alteration were enough in itself.

Clearly, established formats allowed him to assert continuities, to the point of archaism. Yet it was not simply a question of traditionalism for its own sake. In every case he both deepened the genre and, more intriguingly, claimed it as his own. In Stekel's terms he was a harem cultist, or collector of personalized genres. He himself appears in *The English at Home*, as does Rolf, his brother, and Rolf's wife, Esther: 'I'm no angel', on Brighton beach (p. 54). In addition he associated both city and nation with the books of his childhood.

Both as a traditionalist and harem cultist he was at odds with the ethos of his era. *The English at Home*, for example, coincided in 1936 with Laszlo Moholy-Nagy's *The Street Markets of London*, with sixty-four pages of pictures and an extensive text by Mary Benedetta. Had Brandt read Moholy-Nagy's foreword he would have found his own nostalgic approach called into question, for the great modernist and instructor frowned on 'romantic notions of showmen, unorganised trade, bargains and the sale of stolen goods' – exactly the picturesque notion of London which Brandt preferred.

His nostalgias were even less tenable when he was confronted by evidence of social misery in the North of England. Yet the shock of the North did not mean that he underwent any radical change of heart, that he all of a sudden and in response to difficult circumstances became a responsible reporter. In the opening phrases of his career he presents himself as staging a child's eye-view of the city and of its culture. Under the new serious dispensation the child continues to be present, but its presence is hardly

admitted to. The photographer now becomes the child, and works from the child's viewpoint, as an astounded but discreet witness. He is as playful as ever, except that the new game is serious, even monstrous.

NOTES

1 For details of Adolf Loos's plans for the Schwarzwald School Gymnasium of 1915, for example, see Benedetto Gravagnuolo, *Adolf Loos*, Milan, 1982.

2 For details of Brandt's youth in Hamburg and Vienna, see Dr. David Mellor's introduction to *Bill Brandt*, Bath, 1981.

3 See *The Autobiography of Wilhelm Stekel*, London, 1950.

4 See, for example, Margaret Bourke-White's *Eyes on Russia*, New York, 1931, and a special issue of *Vu*, 'La France: pays de la mesure', June 1932, in which François Kollar's *La France travaille* was advertised.

5 Germaine Krull's pictures of the more decrepit suburbs and their inhabitants appear in André Warnod's *Visages de Paris*, Paris, 1930.

6 Wilhelm Stekel's publications include *The Beloved Ego* (1921), *Disguises of Love* (1922), *Conditions of Nervous Anxiety* (1923), *The Phenomenon of Fetichism* (1934), *Sadism and Masochism* (1935). *Sadism and Masochism*, from which most of the cases in point are drawn, is a two-volume book of case studies, and was first published in German in 1929.

7 L. Cheronnet, *A Paris vers 1900*, Paris, 1932. Another model for *The English at Home*, under the heading of 'La Rue' appear pictures of a police van and of a street chiropodist. La Belle Otero appears under 'Demi-mondanité'. A Nadar picture, 'Déshabillé galant', has been cut out of Brandt's copy and preserved, as if for framing.

8 *Etes-vous fous?* was published in Paris in 1929, and reprinted subsequently with the original pagination.

9 This phase of work for the Ministry of Information and National Buildings Record is detailed in Dr. Mellor's introduction to *Bill Brandt*, Bath, 1981.

10 Giorgio de Chirico's *Hebdomeros* was originally published in Paris; the English translation referred to here is by Margaret Crosland, London, 1964.

11 The genesis of *Literary Britain* is recounted by Mark Haworth-Booth in an informative afterword to the re-publication by the Victoria and Albert Museum, London, in 1984.

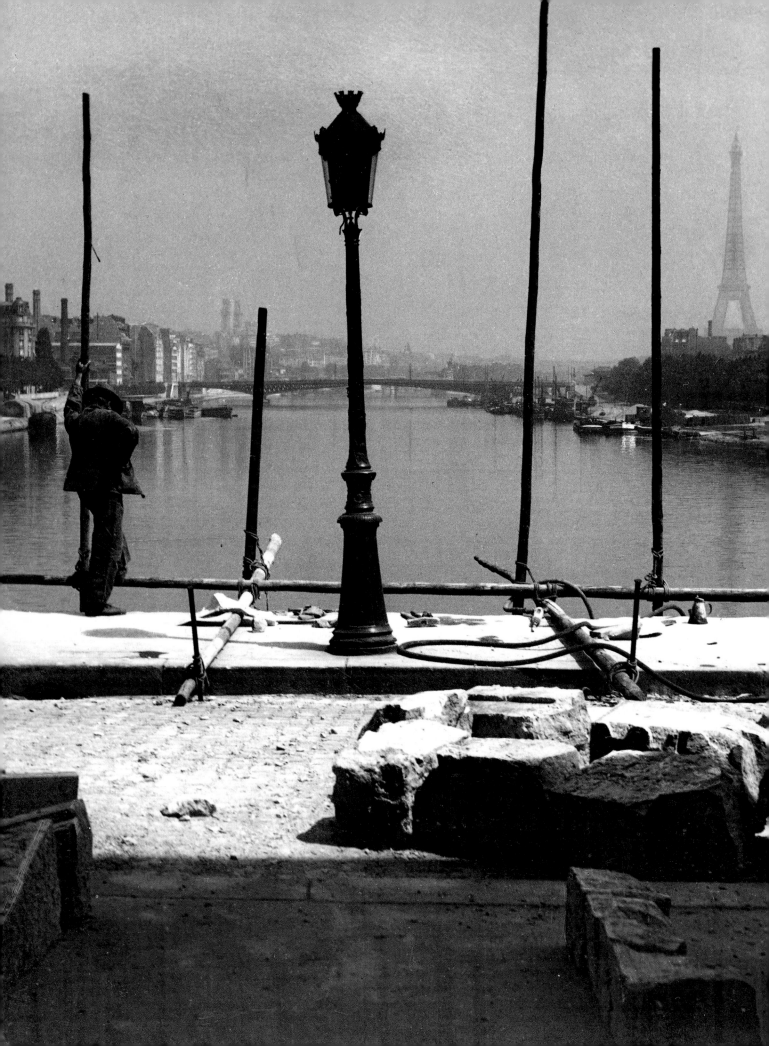

Brandt began as a photographer as he would go on, with such dramatic storybook figures as the night-watchman and Death and the Industrialist, both from Barcelona. His dramatization of his first wife, Eva Rakos, as a street woman in Hamburg was the first of many projects of glamour in relation to danger. Although he had been attached to the Man Ray studio in Paris for three months in 1929 he remained, at heart, an illustrator with a taste for melodrama. Surrealism, then a dominant movement in Paris, alerted him to a charisma in vernacular motifs: statuary, couture dummies, street paraphernalia. The Goyaesque mendicant stands out in the work of these apprentice years, and was first published in the *Photographie* annual of 1933-34. The two standing mannequins found fame in *Minotaure* in 1934, as the occasion for an article by the Surrealist writer René Crevel. Brandt's early pictures came to constitute a reserve to be used as required by *Picture Post* and by *Lilliput* during the 1940s.

Paris, 1931

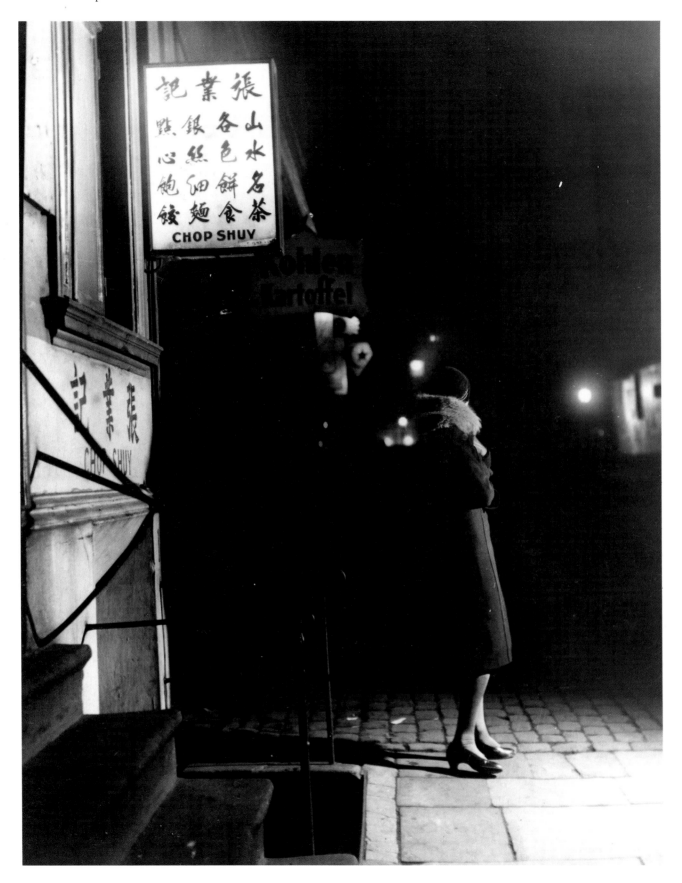

Woman in Hamburg, *c.* 1930

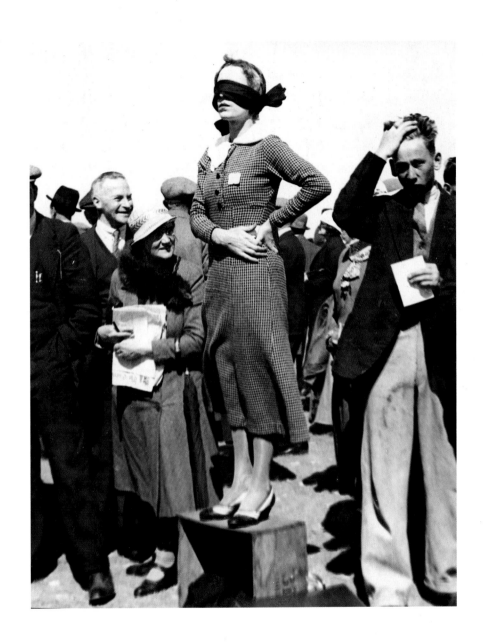

'Voyante' (Derby Day), 1936, *Weekly Illustrated*, 23 May 1936

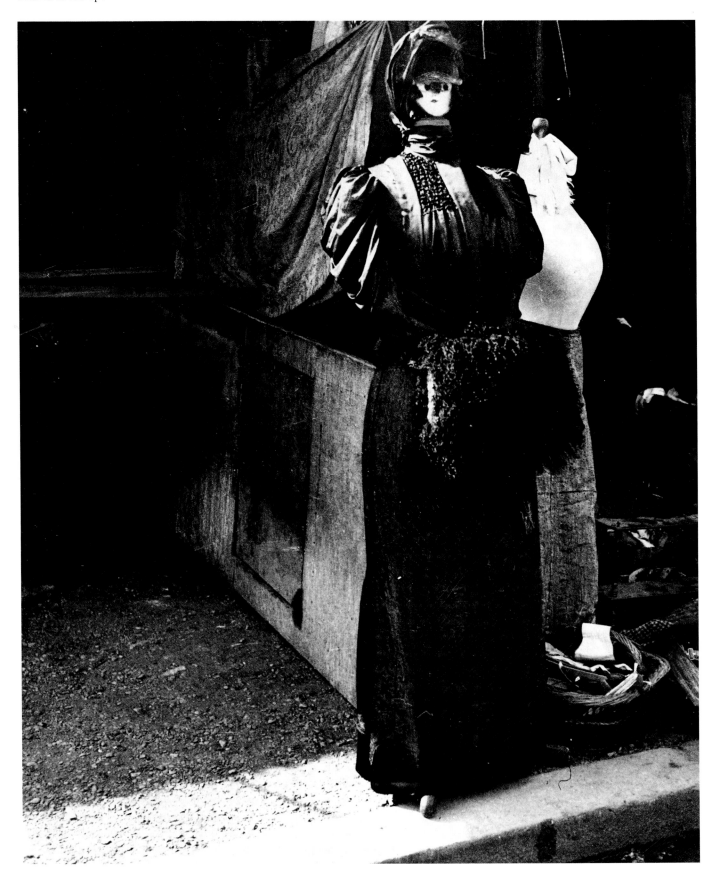

Mannequins, Paris, 1929

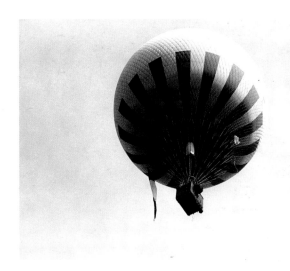

Street photographer's background, *c.* 1930

Balloon, Paris, 1929

Wax museum, *c.* 1930 Night-watchman, Barcelona, 1932

Death and the Industrialist, Barcelona, 1932

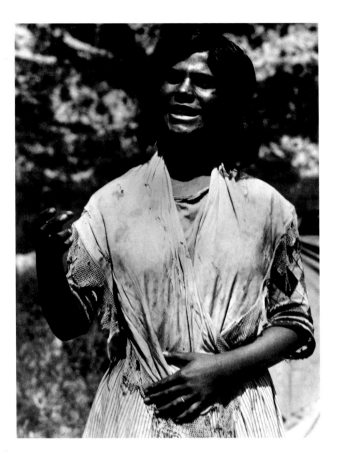

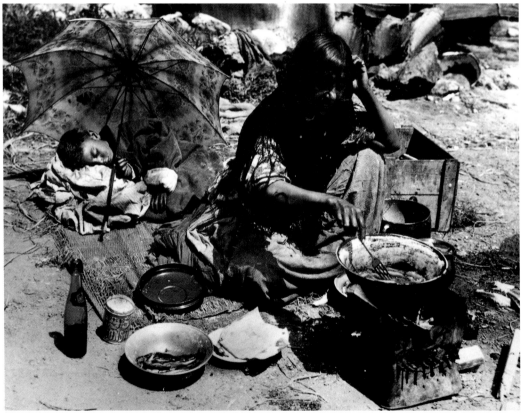

Gipsies, Spain, 1932 Gipsy woman, Spain, 1932

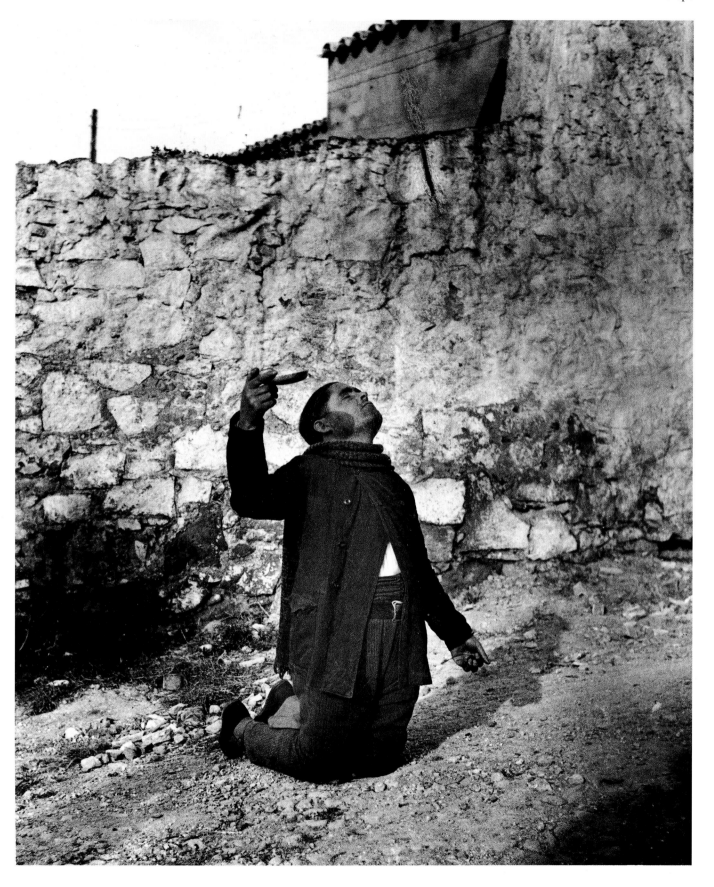

Beggar, Barcelona, April 1932

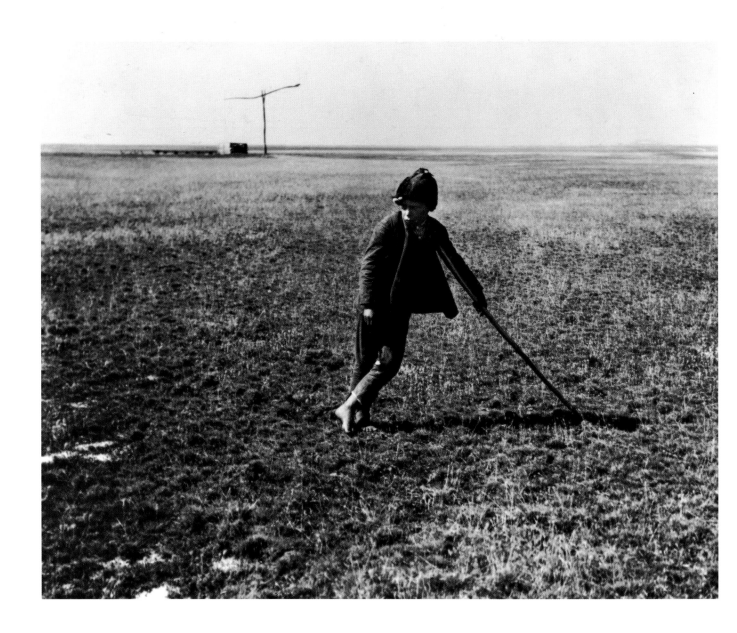

Hortabagy, Hungary, July 1933

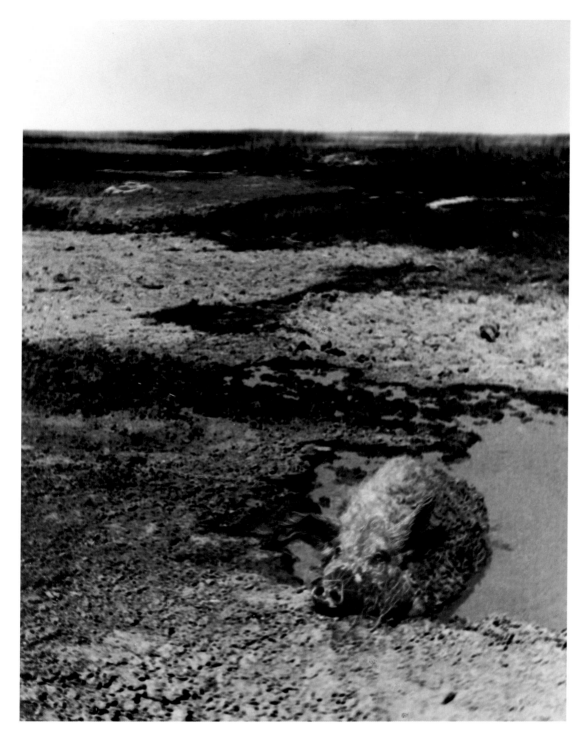

Near Szeged, Hungary, September 1932

The English at Home (1936) and *A Night in London* (1938) were Brandt's principal works of the 1930s. Both books were designed to show the whole social range: toffs to tradesmen and beyond. Both dealt in the experience of the generations, of children in the presence of adults. Montage pairings drew attention to social extremes, to destitution in the presence of plenty, but Brandt seems to have been as entranced by the social range as he was critical of it. In addition, English social life and the experience of the city were shown under a surreal sign of the night wanderer. Throughout this social phase Brandt aimed for completeness: first for a full survey of English social life, and then for a cross-section of the city in a limited period. He continued to think in terms of social and temporal entities in his day-in-the-life presentations for *Picture Post*. Some of the early social pictures were taken for *Weekly Illustrated*, with which he had a little-publicized relationship. Other influences were the illustrations of the Beggarstaff Brothers, *c.*1900, and Brassaï's *Paris de Nuit* of 1933. During the 1940s he continued to report on English social life for *Lilliput*, on the interface between the pub and Bohemia: Soho in April 1942, and Chelsea in August 1944. His devotion to an archaic, pre-war model of Britain is evident in a 'Farewell to London' (*Picture Post*, 9 March 1946), 'The Doomed East End', and finally in 'The Forgotten Gorbals' (*Picture Post*, 31 January 1948).

Brighton belle, *The English at Home*, 1936

Epsom racegoers, *The English at Home*, 1936

Cricket in the park, *The English at Home*, 1936

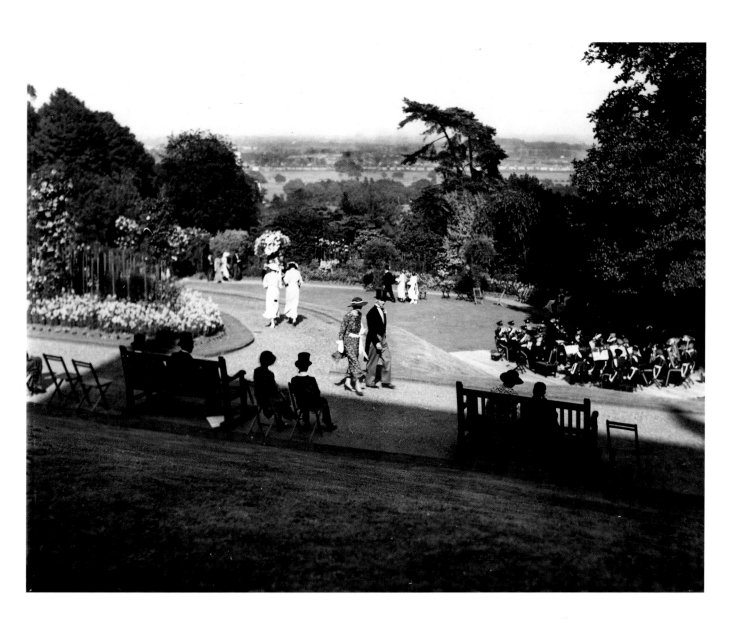

Garden party at Harrow, *The English at Home*, 1936

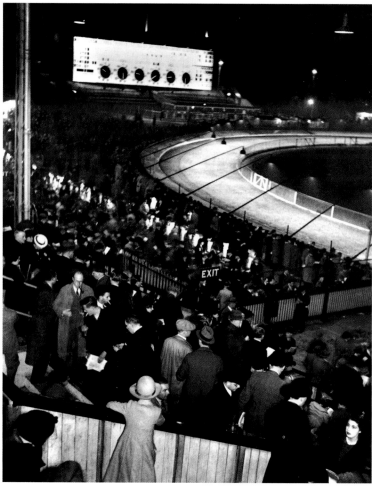

Piccadilly Circus,
variant of an illustration in
A Night in London, 1938

Greyhound race-track, *A Night in London*, 1938

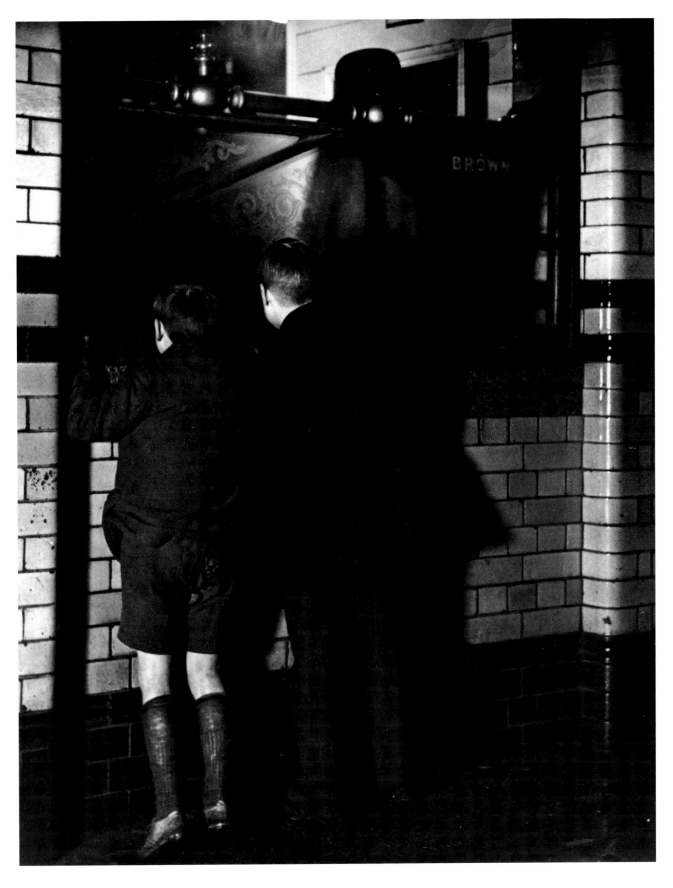

Boys peeping, *A Night in London*, 1938

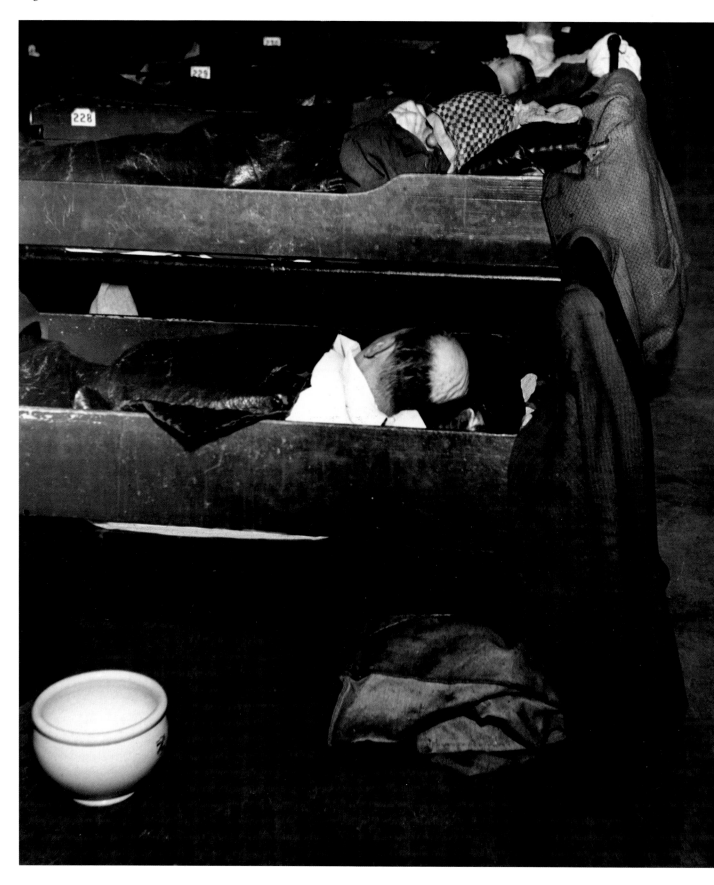

Inside a common lodging house, *A Night in London*, 1938

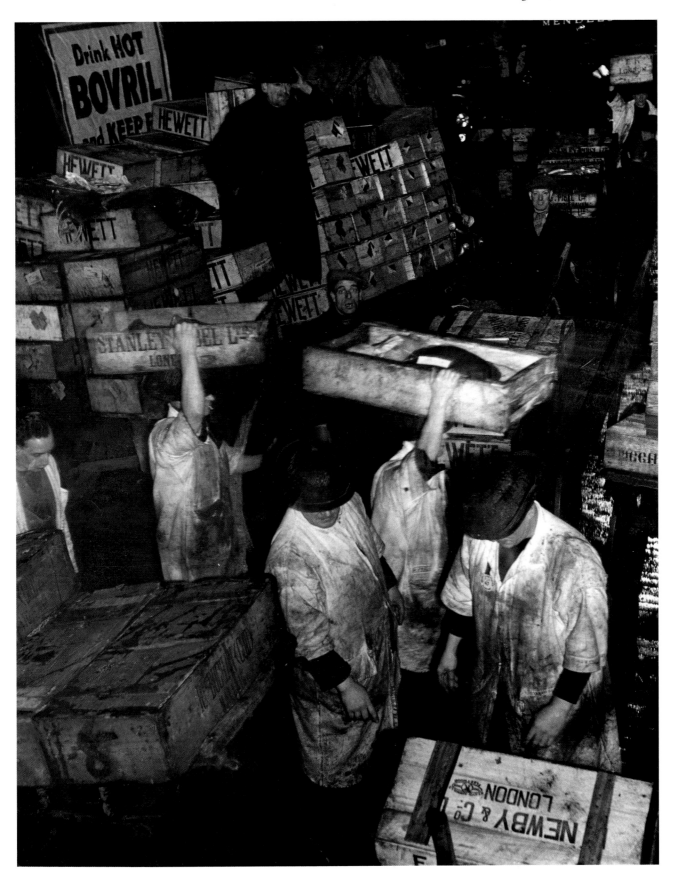

6 a.m. at Billingsgate, variant of a photograph in *A Night in London*, 1938

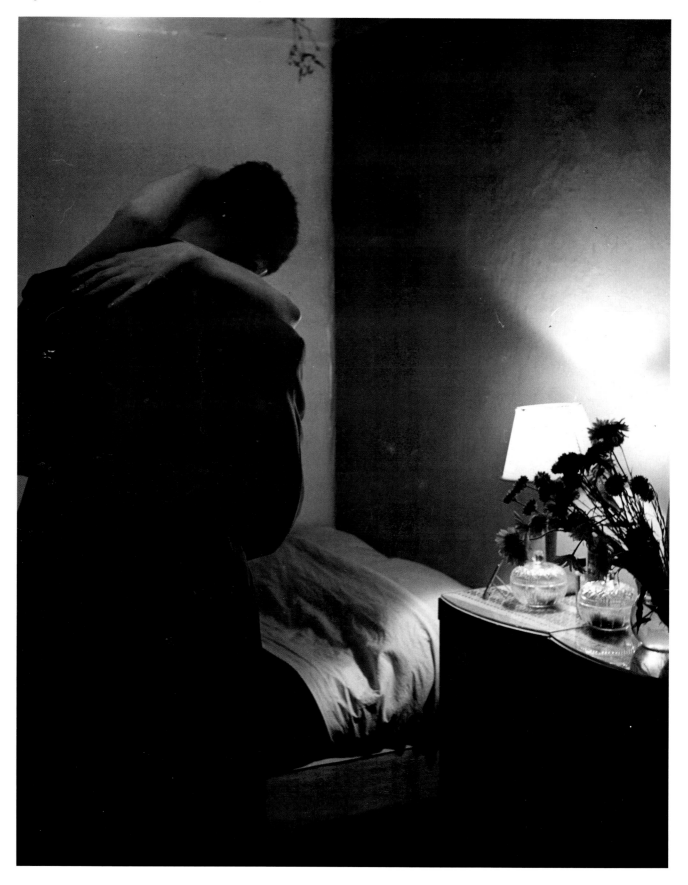

'Top Floor', *A Night in London*, 1938

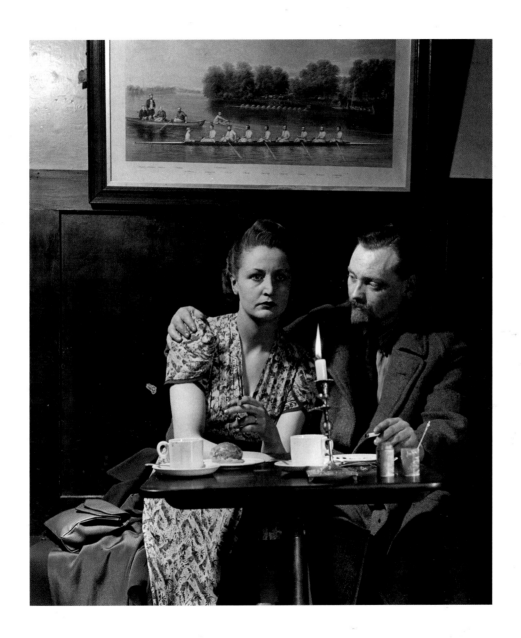

'The Blue Cockatoo', Chelsea, March 1944, *Lilliput*, August 1944

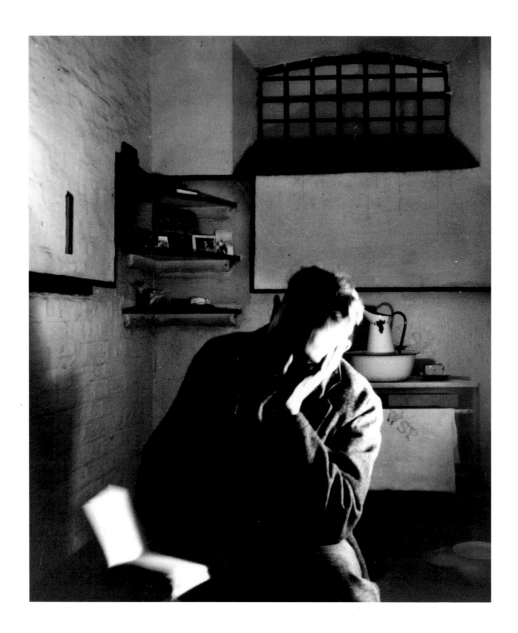

The reader in the cell, Wormwood Scrubs Prison,
Picture Post, 27 December 1947

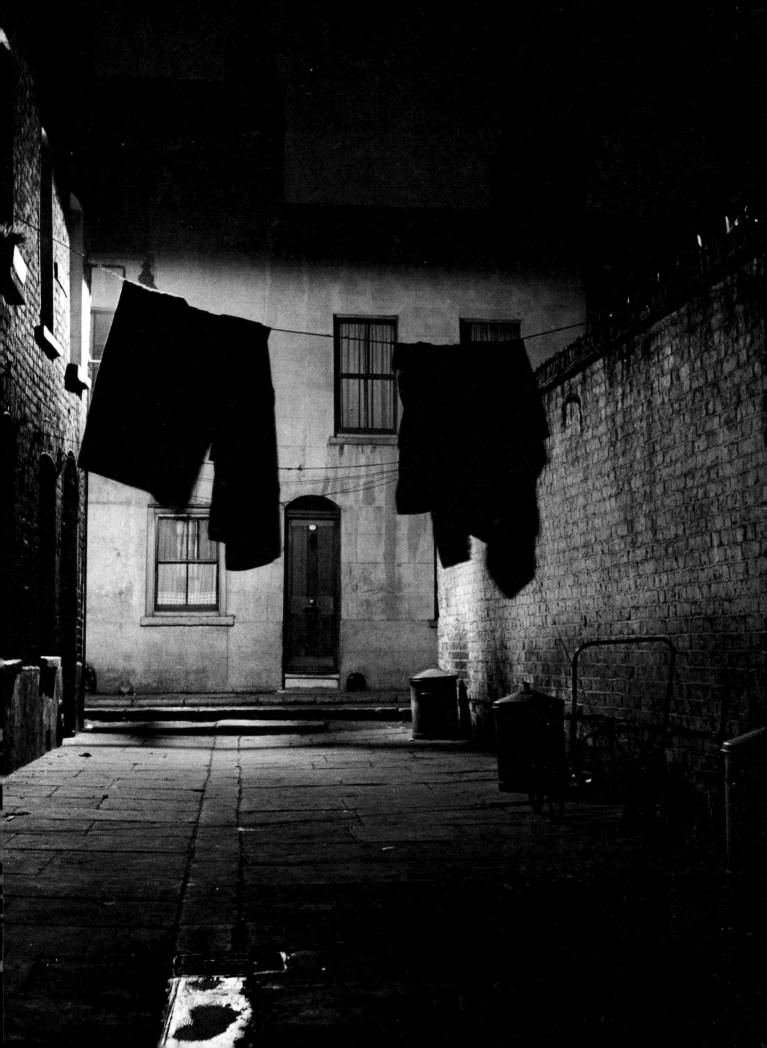

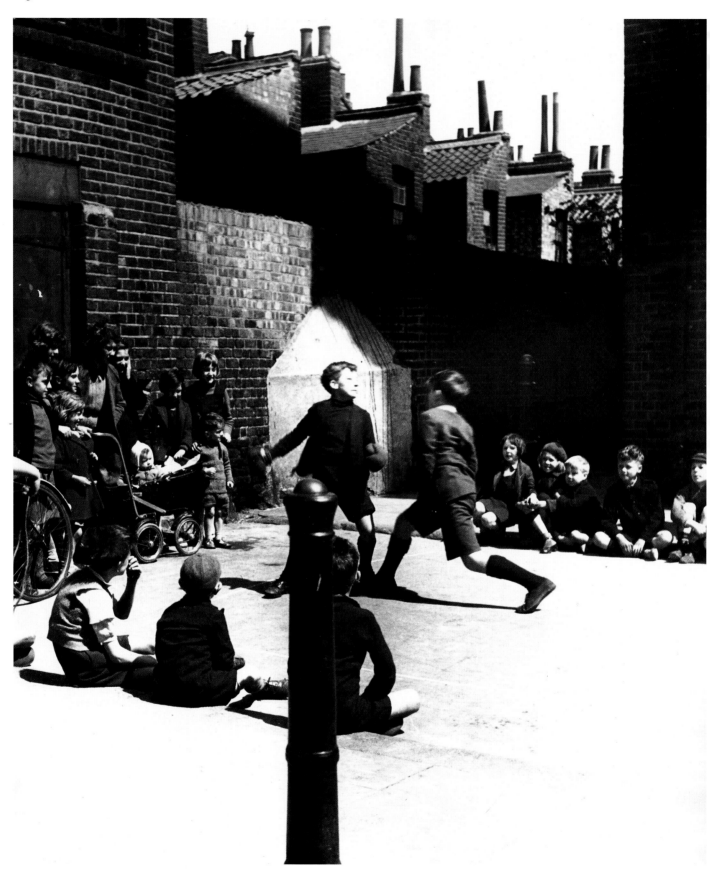

East End fight, 1939, *A Camera in London*, 1948

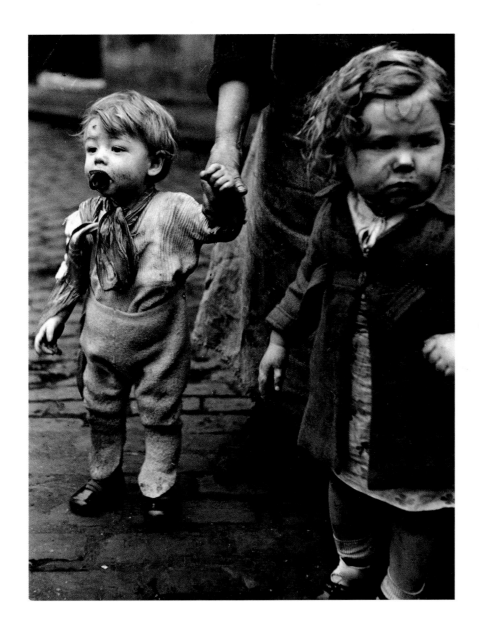

Children in Sheffield, 'Hail, Hell and Halifax', *Lilliput*, February 1948

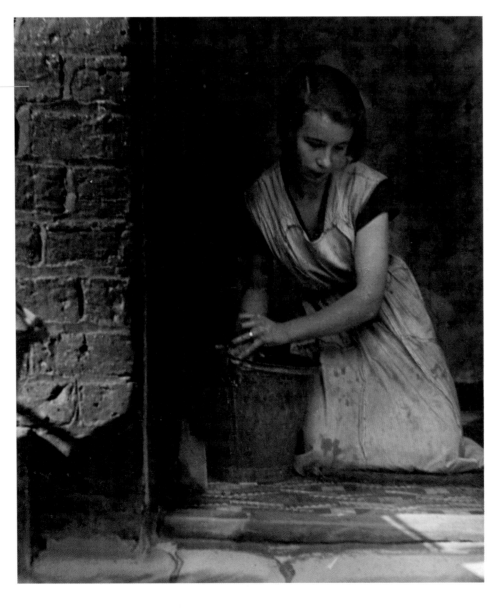

East End morning, September 1937

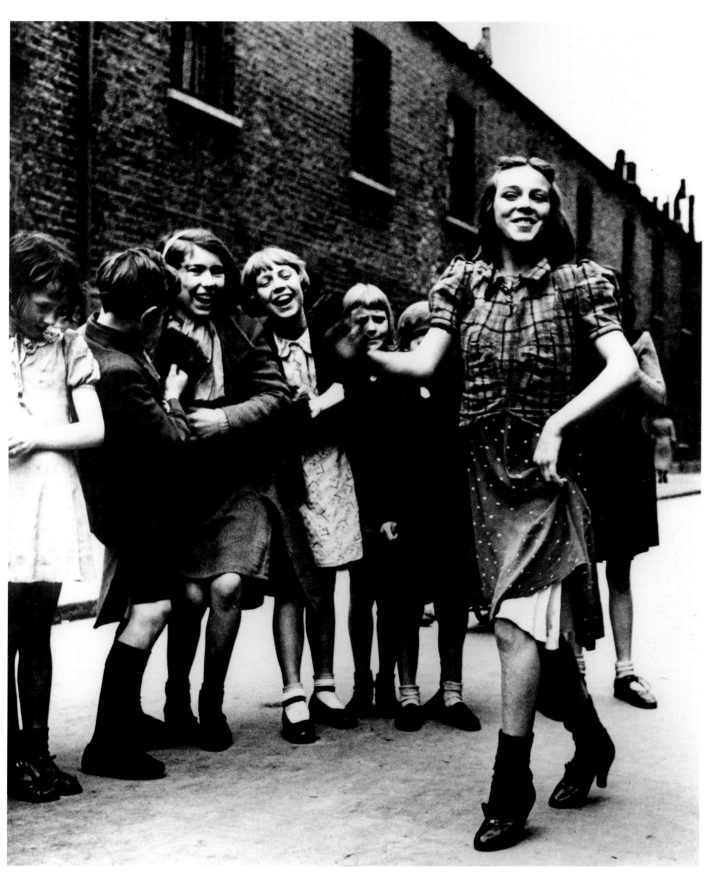

'Are we planning a new deal for youth?', *Picture Post*, 2 January 1943

Bedroom, *Picture Post*, 6 March 1943

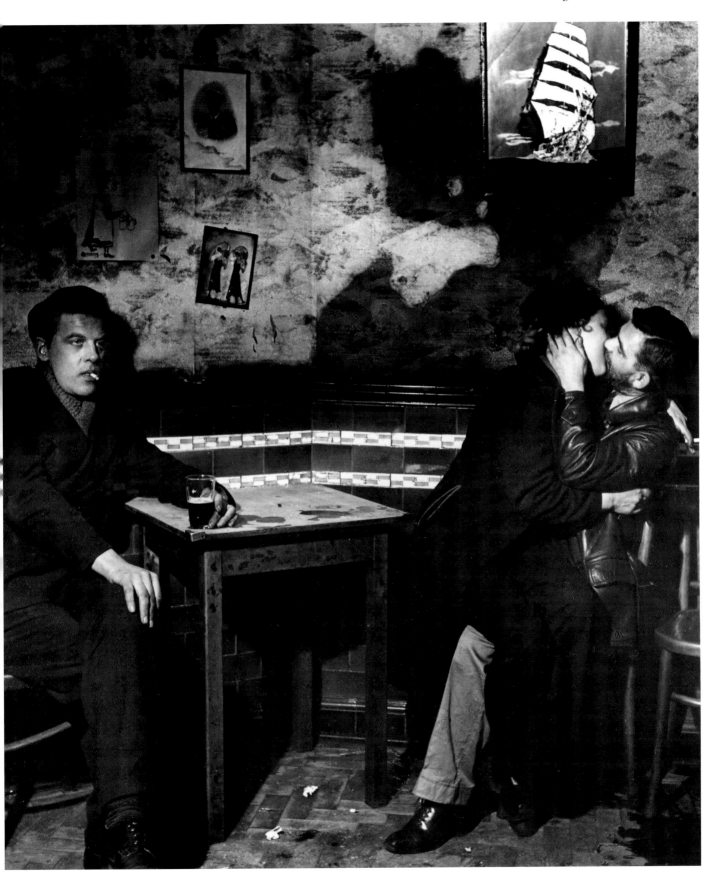

Corner table at 'Charlie Brown's', 1945

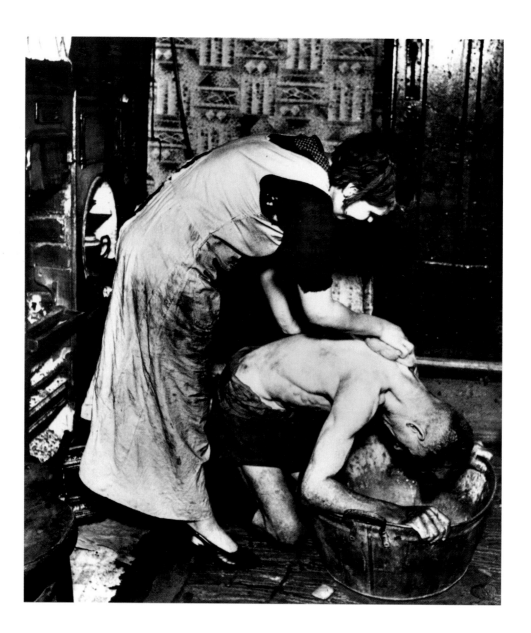

Coal-miner's bath, Chester le Street, 1937

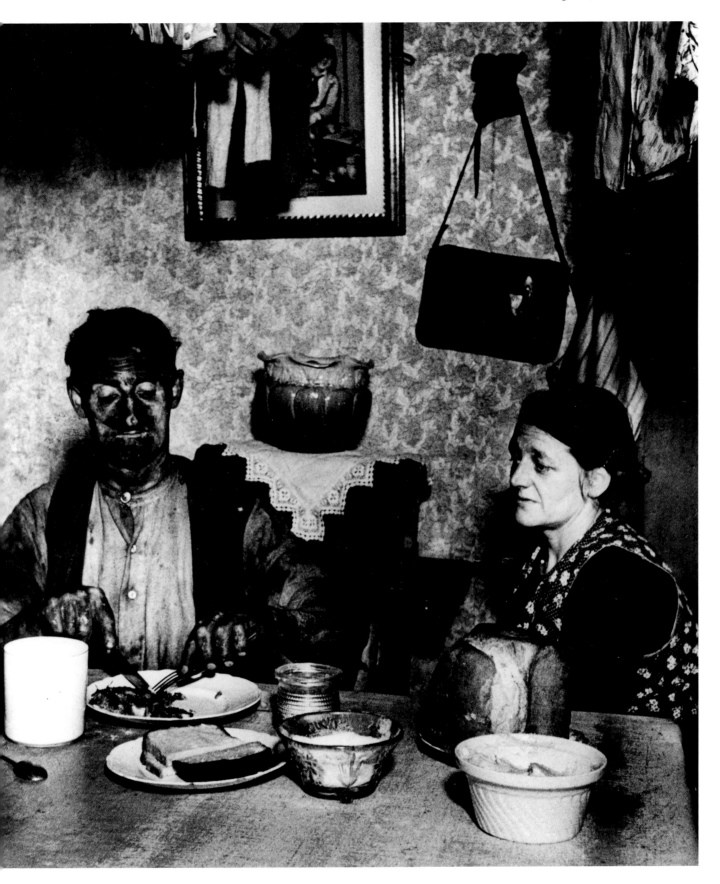

Northumbrian miner at his evening meal, 1937

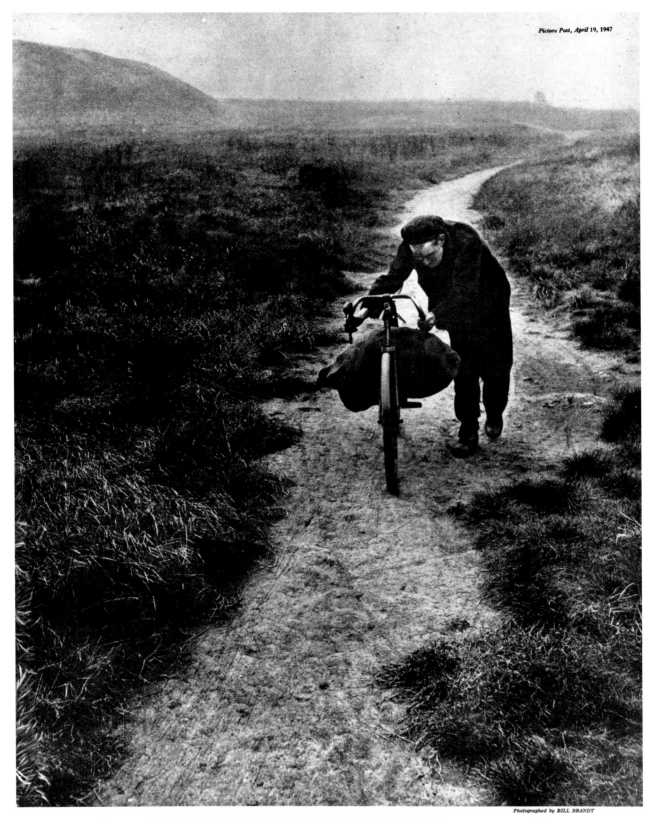

Picture Post, April 19, 1947

Photographed by BILL BRANDT

THE WASTED YEARS: THE MAN WHO MIGHT HAVE BEEN HEWING COAL IN TONS, SCRATCHES FOR OUNCES ON THE SLAG HEAPS
An unemployed Durham miner on his way home in 1936 after a day's search for coal to heat his home. He was one of an army of 1,880,000 unemployed. One miner in five was out of work. They were part of the price we paid for failing to modernise our industries and falling back on restriction, wage-cutting, price-fixing. We are paying another part of the price today in empty grates and half-time factories.

15

Coal searcher returning home, Jarrow, 1936

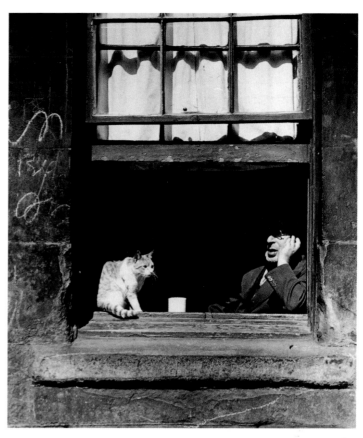

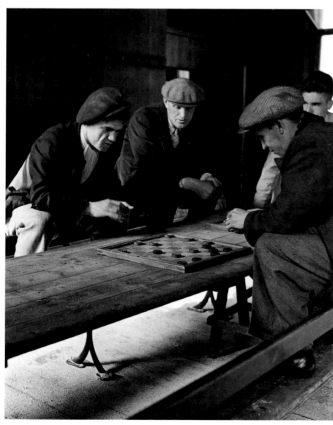

Unemployed men in a working class club in Jarrow, 1937

'The Forgotten Gorbals',
Picture Post, 31 January 1948

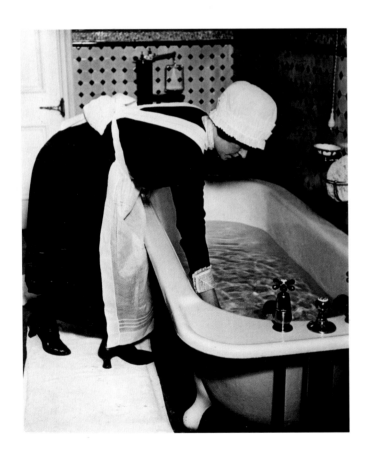 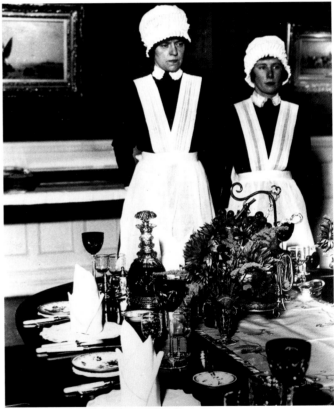

'The Perfect Parlourmaid', *Picture Post*, 29 July 1939

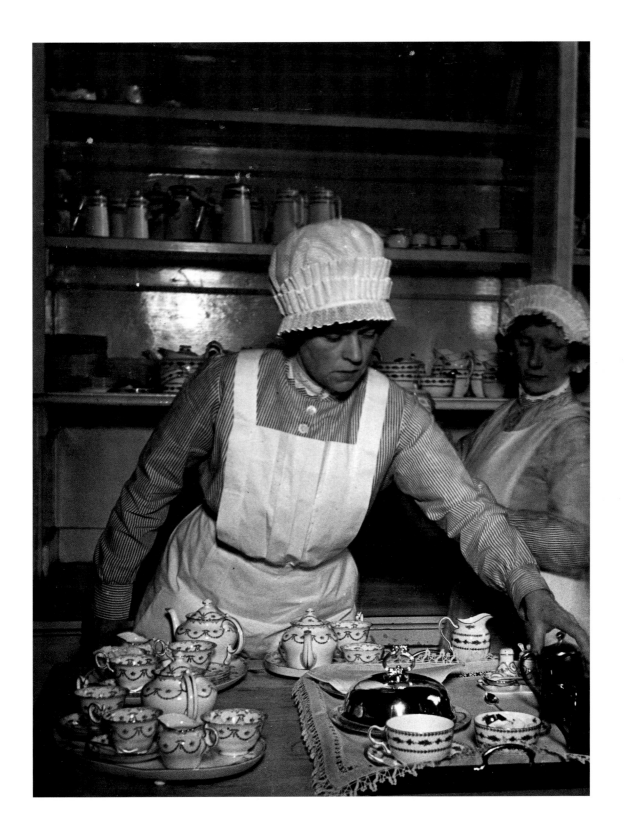

'The Perfect Parlourmaid'

'Nippy. The story of her day ...', *Picture Post*, 4 March 1939

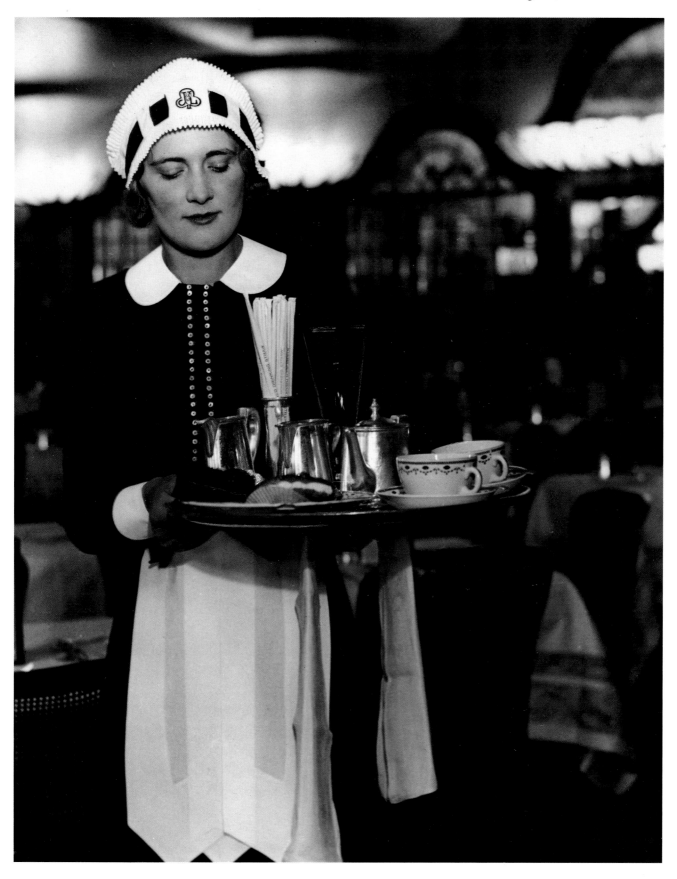

A Lyons Nippy (Miss Hibbott), 1939

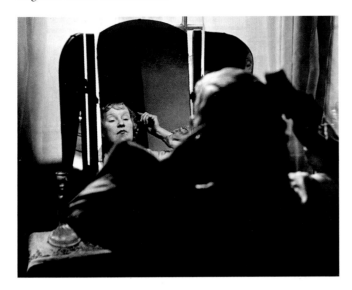

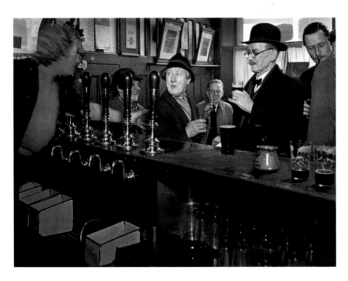

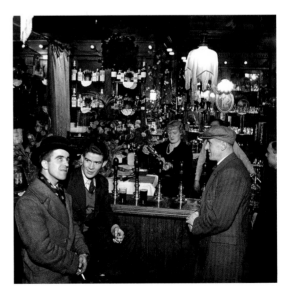

'A Barmaid's Day', *Picture Post*, 8 April 1939

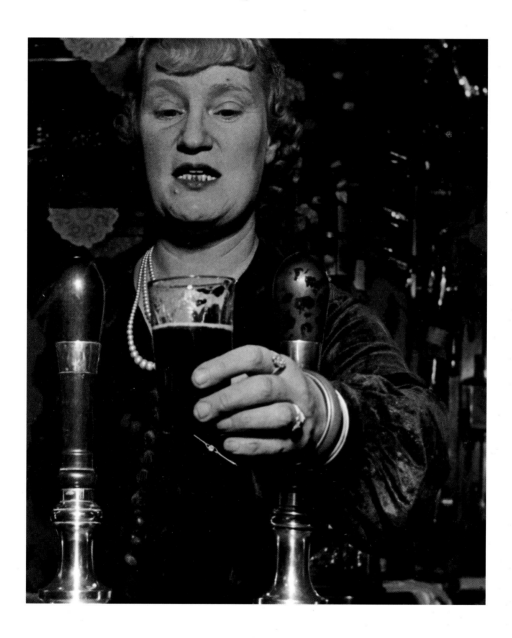

Alice, barmaid at 'The Crooked Billet', March 1939, *Lilliput*, March 1943

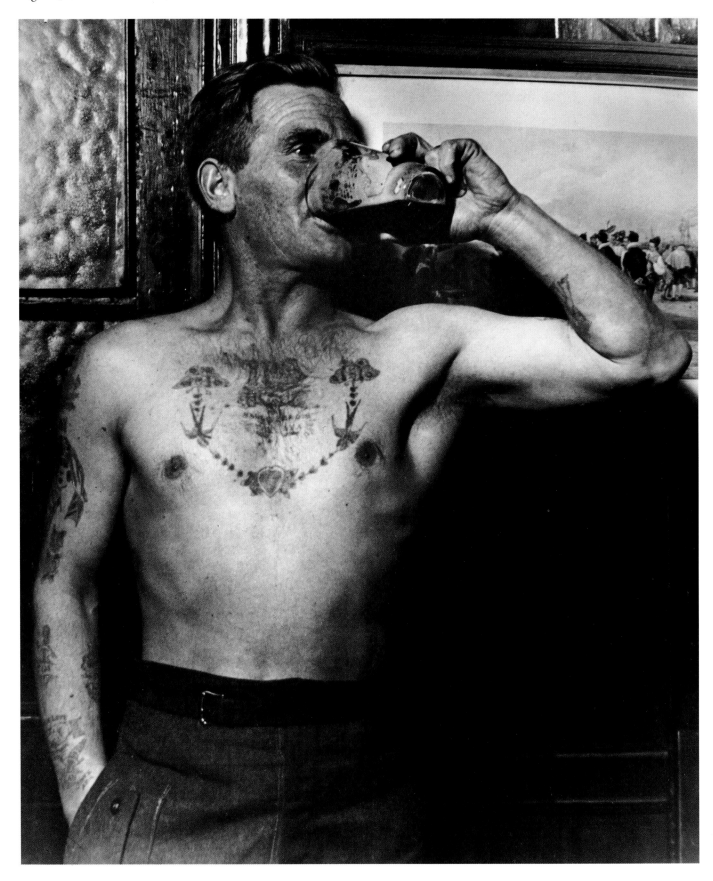

Jack, 'The Doomed East End', *Picture Post*, 9 March 1946

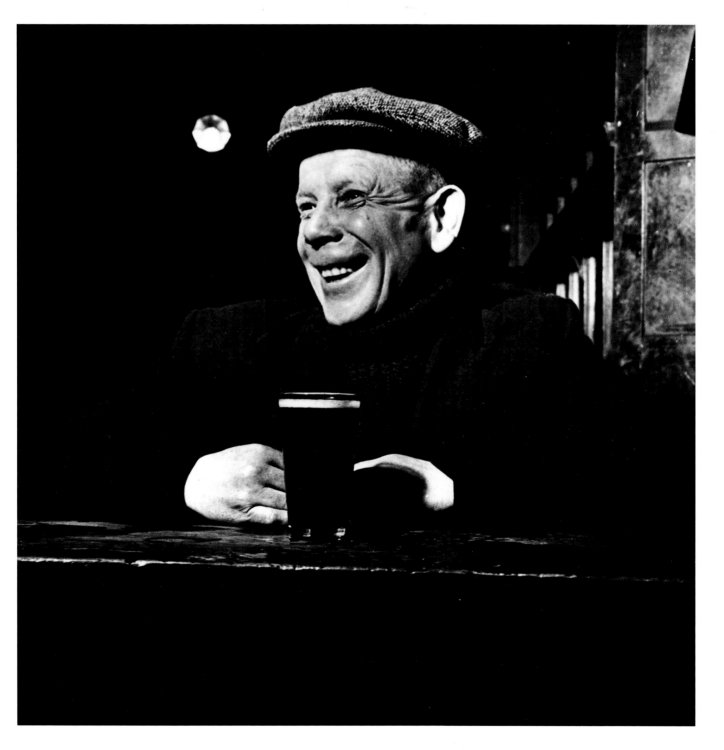

'The Doomed East End'

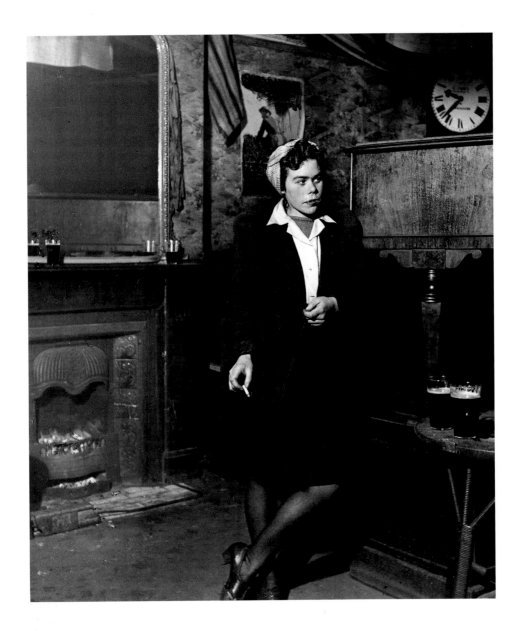

'Charlie Brown's', 'The Doomed East End'

'The not-so-lonely girl', 'The Doomed East End'

Girls looking out of a window,
Stepney, February 1939

'Just a line to let ...', reversed in *Lilliput*, December 1946

Greek boarding-house keeper, 'Soho in wartime
Eight bits of a quarter', *Lilliput*, April 1942

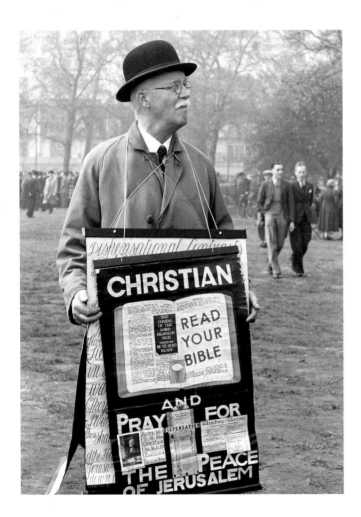

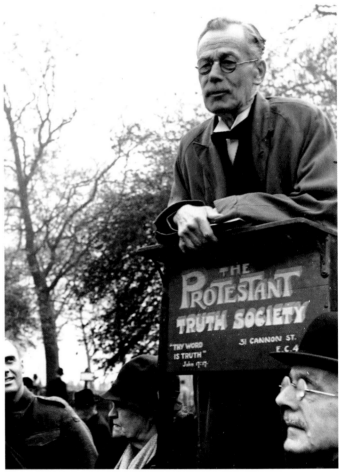

'Be sure to go to church on Sunday', Hyde Park,
Lilliput, September 1941

Hyde Park, 1930s

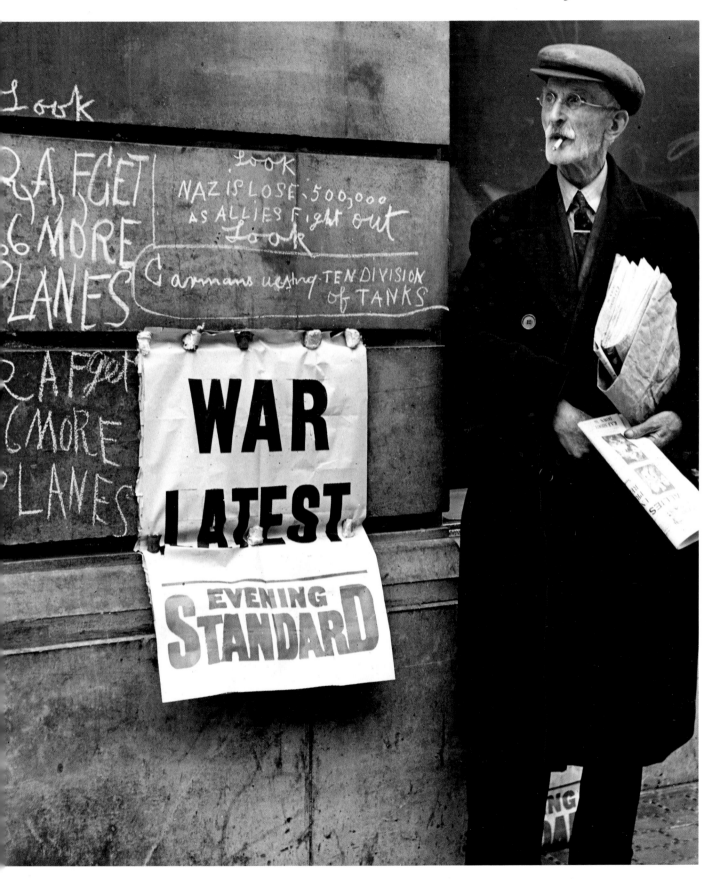

News-vendor in Regent Street, London, 1 June 1940 (third day of Dunkirk)

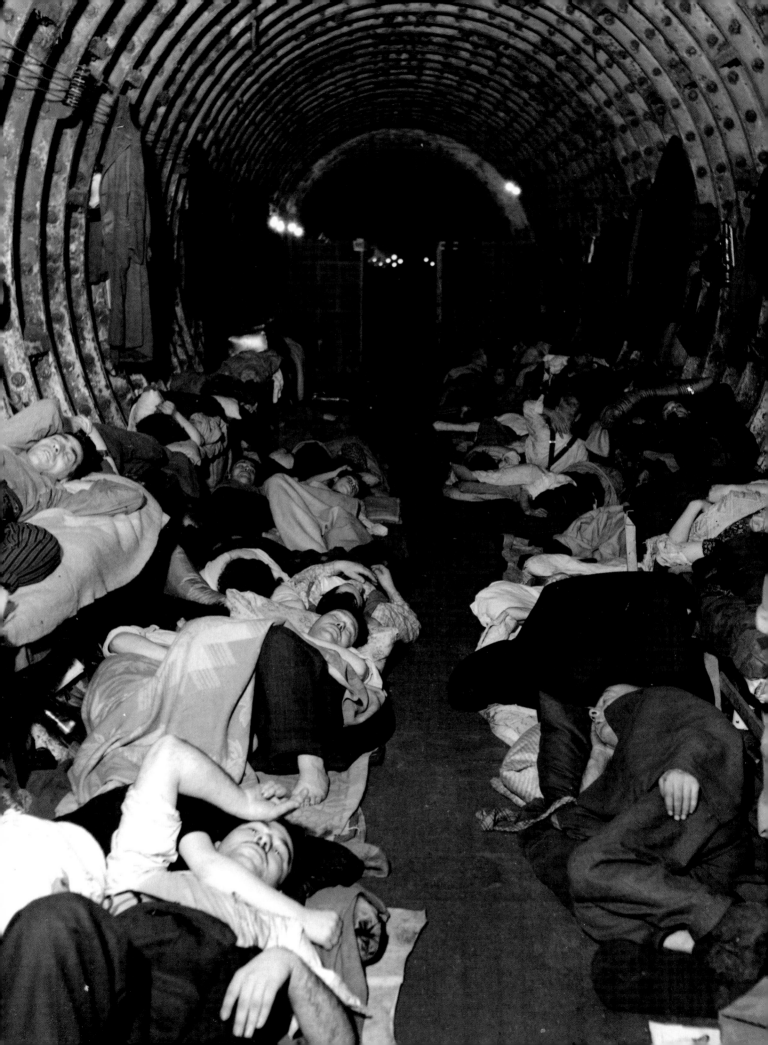

In November 1940 Brandt was commissioned by the Ministry of Information to record life in London's air-raid shelters in the Underground, in basements and underneath railway arches. The Shelter pictures constitute something like a vision of Christmas in Hell, with family and nativity scenes. Darkness and eccentric spaces gave him the chance to experiment with compositional arrangements which recall Tintoretto. Then, during the autumn of 1941, he worked for the National Buildings Record, photographing endangered monuments, most successfully in Canterbury Cathedral, where he was fascinated by Renaissance and Baroque monuments, with their theatrical grandees and forbearing spouses. War metaphors he found in the bleak landscape of the Roman Wall, taken in the autumn of 1943, and as a spectral entertainment revealed by the headlamps of a car, in the spring of 1945. Otherwise his war was Arcadian, in the plum orchards of Kent and in the parks of London and sometimes grotesque: in respect of Tom Haffenden's puppet show, for example, and a series of Waughian Army 'Suitability Tests' taken in the early part of 1942.

Underground air-raid shelter, November 1940

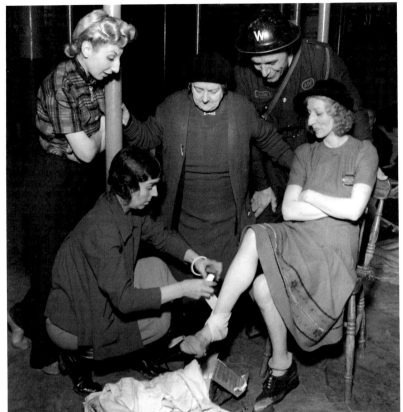

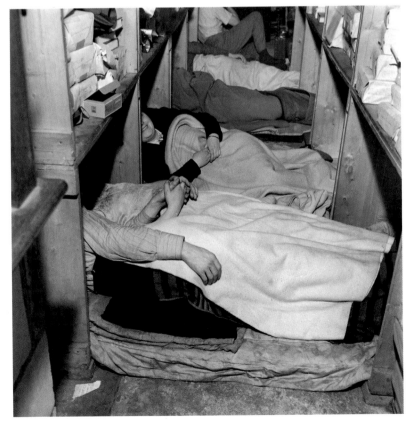

London air-raid shelters,
November 1940

West End book business basement shelter, November 1940

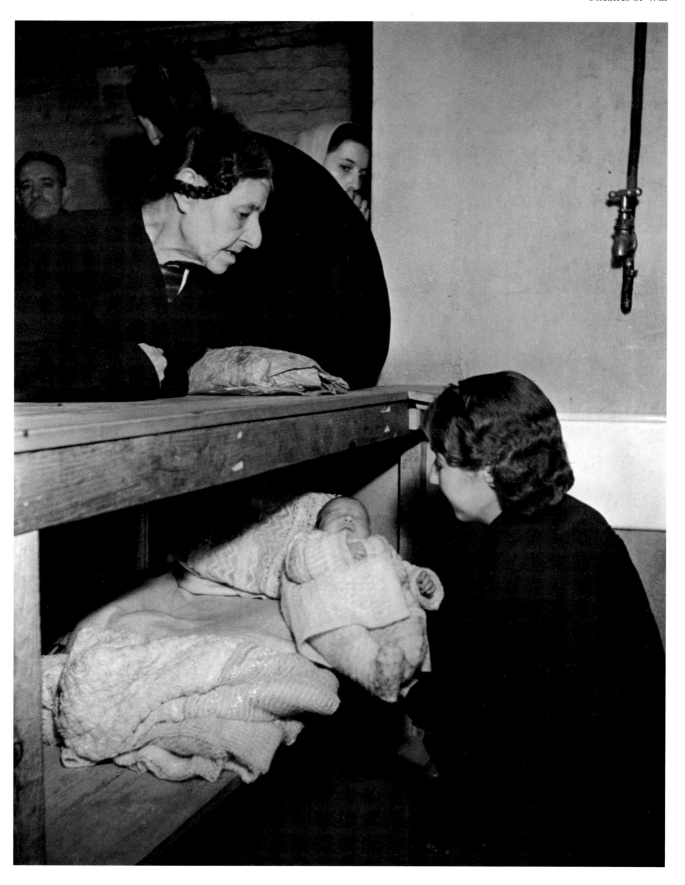

A family group in a north London basement shelter, November 1940

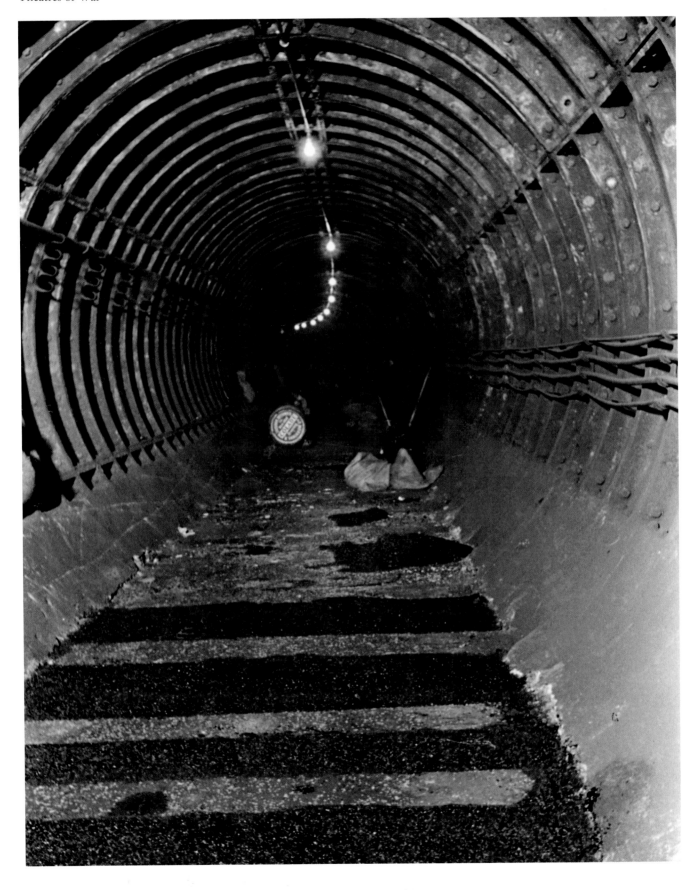

London West End shelter, November 1940

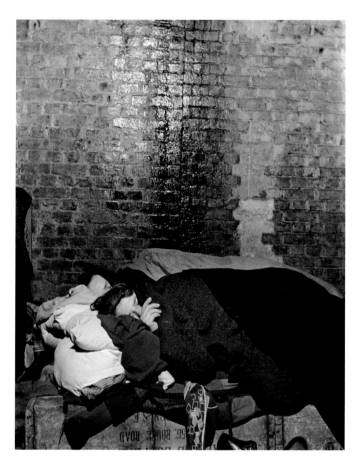

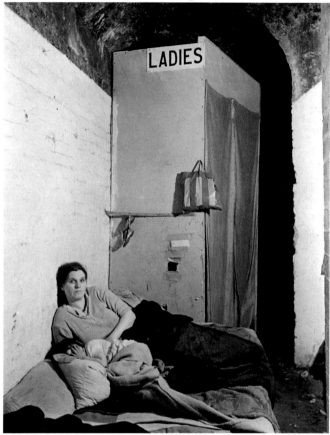

Shelterers in south-east London, November 1940

In a south-east London air-raid shelter
underneath railway arches, November 1940

'Holiday Camp for War Workers', *Picture Post*, 26 September 1942

'A Day on the River', *Picture Post*, 12 July 1941 (unpublished photograph)

'A Day on the River' (unpublished photograph)

'Spring in the Park', *Picture Post*, 10 May 1941

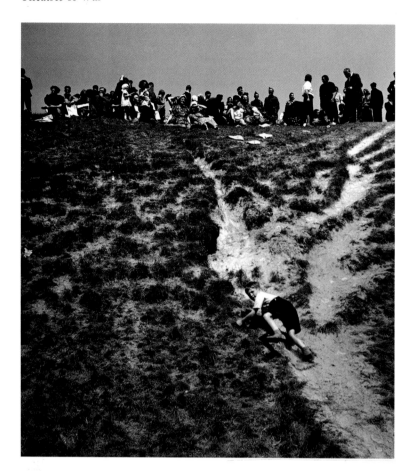

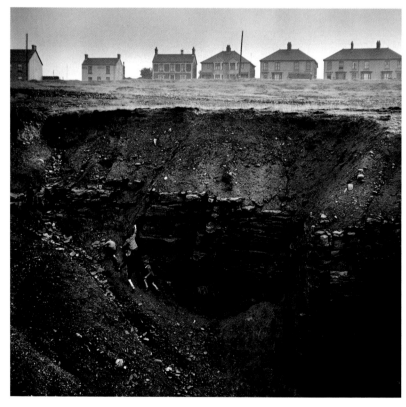

'This was the war-time Derby!',
Picture Post, 5 July 1941

'We plan a valley in South Wales', *Picture Post*, 1 January 1944

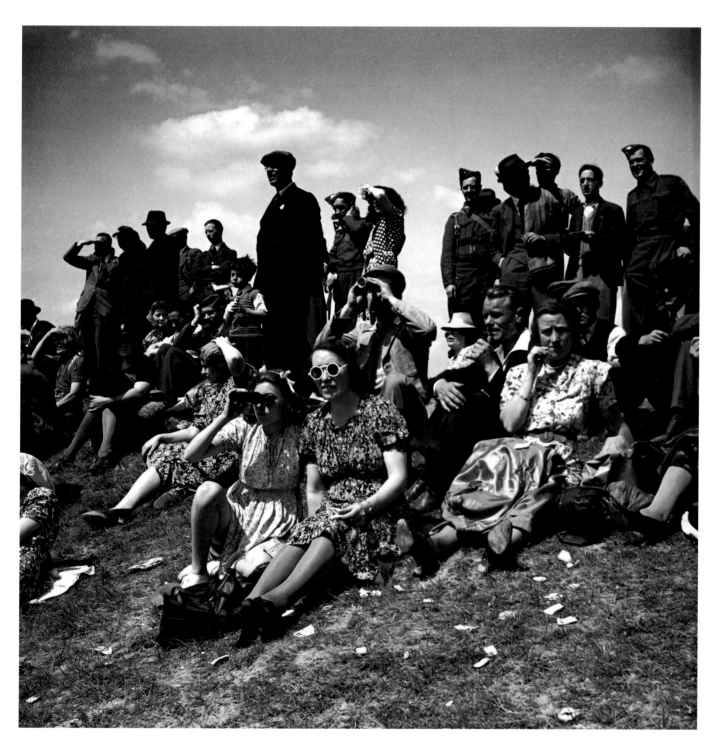

'This was the war-time Derby!', *Picture Post*, 5 July 1941

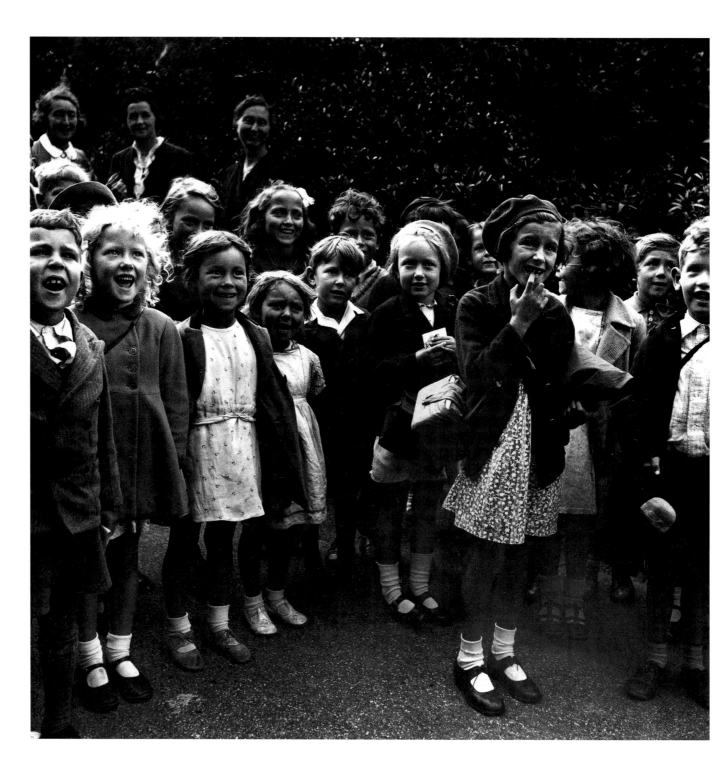

'What are all these children laughing at?', *Picture Post*, 23 August 1941

'What are all these children laughing at?'

'Saving Britain's Plum Crop', *Picture Post*, 12 September 1942

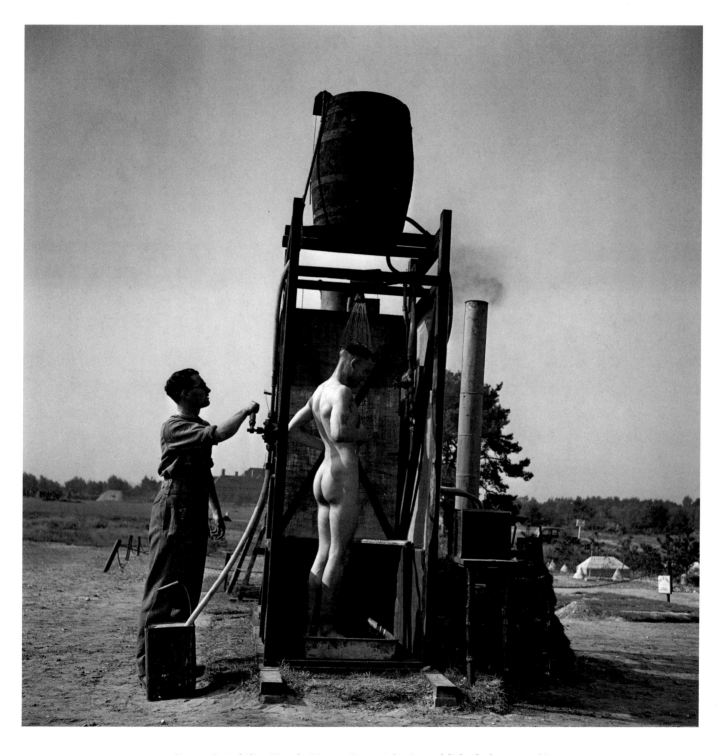

'Army Suitability Tests', *Picture Post*, 1942 (unpublished photograph)

'Transport: Key to Our War Effort', *Picture Post*, 26 September 1942

'Fire guard on the House of Commons', *Picture Post*, 14 November 1942

'Religion goes on the air',
Picture Post, 17 February 1945

'A town that takes care of its troops' (St. Andrews),
Picture Post, 3 October 1942

'The Archbishop studies the housing problem ...', 'Should the church keep out?',
Picture Post, 24 April 1943

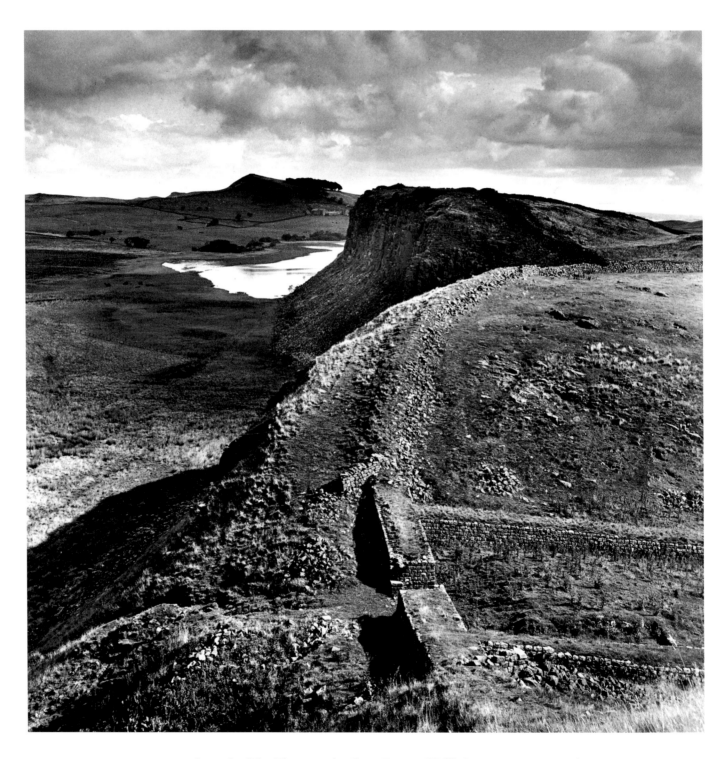

The Roman mile-castle, 'The Threat to the Great Roman Wall', *Picture Post*, 23 October 1943

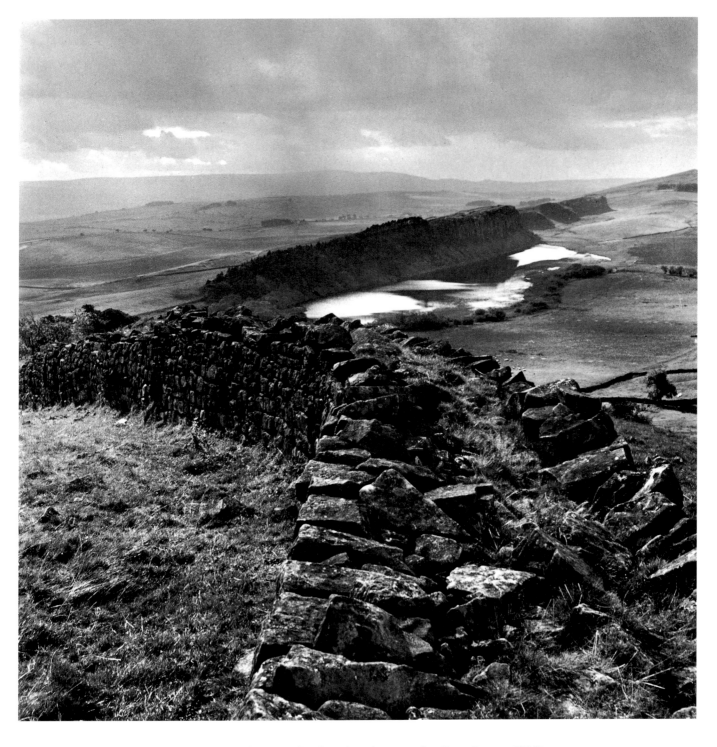

Crag Lough from Hotbank, 'The Threat to the Great Roman Wall'

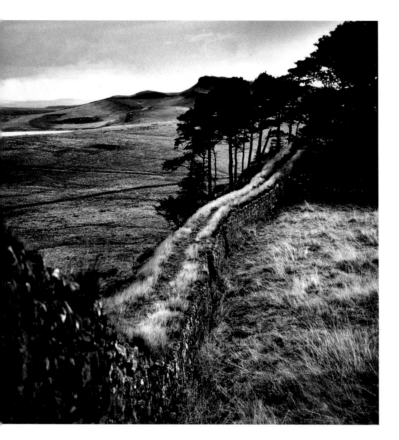

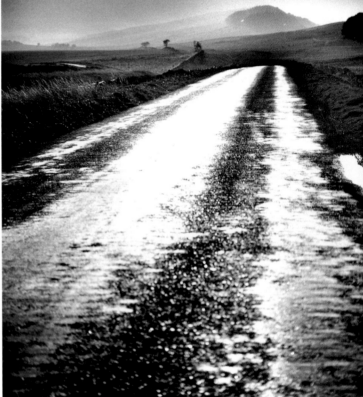

The wall through the wood,
'The Threat to the Great Roman Wall'

The Roman road,
'The Threat to the Great Roman Wall'

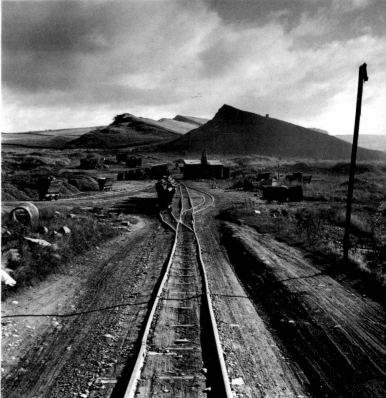

Quarrying,
'The Threat to the Great Roman Wall'

Cawfield,
'The Threat to the Great Roman Wall'

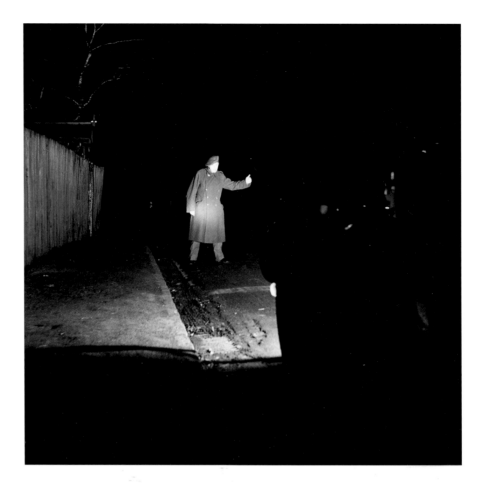

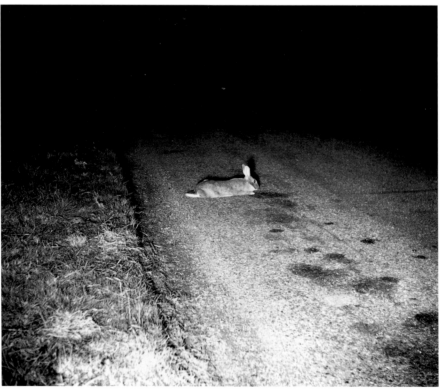

'The Magic Lantern of a Car's Headlights', *Picture Post*, 31 March 1945

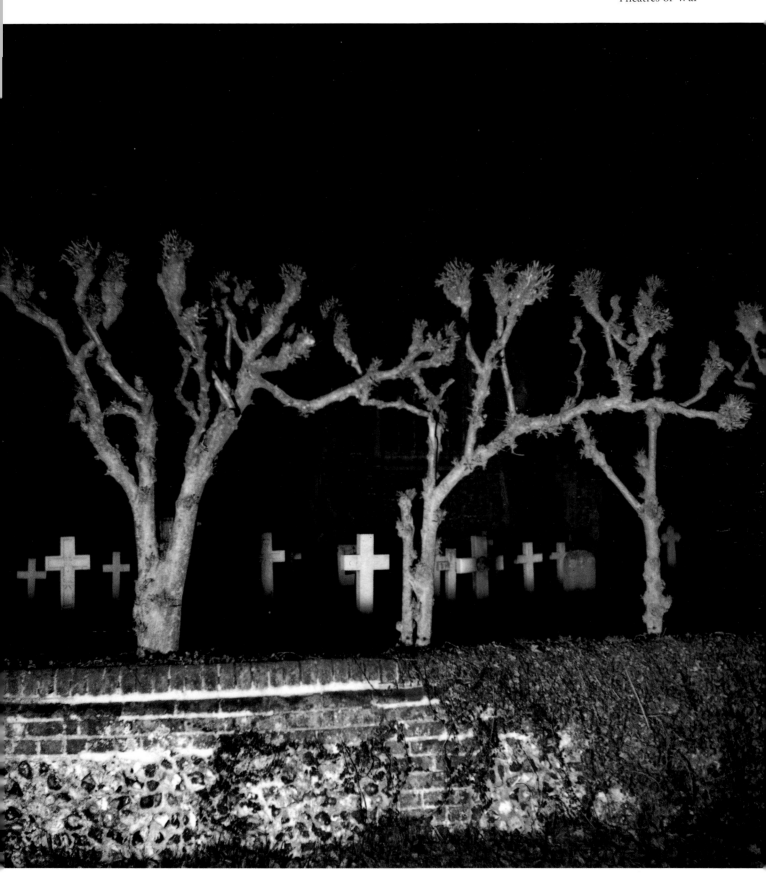

'The Magic Lantern of a Car's Headlights'

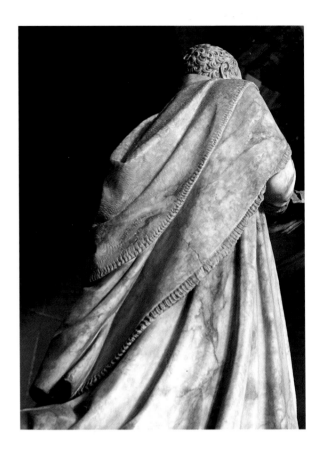

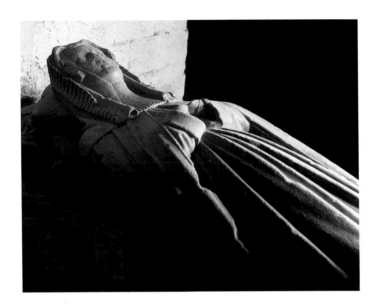

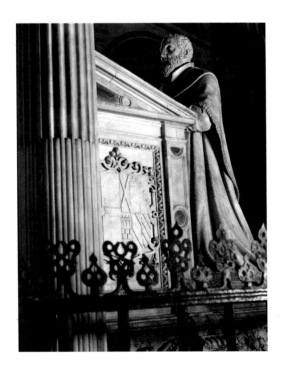

Canterbury Cathedral, monuments, December 1941

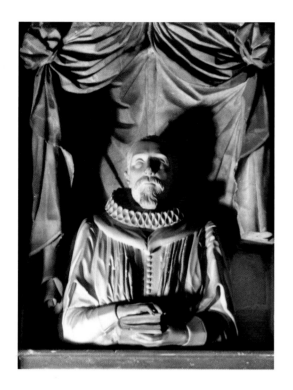

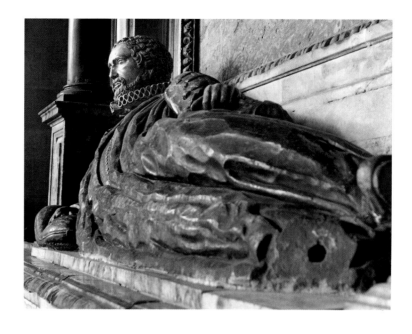

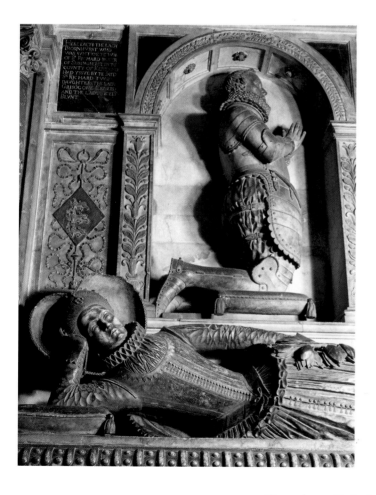

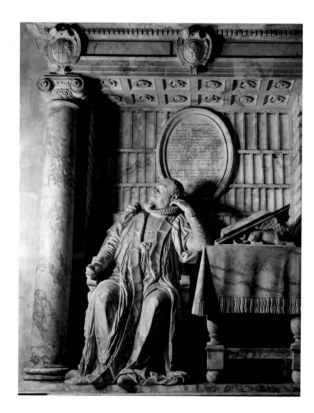

Canterbury Cathedral, monuments

The Science Museum, London,
'Odd corners of museums', *Lilliput*, February 1944

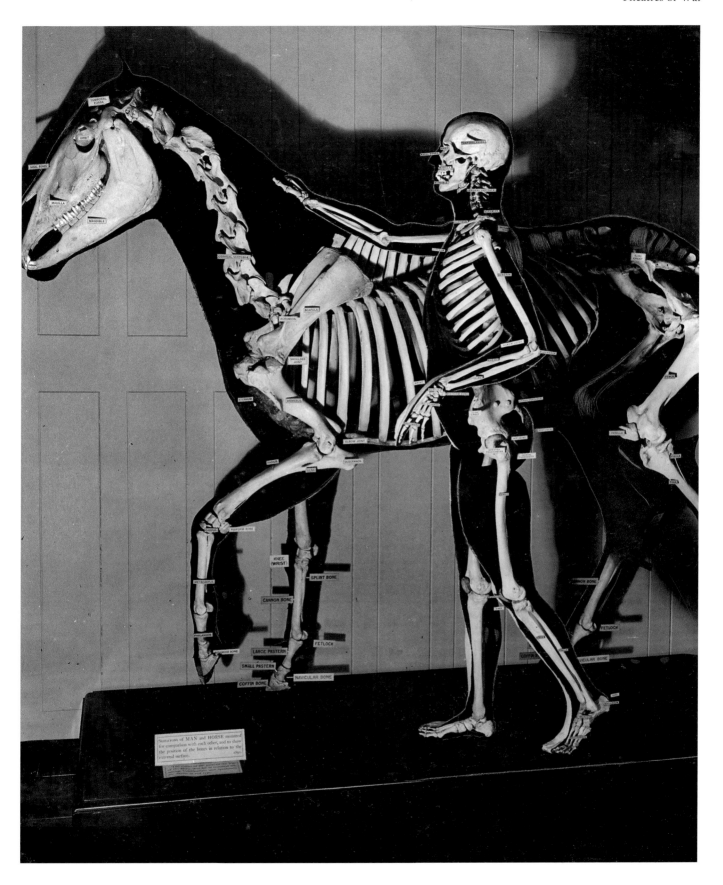

The Natural History Museum, London, 'Odd corners of museums'

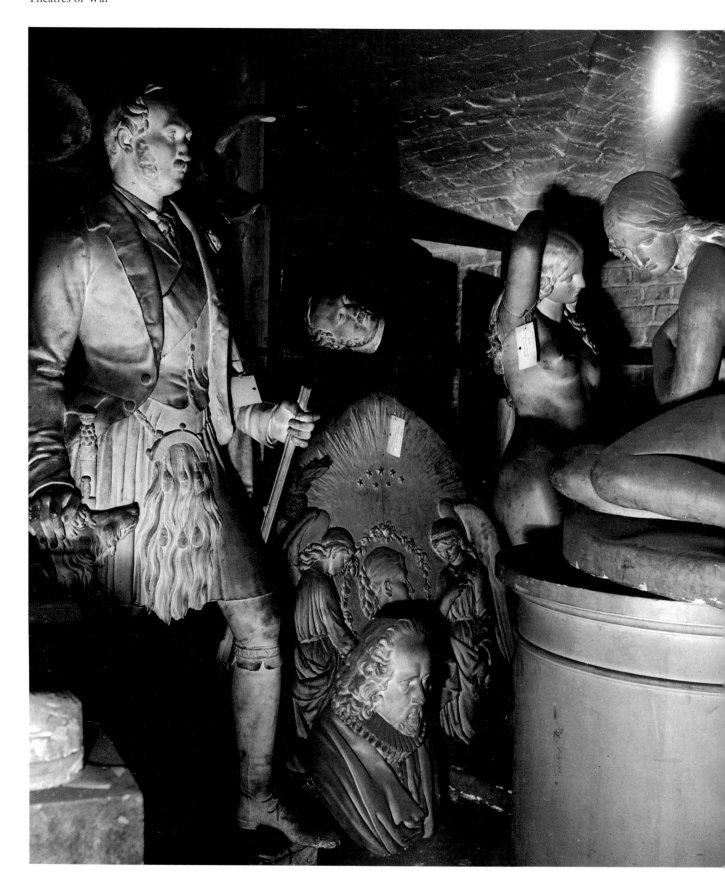

'Cold storage', *Lilliput*, August 1949

The Maritime Museum, Greenwich,
'Odd corners of museums'

Figureheads, Scilly Isles,
Minotaure, winter 1935 121

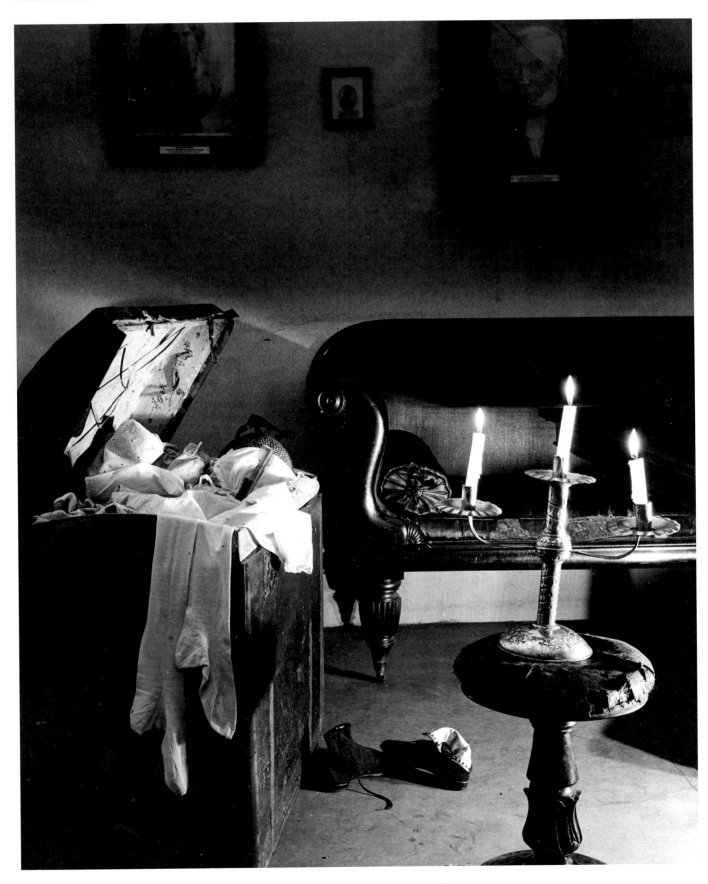

A room in Haworth Parsonage, 'Bill Brandt visits the Brontë country', *Lilliput*, May 1945

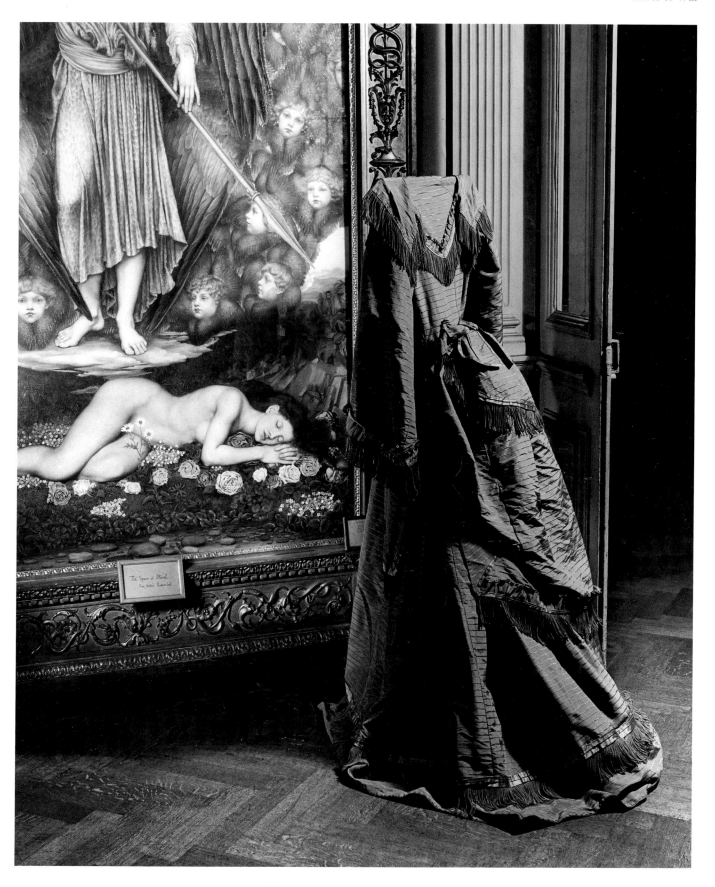

The De Morgan Collection, Old Battersea House, 'Odd corners of museums'

Landscape is one of Brandt's more impure categories, for it is most often landscape with building. There is little landscape in the 1930s, if any, and he was a portraitist before he entered on landscape proper. His first landscape was, in fact, a kind of town- and sky-scape developed with reference·to Edinburgh, 'The Northern Capital in Winter', *Lilliput*, February 1942. After that there was a long gap to 'The Garden of England', *Lilliput*, October 1943. Almost from the beginning he composed in terms of paired images, which means that single pictures can look eccentric in isolation. Pairing was especially suited to publication in *Lilliput* where images were printed to the edge of the page and into the gutter; thus forming a unit in any case. In *Picture Post*, on the other hand, the page size was larger and better suited to symmetrical and evenly banded landscapes. Many of the *Lilliput* pieces are of townscapes with rapidly dipping or ascending alleys, corridors and coulisses: 'Hampstead under snow', *Lilliput*, February 1946. His most remote and minimal landscapes were of Stonehenge, used in a special crisis issue of *Picture Post*, 19 April 1947, and of Wiltshire apropos of the centenary of the birth of the writer Richard Jefferies, *Picture Post*, 6 November 1948. The landscape phase ended with one of photography's most magnificent projects, 'The Vanished Ports of England', *Picture Post*, 24 September 1949, in which basic spaces are divided and calibrated by cyclopean ruins. While the human figure allowed Brandt to reflect melodramatically on the heroic, the grotesque and the ludicrous, landscape allowed him to imagine the first day and the last.

Sheffield, 1937

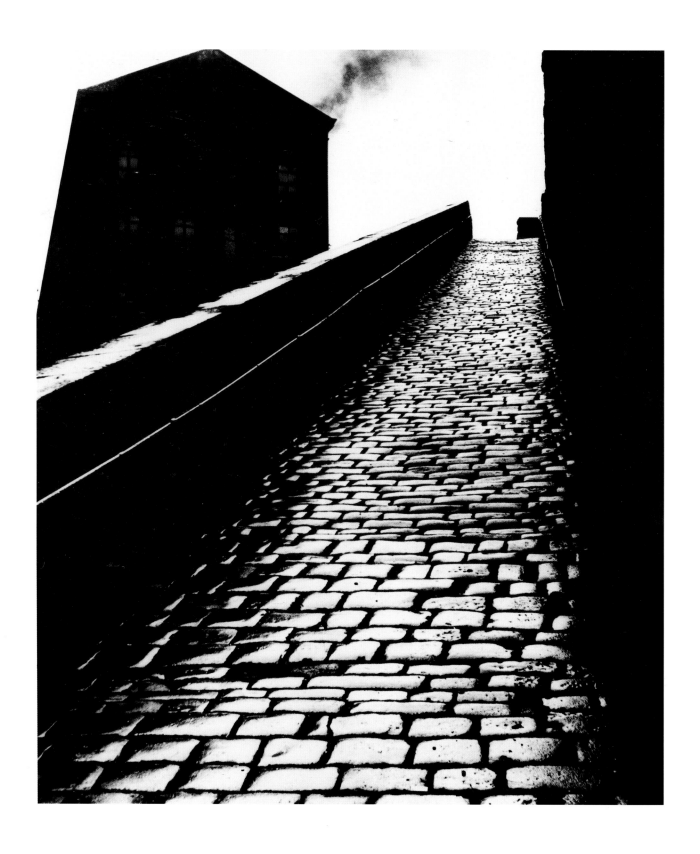

A snicket, 'Hail, Hell and Halifax', *Lilliput*, February 1948

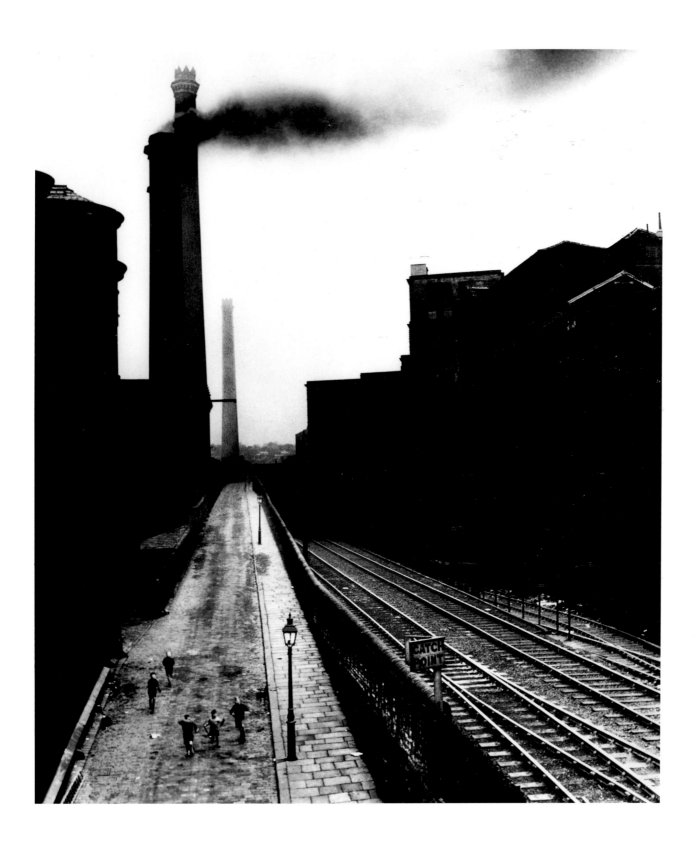

Catch point, 'Hail, Hell and Halifax'

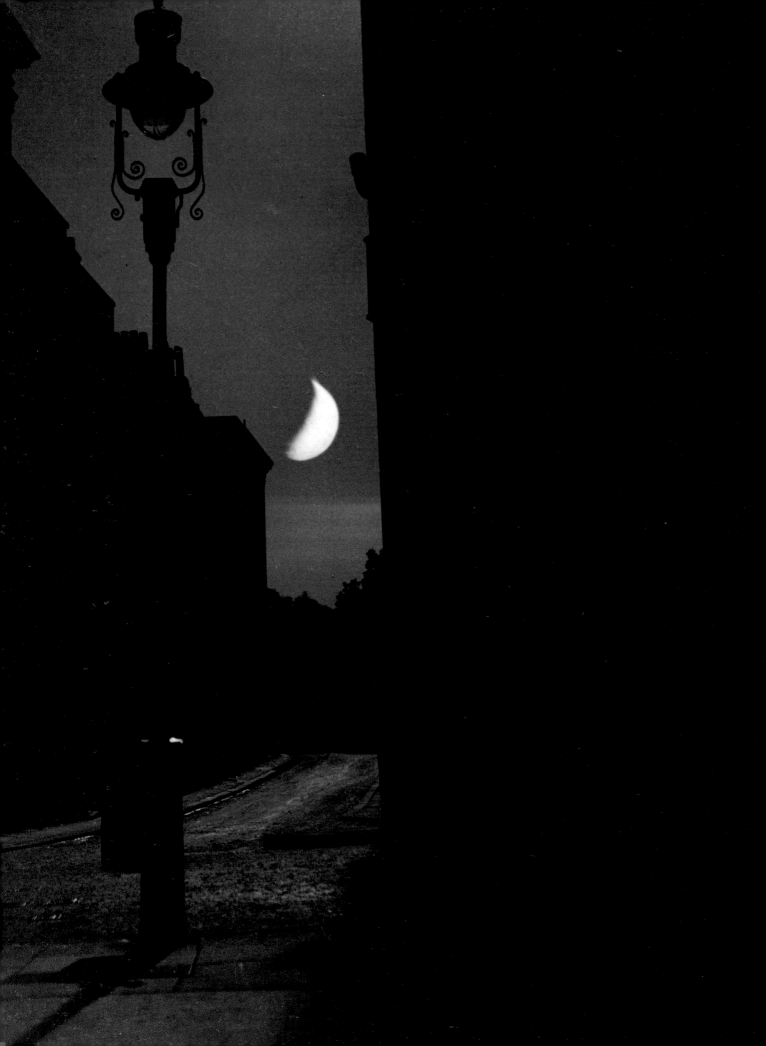

Adelphi, September 1939,
'Blackout in London',
Lilliput, December 1939

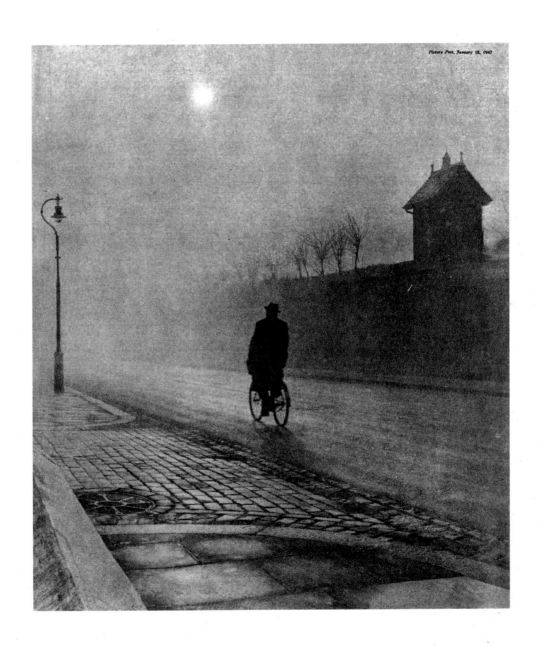

Picture Post, January 18, 1947

'The Man Who Found Himself Alone in London',
Picture Post, 18 January 1947

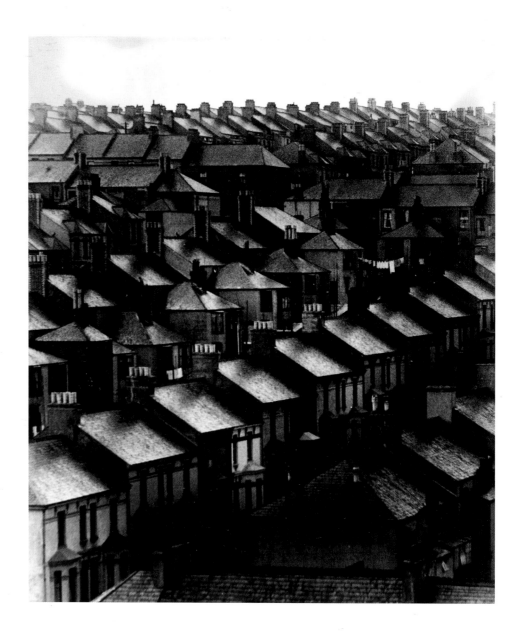

Rainswept roofs, 1933

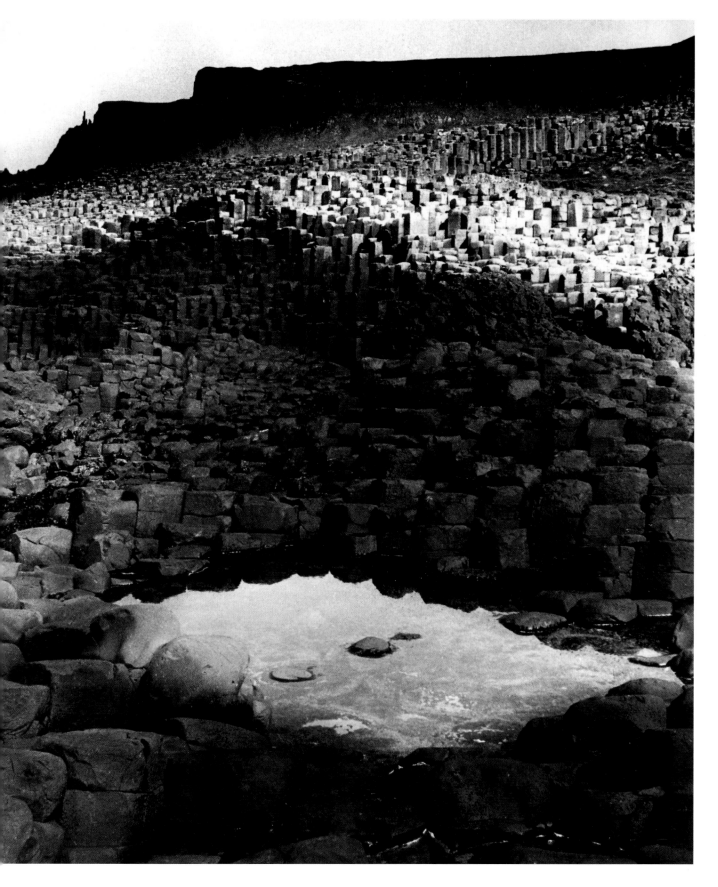

Giant's Causeway, 1947

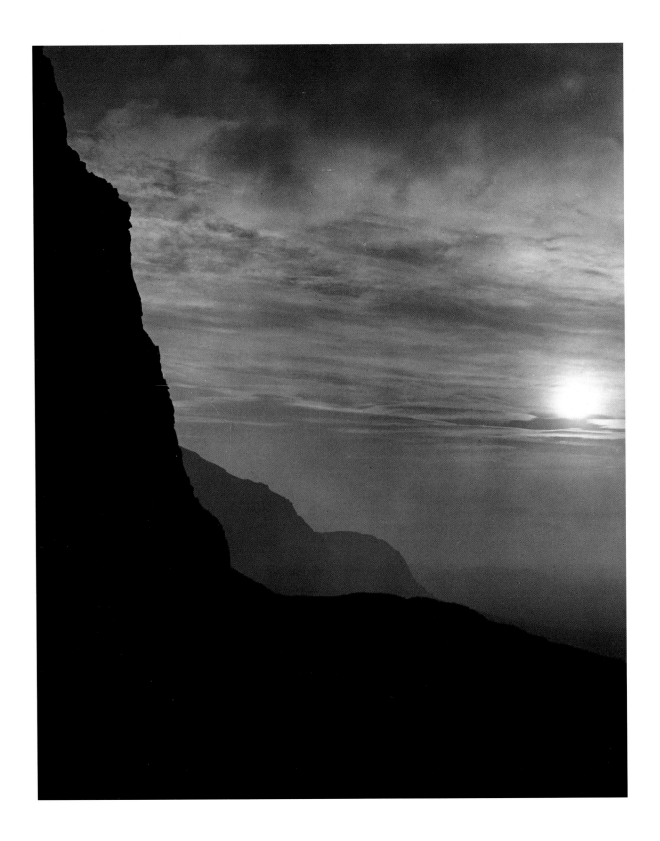

'The Northern Capital in Winter' (Edinburgh), *Lilliput*, February 1942

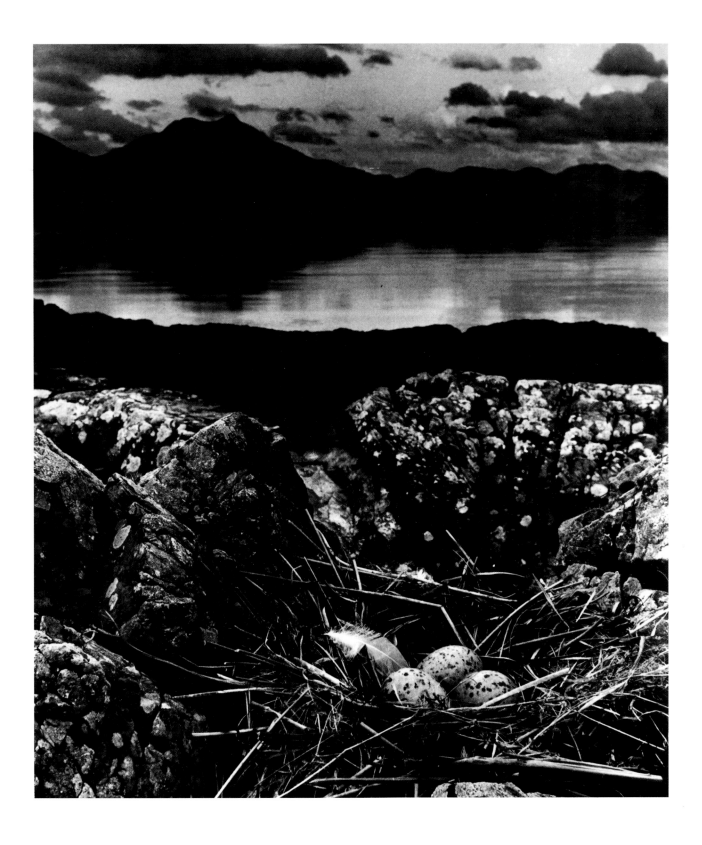

Gull's nest, late on Midsummer Night, 'Over the sea to Skye', *Lilliput*, November 1947

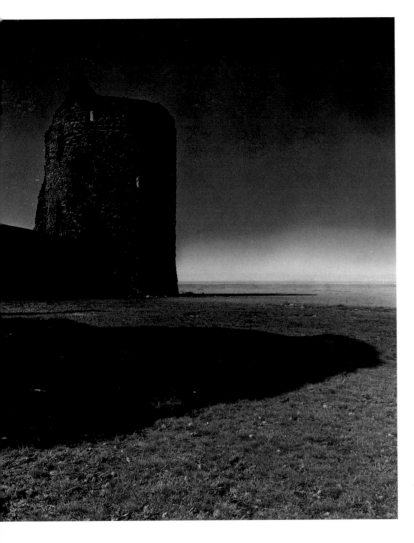

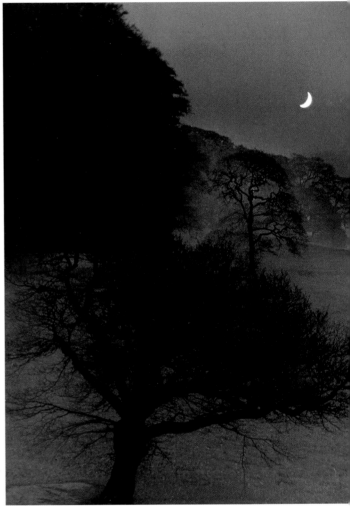

Flint Castle, *Richard II*, Act III, Scene 3,
Literary Britain, 1951

A winter picture, *Lilliput*, January 1942

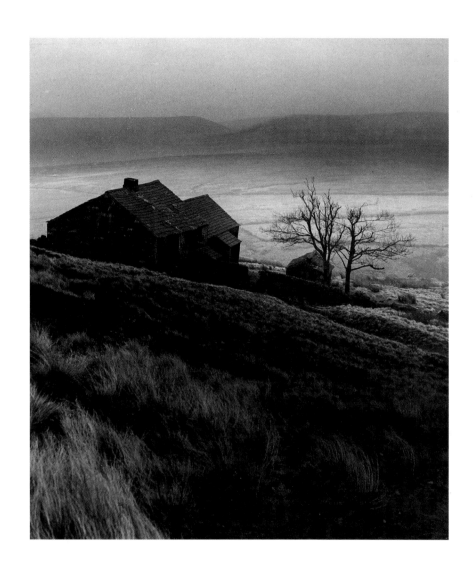

'Top Withens' (*Lilliput* caption),
'Bill Brandt visits the Brontë country', *Lilliput*, May 1945

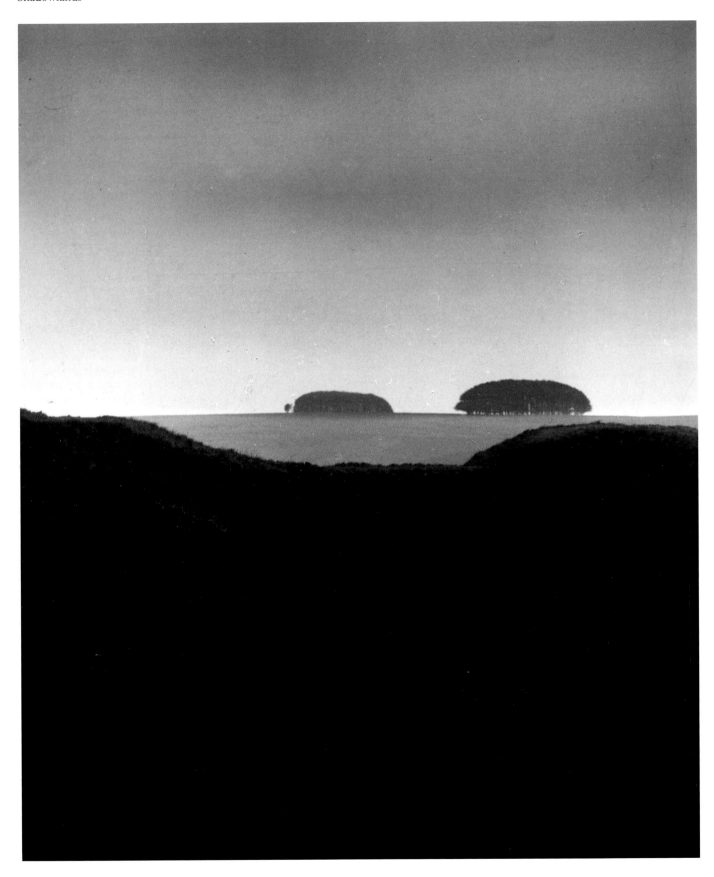

Barbary Castle, Marlborough Downs, Wiltshire, 1948,
'The horizon of Richard Jefferies', *Picture Post*, 6 November 1948

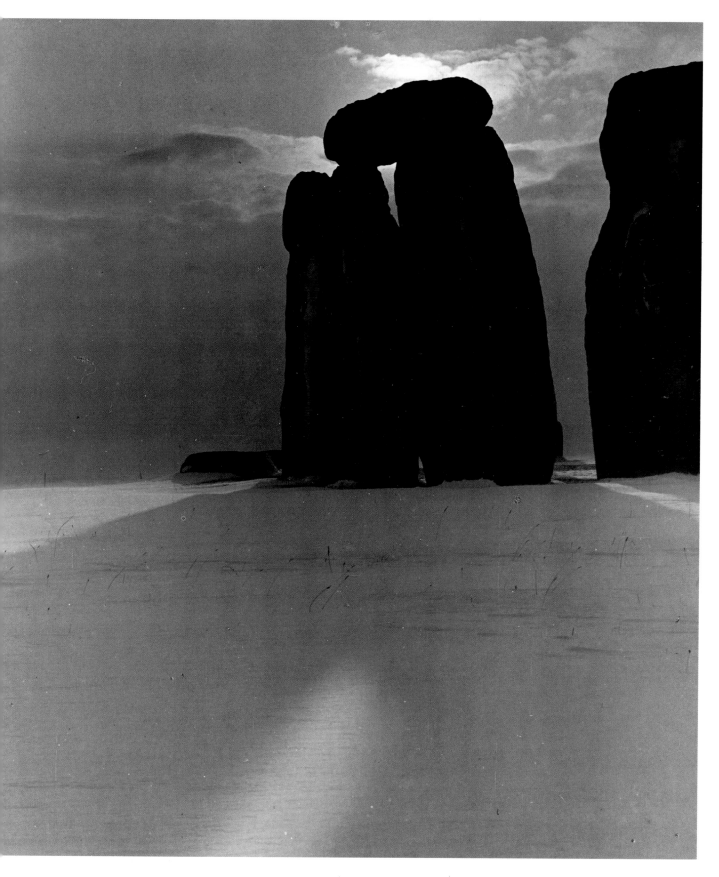

Stonehenge, 1947

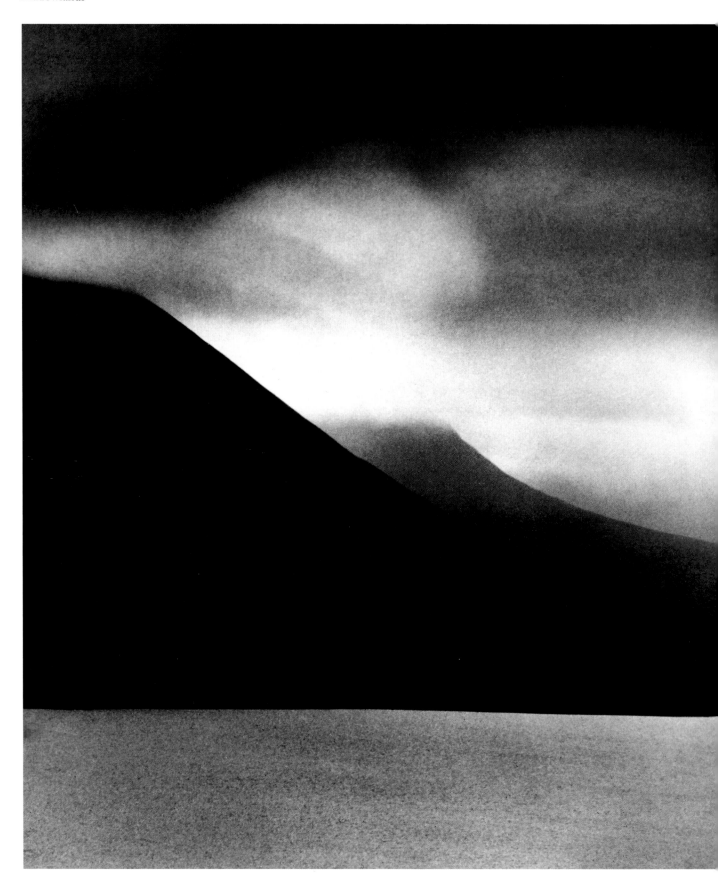

'Over the sea to Skye', *Lilliput*, November 1947

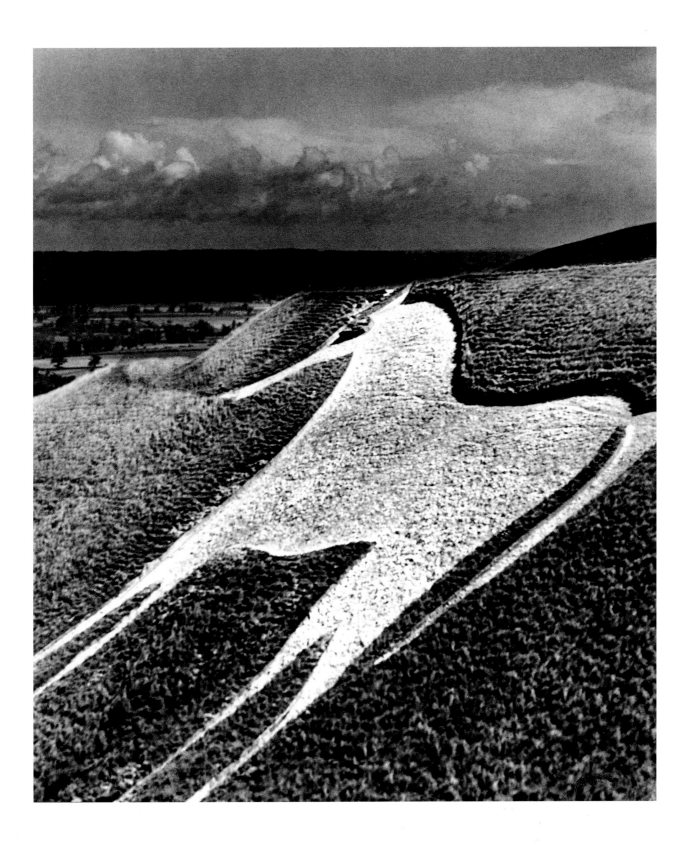

The White Horse, near Bratton, Wiltshire, 1951

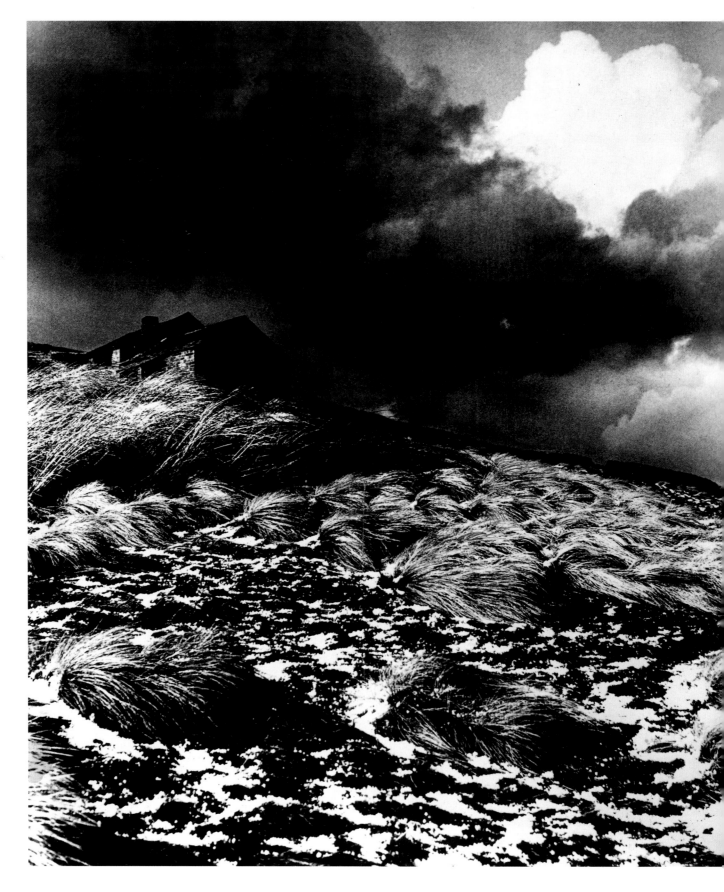

'Top Withens', West Riding of Yorkshire, 1945

The Pilgrim's Way, Kent, 1950

Figurehead of Neptune
on Tresco (Scilly Isles), *c.* 1935,
'Anti-invasion outpost',
Lilliput, August 1943

Garsington, Oxfordshire, 'The Garden of England',
Lilliput, September 1943.

Coate Water, 'The horizon of Richard Jefferies',
Picture Post, 6 November 1948

'Daybreak at the Crystal Palace',
Picture Post, 11 February 1939

'The one Aunt Emily posed for' (*Picture Post* caption),
'Daybreak at the Crystal Palace', *Picture Post*, 11 February 1939,
also published as 'Introvert', *Lilliput*, March 1946

Winter in a park, 1930s, *Lilliput*, January 1942

Orford Castle, Suffolk, 'The Vanished Ports of England', *Picture Post*, 24 September 1949

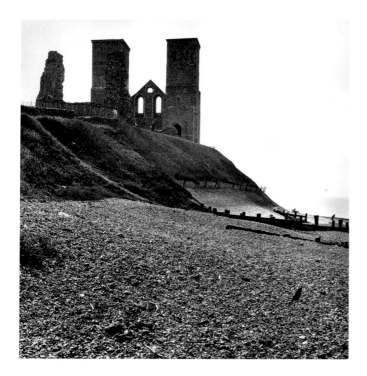

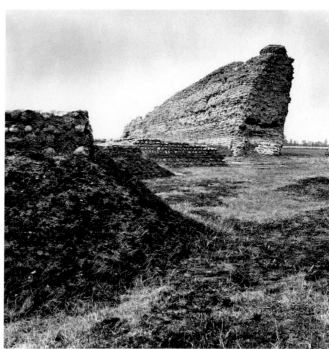

Reculver, Kent, 'The Vanished Ports of England'

Richborough, Kent, 'The Vanished Ports of England'

Pevensey, Sussex, 'The Vanished Ports of England'

Portchester, Hampshire, 'The Vanished Ports of England'

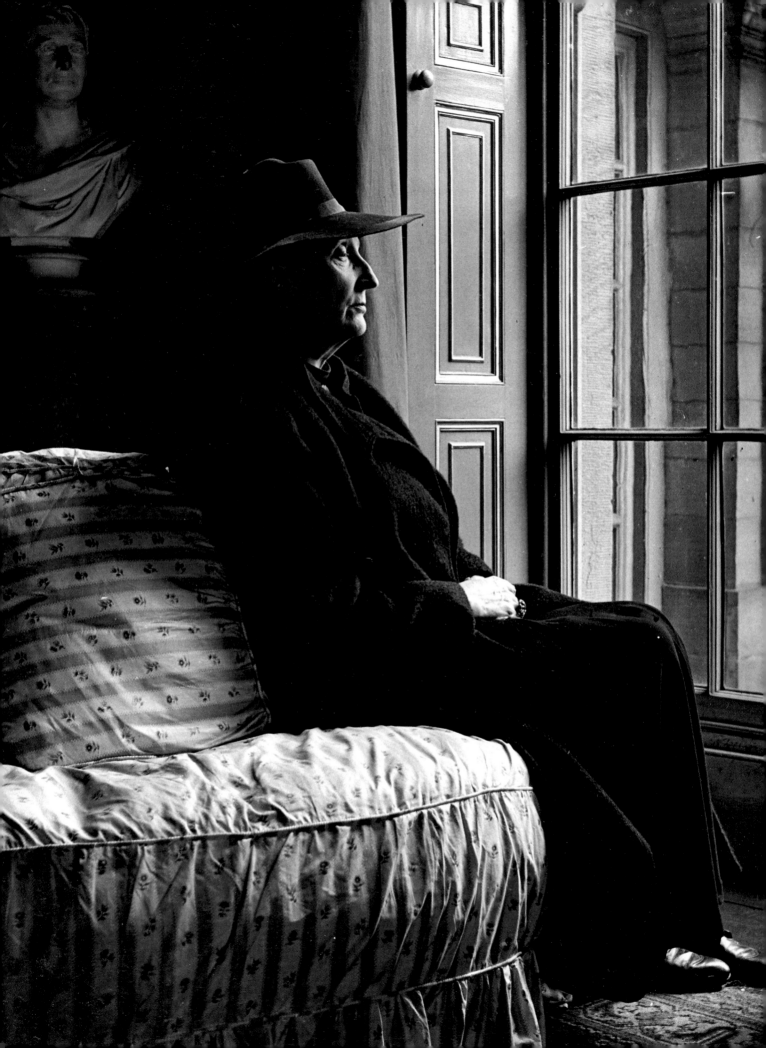

Brandt's first major essay in portraiture was 'Young Poets of Democracy', *Lilliput*, December 1941, and continued with 'What our artists look like', *Lilliput*, March 1943. His subsequent portraits appear either in that magazine, or in *Harper's Bazaar* from the summer of 1943. In many cases his subjects vie for attention with a conceit or obtrusive material element: trees, tiles and a tea service, for example. Later tactics involved elaborate architectural settings into which the sitter was fitted as a design element. Subject to this dispassionate, technical treatment most became indifferent-to-melancholic and even oracular, which was his own and André Breton's term for a desirable portrait. Women he preferred to show as sympathetic dreamers, and men as threatening presences from *film noir*.

Edith Sitwell, *c.* 1945

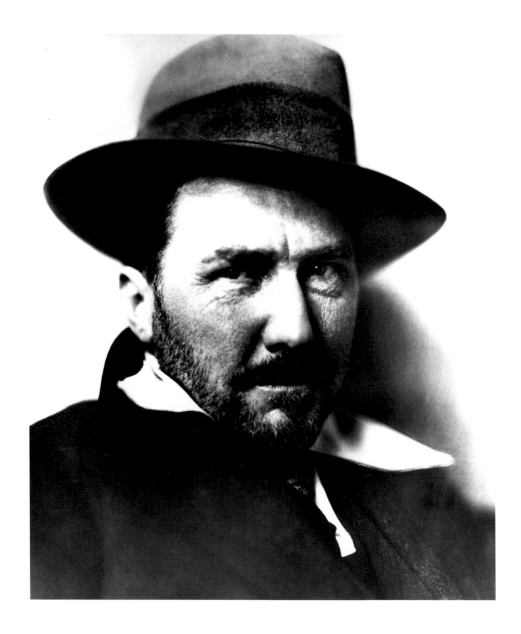

Ezra Pound, 1928

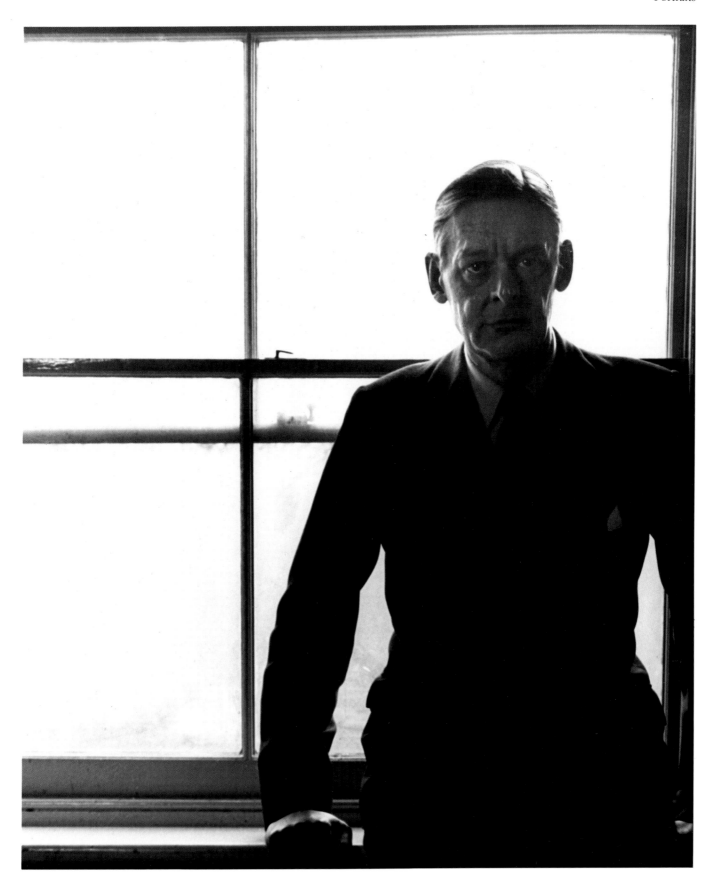

T.S. Eliot, 'The common reader and the modern poet', *Harper's Bazaar*, June 1945

152 Robert Graves and friends, 'What I believe about ghosts', by Robert Graves, *Picture Post*, 27 December 1941

Sir Kenneth and Lady Clark, *Harper's Bazaar*, December 1944

Tom Arnold, 'Box-office boys', *Lilliput*, December 1950

Peter Sellers on the set of *A Shot in the Dark*, 1963

Kenneth Tynan, *Harper's Bazaar* (USA), 24 February 1951

René Magritte, 1963

Miró on the platform of his windmill, which pumps water for his house, 1964

Walter Trier, 'What our artists look like', *Lilliput*, March 1943

J.B. Priestley relaxes at a Bournemouth hotel, 'I look at Bournemouth', *Picture Post*, 21 June 1941

Francis Bacon on Primrose Hill, 1963

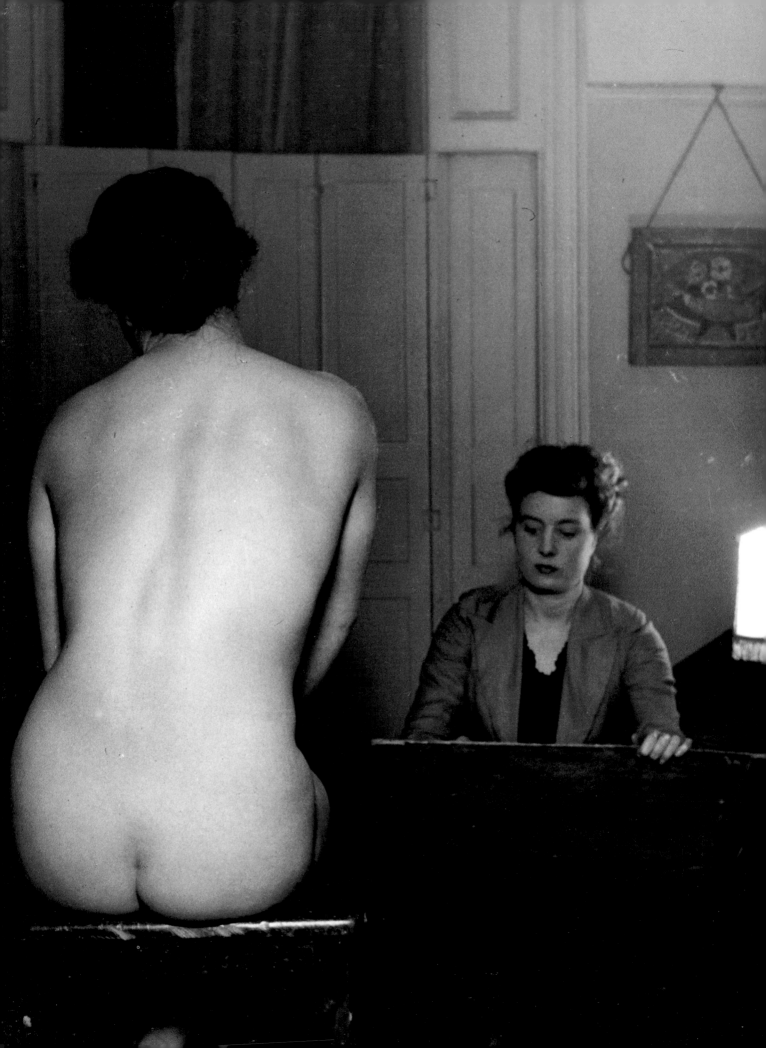

Nudes were a measure of mastery in photography during the 1930s, but it was only during the mid 1940s that Brandt began to photograph nudes to any great degree, and then rather as a portraitist. He took pictures of bathers for *Picture Post* and then made seaside portraits of an oracular woman of the rocks for *Lilliput* in 1942-43. His indoor nudes began in 1944, but it was only in 1946 that they were published, sparingly, in *Lilliput*, under such titles as 'The Watcher', 'Reflection' and 'Woodman's Daughter'. These amount to encounters with far from acquiescent beauties in abandoned Regency properties. They are women of the shadows, more especially women of the lighting systems of such Alfred Hitchcock films as *Suspicion* (1941), and might be meant as *femmes fatales* and/or secret agents. Some of them are recognizable as models whom he met whilst undertaking fashion work for Rima Model Gowns from 1944 and for *Picture Post* in the late 1940s. Dressed by Rima they look like thoughtful châtelaines. These sequestered images were not much published because they carried about them an air of privacy. When he set himself to photograph nudes more systematically in the 1950s they were envisaged in far more transformational terms, as sculpture enhanced and even dissolved by light. The earlier nudes are redolent of identity, time and place, all of which qualities are suppressed in the fragmented later figures, published in *Perspective of Nudes* in 1961.

Artist and model, similar to a photograph
published in 'Day in the life of an artist's model',
Picture Post, 28 January 1939

'Raincoats are promoted to fashion', *Picture Post*, 14 January 1950

'Fashion in bras', *Picture Post*, 20 August 1949

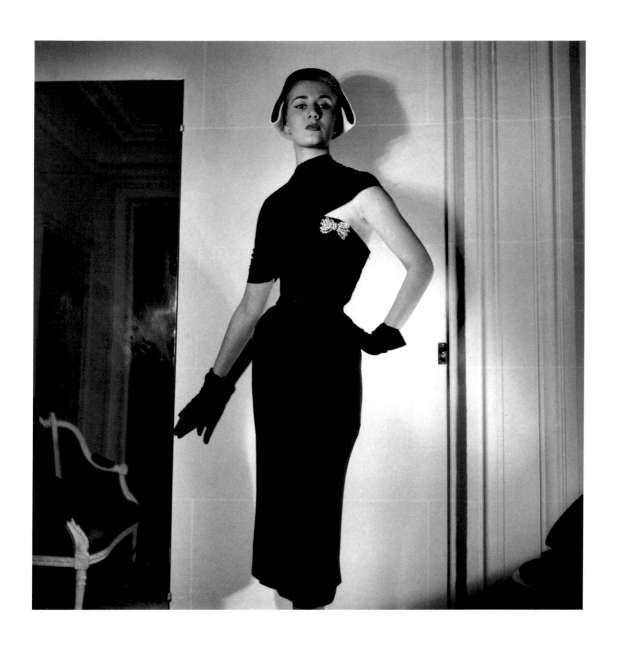

'Cocktail dress with a clever stole effect by Dior',
'Afternoon and evening', *Picture Post*, 14 April 1951

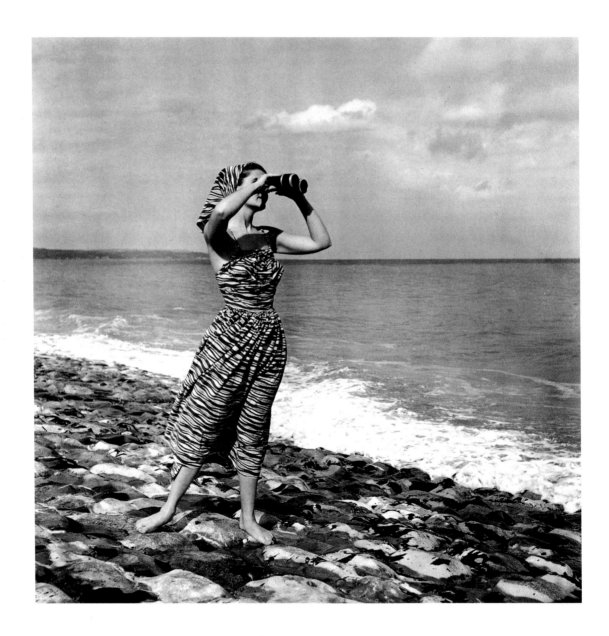

'The ballerina beach-dress', 'Fashion-on-sea', *Picture Post*, 24 July 1948

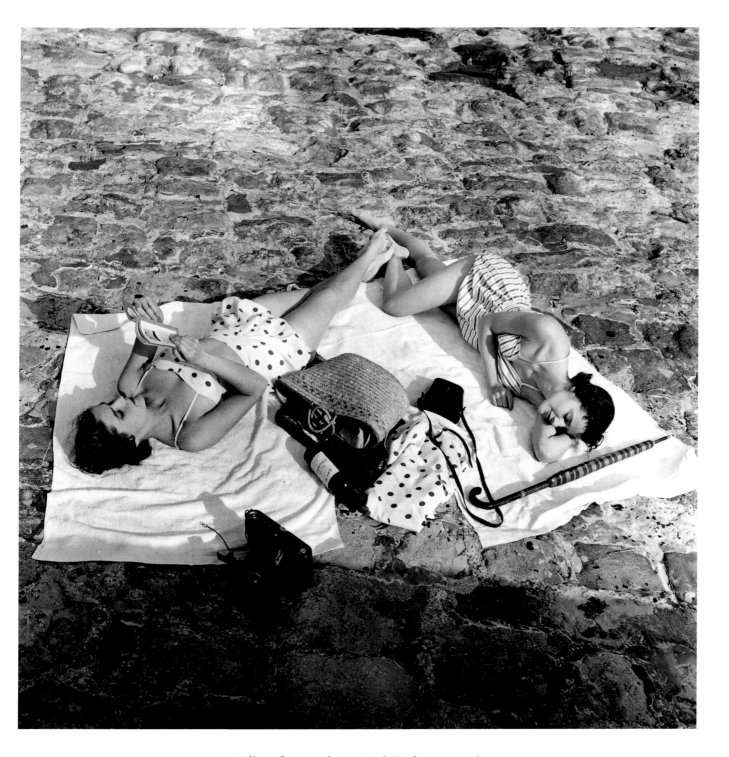

'All set for a seashore siesta', 'Fashion-on-sea'

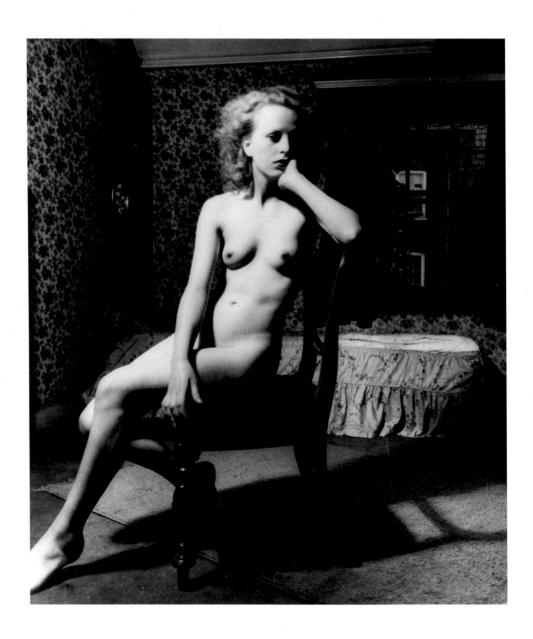

Nude, Hampstead, 1945

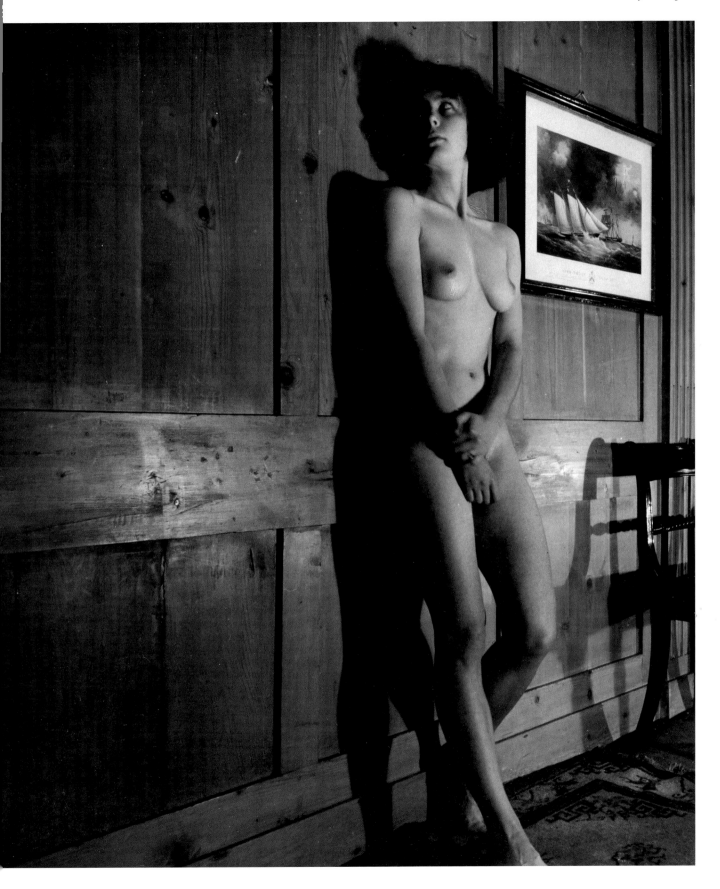

'Woodman's Daughter', *Lilliput*, July 1948

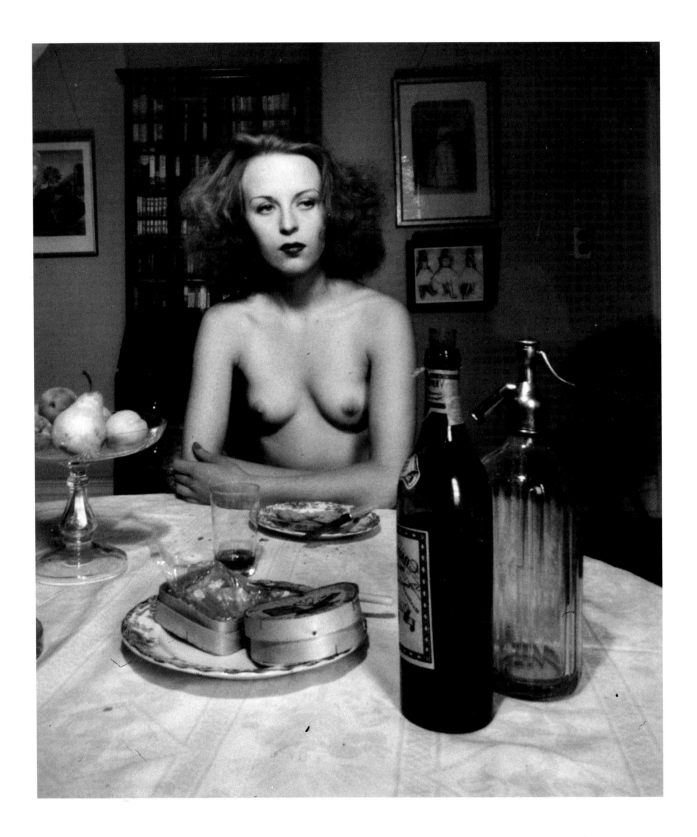

Untitled nude, *c.* 1945

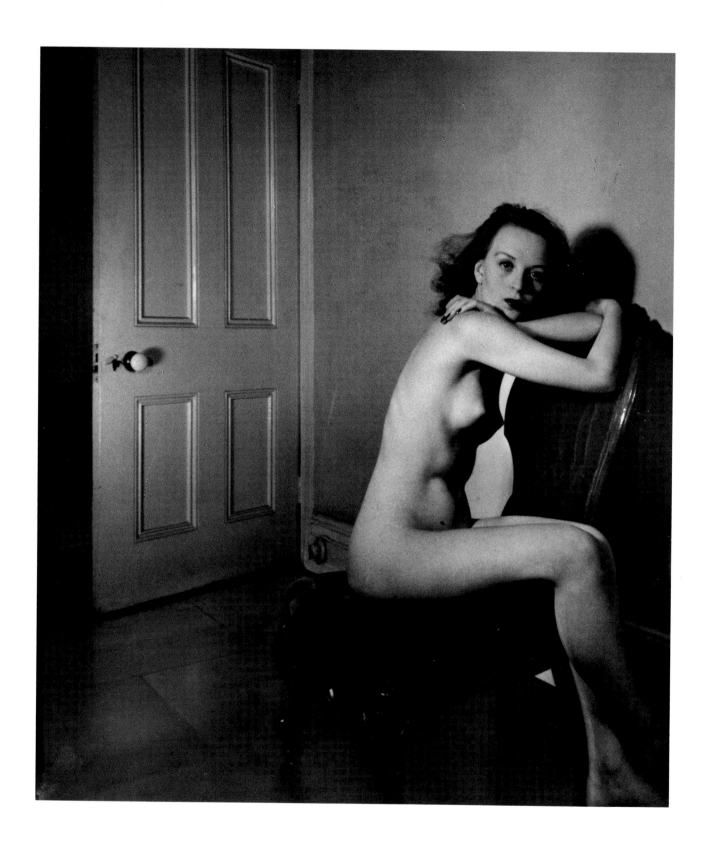

'Reflection', *Lilliput*, March 1949

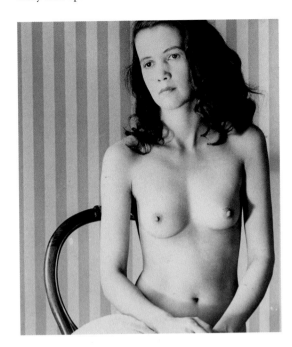

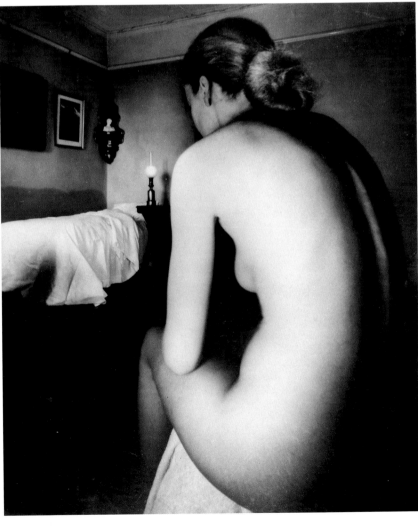

Untitled nude,
Picture Post, 20 August 1949

Campden Hill, London, 1949

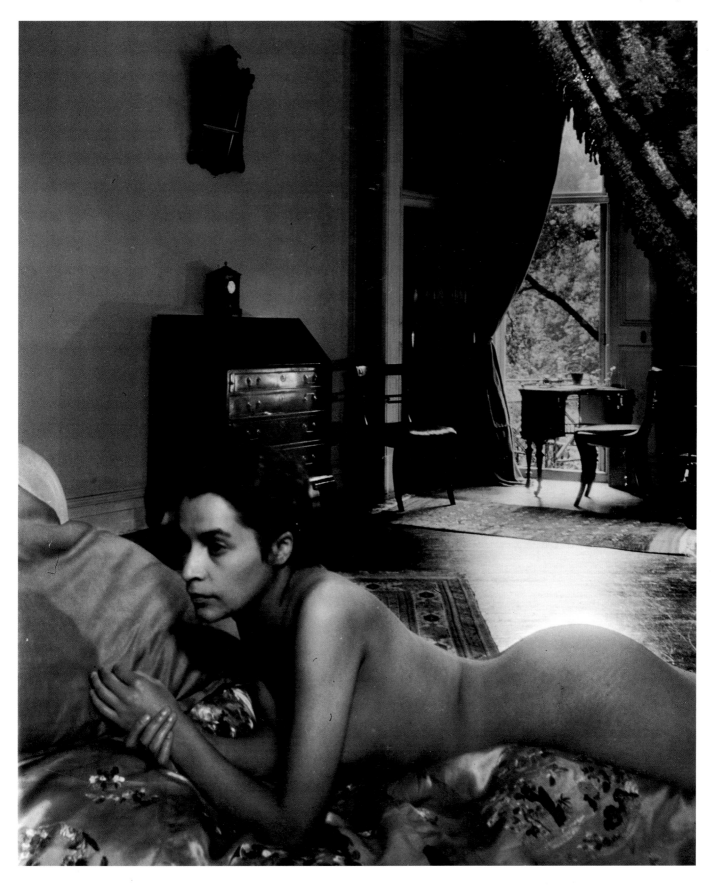

Untitled nude, August 1944

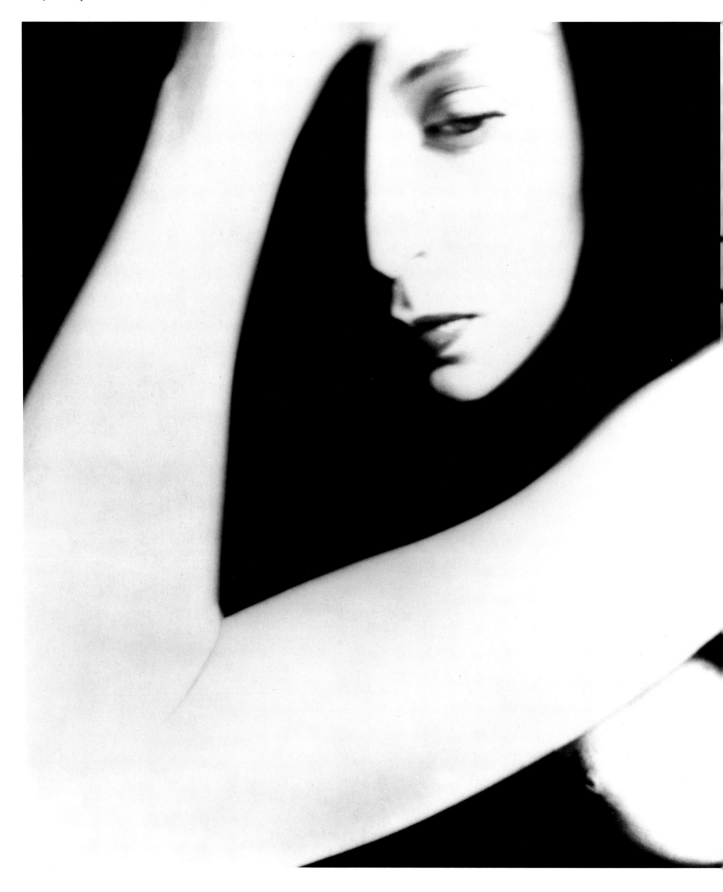

London, 1952

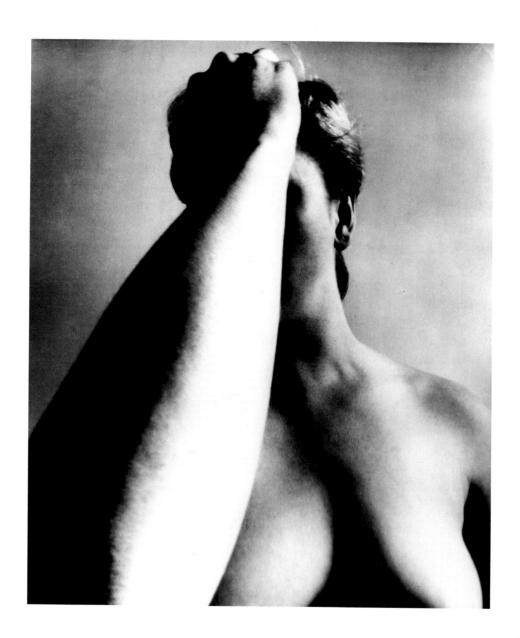

Untitled nude, 1953

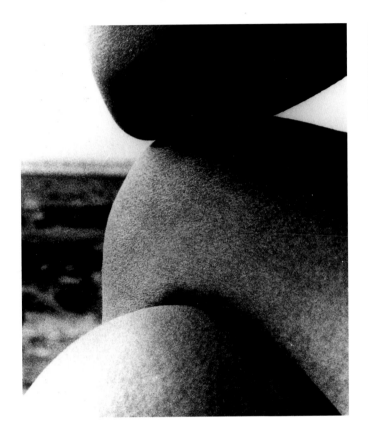

Normandy, 1959 From *Perspective of Nudes*, 1961

East Sussex, 1957

Weekly Illustrated: features relevant to Brandt's photography 1934-38

1934

21 July: 'London by Night'; 12 photographs over two pages, including a waiting hansom, 'one of the narrow courts of Whitechapel', and a guardsman in a scarlet tunic. A pairing of a motor-café for the homeless and hungry and the plate-glass windows of the Savoy anticipates some of the juxtapositions in *The English at Home*.

1 August: 'Daybreak over London'; 14 photographs over two pages, including patrolling policemen, a lone milkman at Piccadilly Circus, and empty bottles awaiting collection.

6 October: 'Coal and the men who get it'; photographs by James Jarché, and an iconography which impressed Brandt: 'Part of the ritual in a mining household is for the wife to give her husband a scrub down when he returns home unless he works where there are pithead baths'.

17 November: 'Fine fresh fish'; porters of Billingsgate fish market in their 50-shilling hats and wooden-soled boots. (Compare *The English at Home* and *A Night in London*.)

17 November: 'Pull down the slums'; the grating 'front windows' of a basement, and a view down into backyards, both of which Brandt took as types of exposure photography. (Compare 'Enough of all This', *Picture Post*, 1 April 1939.)

1 December: 'Fog comes to London'; this was Brandt's first essay in 'fog' as a photographic topic.

1935

2 February: 'Changing Britain'; factories, river, tombstones and back-to-backs from Paul Rotha's new film *The Face of Britain*.

30 March: 'The hotel that pays its guests'; indoor photography, with trance-like participants, in a Rochester hostel.

27 April: 'The park everyone knows'; a model for Brandt's park work of the early 1940s.

18 May: 'Showgirls' home-from-home'; including a shower after the show and lunch at their own canteen – in anticipation of 'Backstage at the Windmill', *Lilliput*, October 1942.

1 June: 'Derby Day'; Jack Dutton, bookie, and spectators of 1871 on coaches in contrast to contemporary charabancs.

8 June: 'Dogs of chance'; tic-tac men and greyhound racing.

22 June: 'A student of Cambridge'; including a head porter, a girl student making up for acting, and a rower practising in front of a mirror. Nos. 45 and 46 in *The English at Home* were of Cambridge, and the connection is very close.

24 August: 'Jungle parade – a corner of a taxidermist's shop in Camden Town'; from a picture provided by Brandt to the Black Star Agency.

26 October: 'Engine drivers' home from home'; supper, cards and lights out in a Gateshead hostel.

16 November: 'Scotland Yard fights crime with maps and pins'; a control room suite; c.f. 'Transport: Key to Our War Effort', *Picture Post*, 26 September 1942.

30 November: 'Night in a Hospital'; the Charing Cross casualty department, where the police question a witness, and nurses eat in tranquillity before relaxing around a fire place, 'An hour's rest within call'. This set of 15 is thorough and intimate enough to be by Brandt.

21 December: 'Ship's quick turn around'; three pages from the *Aquitania*, including a line-up of bell boys, and behind-the-scenes in refrigeration and engine-room.

1936

11 January/18 January/8 February: articles on the 'Mid-Rhondda', 'Children of the coalfields' and 'Week-end in a mining village'; Brandt's iconography rehearsed: the fire-side bath, a miner's living room, a dog foraging in a back-to-back street, a pub seen from behind the bar.

23 May: 'Derby Day'; a voyante ('She can see as much of the race as most') in a collage of 20 images. The voyante was by Brandt, possibly photographed in Paris, and a line of toppers and binoculars recalls the frontispiece to *The English at Home*.

30 May: 'Opera in a Country House'; nine pictures from Glyndebourne, an alternative version of an article in *The Bystander*, 3 June 1936, credited to Brandt.

20 June: 'Shakespeare gives them all a job'; 11 pictures from Stratford-on-Avon, with shop façades and statuary heads in windows looking over the town.

11 July: 'Topper versus Boater'; the Eton (topper) v. Harrow (boater) cricket match. The match took place on 10-11 July, and

Brandt in an interview recalled the article as his; seven photographs, including hats in a window and old and young on shooting sticks.

1 August: 'East End seaside'; a £25,000 swimming pool in Victoria Park.

8 August: 'These little kids stayed at home'; a shingly beach by the Tower, and a sand pit by the Houses of Parliament.

22 August: 'They do as they please'; Dora Russell and the Beacon Hill School. At *Picture Post* Brandt had some credit as a schools photographer: 'We want more nursery schools', 25 October 1941, and he may have been involved in these three August pieces.

29 August: 'London roars around them'; solitude in the gardens of St. Paul's Church.

31 October: 'Gas, Bomb & Shell Proof'; London's first gas and bomb-proof office building. A gas-masked woman with a lamp and a vignetted group look like Brandt phantasms. Compare 'Fire guard on the House of Commons', *Picture Post*, 14 November 1942.

12 December: 'East End gets a palace'; the new People's Palace in the Mile End Road, with suspicious idlers under lamps from the bad old world, 'Nowhere to go'.

26 December: 'All this goes to make a hotel Christmas'; 2 pp. with eleven trades and six action pictures, in the Cumberland Hotel. A line-up of bell-boys, and attention to the hotel's air tunnels point to Brandt.

1937

6 February: 'This school versus blind alley'; the London County Council School at West Kensington, systematically narrated as a day's work, in the manner of the *Picture Post* articles of 1939 – bathing a baby, typing in echelon, learning to serve and set meals, getting ready for the party (always characteristic of Brandt's heroines of 1939).

27 February: 'Mugs, mugs, mugs'; a visit to the Potteries, apropos of coronation souvenirs; girl workers at lunch, washing in a backyard, and women seen through a window. Brandt is known to have visited the Potteries area in 1937.

6 March: 'It looks so easy – but much has to happen behind the scenes before the elegant mannequin comes strolling in'; waiting in the wings and the entry of the finished job – in advance of Brandt's fashion work for *Harper's Bazaar* in 1944.

29 May: 'The bedroom in which Stanley Baldwin was born, Bewdley – Worcestershire'; a flash-lit interior, in anticipation of *Literary Britain*, 1951.

19 June: 'Behind the scenes at Windsor Castle'; a day in the life of Windsor, from the moment of the early morning milk delivery; an institution comparable to the Cumberland Hotel, the *Aquitania* and the Charing Cross Hospital.

26 June: 'Dead town comes to life'; a page on Whitehaven, with a steep ramp of a street, like a Halifax snicket, and girl screeners of coal.

7 August: 'This is a Channel crossing – but a certain Mr. Potter had one like this –'; spectral Surrealism on an empty ferry to France.

21 August: 'Making the Underground safe for you'; six pictures of working and walking in tunnels, in anticipation of the Shelter pictures, for example.

23 October: 'More praise than pay'; a thoroughly Brandtian article on nurses' pay, including their main staircase, their privacy and comfort, and their mealtimes. Continuous with his Home Front essays of 1941-42 for *Picture Post*.

23 October: 'Oxford goes back to work'; a girl's room at Somerville, and swords on a wall, in anticipation of 'The Portraits in the Servants' Hall', *Picture Post*, 24 December 1943.

4 December: 'Sun-trap for the young'; the Middle Park School at Eltham, with children resting and putting dolls to bed, and window views of other buildings.

1938

26 February: 'Night falls on Madrid's underground'; the first Shelter pictures.

5 March: 'Canterbury – England's first cathedral'; possibly his first experience of ecclesiastical architecture – followed on 12 March by a piece on 'Canterbury's boy singers', in which a boy looks into a bath, and others lunch.

16 April: 'York – sacked, plundered, fought over'; including the tomb of Sir William Gee (comparable to the Canterbury tombs Brandt photographed in December 1941) and regulatory details such as its own police force.

23 April: 'It's budget week again'; the invisible cost of a day out. This is a resumé of Brandtian iconography, including a group who look at film stills, a guardsman, a mealtime, and a child who watches his father smoking. This is a systematic staging and analysis of a day which leads directly into the *Picture Post* day series of 1939.

1937

In August, in the second issue of *Lilliput*, two pictures by Dixon Scott, of the coastline of Seaford Head and of Willy Lot's cottage, prefigure Brandt's landscape interests in the 1940s. It seems that Brandt himself put on deposit a collection of his own pictures to be used as required. September, p. 97: illustration no. 8 from *The English at Home*, 'After the Celebration', used in reverse opposite a picture of Lord Iveagh, over these captions: 'Chairman of Guinness ... Is Good for You'.

November, p. 54: 'Beggar in Spain'.
November, p. 113: '... And the Rain'; of a fountain in Barcelona, opposite 'The Wind' by Szollosy.

1938

In 1938 *Lilliput* began to honour photographers: Erwin Blumenfeld, Brandt and Erno Vadas in particular. In July Blumenfeld was the first to be presented simply as a photographer, and in September six of his pictures were introduced as 'Modern Masterpieces of Photography'. In December Blumenfeld was represented by eight 'Beautiful Women'. In October of that year eight East European village idylls by Vadas included one man with a wheelbarrow who looks like a prototype for Brandt's famous coal gatherer. In the same issue, 'Holiday Pictures of 50 Years Ago' by Paul Martin featured a horizontal love scene in a park – a motif to which Brandt returned.

February, p. 170: 'Loneliness'; a slim wading bird in a park, opposite 'London solitude' (staircase, railing and lamp) – an agency picture.
February, p. 189: 'Release'; a greyhound running on a shore.
February, p. 205: 'Monument to a faithful wife in a Hungarian village'.

March, p. 244: 'The Tic-Tac Men'; this is given as a Keystone picture, and is placed opposite Hitler as 'The Chancellor of Germany'.
March, p. 246: 'Manicure, Please'; another Keystone picture of a London waitress, related to Brandt's Nippy series in *Picture Post*. It faces a Dr. Salomon picture of Anthony Eden, Foreign Secretary: 'Mine are all right'.
March, p. 259: a tipsy Hungarian, as previously published in *Photographie*, ill. 64, 1933-34, 'And when I die/Don't bury me at all,/Just pickle my bones/In alcohol'.

April, p. 435: 'Tombstones', including those of Nora Healey and Charles Spooner, October 1937.

May, p. 459: 'London Hat Shop', a vitrine of stacked toppers – not those shown in *The English at Home*, no. 26 – opposite 'Paris Roof Tops' by Kertész.

June, pp. 581-88: 'London Night'; all but one scene, of dancing in Mayfair, were used in *A Night in London*.

July, p. 52: 'Balloon'; his striped balloon from Paris, opposite the rear view of a hippo, by Bone of London.

1939

The war made little difference to *Lilliput* which had been committed to the democracies since its inception. In January, pp. 81-88, Cecil Beaton entered as 'A fanciful camera-artist'. In June, pp. 617-24, John Everard contributed eight nudes, 'Beauty of the Body' (stripped from the reference copy in the British Museum). Idyllic village life was remembered by Erno Vadas in July, 'Summer in Hungary', pp. 67-74.

February, p. 146: 'Children in England'; schoolgirls at desks, confronting 'Children in Germany', giving the Nazi salute.

May, pp. 485-500: 'Unchanging London'; this was made up of nine photographs by Brandt related to seven engravings by Gustave Doré. Two of the photographs, of a ramshackle grandstand at Epsom, and of a London coffee stall, were previously unpublished.

September, pp. 233-40: 'Twenty-four hours in Piccadilly Circus', 7.30 a.m. to 4.30 a.m., taken from opposite Swan & Edgar's and under the sign of 'Invisible Mending'.
September, p. 299: 'Poor man's child'; a smeared child in front of a cake-making spread at a table is put opposite a Keystone picture, 'Rich man's child – Lance Reventlow at Moritz'.

December, pp. 551-58: 'Blackout in London'; a set of eight, beginning with the dome of St. Paul's and ending with a street corner, moon and a darkened lamp.

1940

January, pp. 45-52: *Lilliput* gave space to the 'Dream-Visions' of Angus McBean, and in June, pp. 509-16, projected an elegant 'Blackout in Paris' by Brassaï. Brandt's star was waning slightly.

August, p. 148: 'Public Schoolboys'.

October, pp. 343-45: 'Autumn in a forgotten wood'; this group might be metaphorically inclined: frosted firs, a dead oak like a lightning strike, the shadowed bole of a beech tree with a toadstool.

November, p. 422-23 'Peeping Tom'; a white terrier at the jamb of an open door, opposite 'Paul and Virginia', about to kiss in a public gathering – also by Brandt.
November, p. 433: 'Goodness, how sad!', a waxworks couple from an opera, from the early 1930s – Paris or Barcelona.
November, p. 436: 'What a revolting creature!', a long-necked, large-billed bird, placed opposite a gaping turtle.

December, p. 528: 'Bar parlour'; a vaguely patriotic barscape, in which a bulldog, of sorts, overlooks a game of cribbage – no. 33 in *The English at Home*, 'Public Bar'.

1941

This was another intermittent year for Brandt, who was relatively busy at the time with work for *Picture Post*, and, later in the year, for the National Buildings Record in Canterbury, Chichester, Colchester and Rochester.

February, p. 121: 'I'm glad I got in that extra ton of coal'; a solitary man by a Belisha beacon on a snowy, fogged street.
February, p. 174: 'Lovers and cats ...'; silhouetted male and female legs, opposite a picture of a cat, casting a long shadow (by Berko of Bombay).

July, p. 62: 'The sleeper'; a woman's head on a pillow, with, beyond the window, a sky crossed by searchlight beams.

August, p. 127: '... fortunately we managed to recapture it, madam'; a Billingsgate fish porter, who was no. 22 in *The English at Home*, published here opposite a Keystone picture of Mrs. Sarah Roosevelt and Lord Halifax: 'But you should have seen the one which got away ...', p. 126.
August, p. 155: 'Runnymede – where ghosts walk'; seven swans on a dark river bank.

September, p. 198: 'Be sure to go to church on Sunday'; a speaker in Hyde Park with the slogan, 'Christians – Read Your Bible', opposite a Suschitzky image of bookies at Brooklands: 'It's the only sure tip for the future'.
September, p. 217: 'I grow old ... I grow old .../ I shall wear the

bottoms of my trousers rolled'; a man standing in the water, watching a bather.

September, pp. 220-21: 'If only I could have gone on the stage', opposite 'Homework would be a rest cure compared with this'. In this pairing a maid washing a doorstep envies Tatiana Riabouchinska from the Russian ballet, kneeling.

September, pp. 235-42: 'A Simple Story about a Girl'; in this narration in eight frames a girl moves from a window to a mirror to the street and then to a park where she looks at flowers before meeting Jack, with whom she dances; then in the park they sit on two chairs, which remain deserted in the final frame.

October, p. 227: 'Now if Roosevelt had asked me ...'; two figures in a pub.

November, p. 341: 'There's just time to look at the pictures ...'; a boy in bed – no. 19 in *A Night in London*.

December, p. 442: 'What's going on down there?'; a statue in Gloucester Terrace, Regent's Park – standing propped, beside chimney pots.

December, pp. 477-82: 'Young Poets of Democracy'; Stephen Spender, Cecil Day Lewis, Dylan Thomas, Louis MacNeice, Alun Lewis, Anne Ridler, Laurie Lee, William Empson; Brandt's first essay in formal portraiture.

1942

During 1942 Brandt was involved in 15 jobs for *Picture Post*, of which six were 'killed'. *Lilliput* gave him more control, and made more allowances for the poetic.

January, pp. 14-15: 'There are worse places to sleep than a coffin'; a scene in a church crypt in London in September 1940 – a Shelter picture; opposite another Brandt from Canterbury Cathedral, of the Sir Thomas Thornhurst monument: 'I've been here four hundred years already'.

January, p. 16: 'Memories of things past'; a bather seated on the prow of a boat.

January, p. 65 & p. 69: two from eight winter pictures, to which Dylan Thomas attached verses; the first is of a tree and moon, and the second of a frosted statue: 'Very often on winter nights the half-shaped moonlight sees/Men through a window of leaves and lashes marking gliding/Into the grave an owl-tongued childhood of birds and cold trees ...'. And, p. 69: 'Asleep may stalk among lightnings and hear the statues speak,/The hidden tongue

in the melting garden sing like a thrush/And the soft snow drawing a bellnote from the marble cheek.'

February, p. 136: 'Who'er she be, that not impossible she' – from Richard Crashaw, 'Wishes to his Supposed Mistress'; Brandt's first *Lilliput* nude, upright through gauze.

February, pp. 145-52: 'The Northern Capital in Winter'; on Edinburgh, with a text mainly by Sacheverell Sitwell; the beginning of buildings in landscape, of which the next major phase will be 'The Garden of England', *Lilliput*, October 1943.

April, p. 282: 'Robert Graves, Poet and Man of Letters'; a portrait to accompany an article, 'My Father – Robert Graves', by Jenny Nicholson; in the last week of December, 1941, *Picture Post* ran an article by Robert Graves, with Brandt images: 'What I believe about ghosts'.

April, pp. 323-30: 'Soho in wartime. Eight bits of a quarter'; Soho types and locations introduced by a Greek boarding-house keeper.

May, p. 354: 'She sells sea shells'; a nude bather arranging shells by rocks.

August, p. 99: 'The real thing'; a wrestling scene, but not no. 21 from *A Night in London*.

August, pp. 131-40: 'London by moonlight'; ten pictures accompanied by a short article on Brandt the photographer, by Tom Hopkinson, who was then the editor of *Picture Post*. Brandt spoke in the captions, for example apropos of St. John's Churchyard, N.W.3: 'I have always loved the Beerbohm Tree Memorial in St. John's Churchyard. By moonlight it looks mysterious and eerie, but by day it has roses climbing all round it'.

September, p. 193: 'The peasants eat their soup'; a Spanish family from the Barcelona period, opposite 'Pierre Laval gives a party'.

September, p. 198: the retiring Archbishop of Canterbury opposite a wine peddler in Cairo; Brandt had done a *Picture Post* article on the Archbishop on 24 January 1942.

September, p. 200: 'Still life on the Farm'; a bucket yoke and hanging pheasant.

September, p. 223: 'I don't mind sinking a pint old chap'; one of his five Dean Boys pictures taken in Canterbury in 1941, for the National Buildings Record.

September, pp. 239-46: 'Flower portraits by Brandt'; Madonna Lily, Delphinium, Iceland Poppy, Michaelmas Daisy, Nelumbo Nucifera, Hydrangea, Red Hot Poker, Water Lily, with captions

by Stephen Spender. Hulton Deutsch records show that Brandt was paid £15 for this, and Spender 4 gns. for the captions. In the same issue Steven Spurrier was paid 5 gns. for two illustrations. Walter Trier was paid £20 for his coloured *Lilliput* covers.

October, p. 264: 'If only we could see a prince'; two women looking right towards Archduke Otto of Austria: 'Would a duke do?'.
October, p. 275: 'The Backyard Blimp'; a crouched cockerel.
October, pp. 308: 'Guardian'; POSTERIA, the concierge of Barcelona.
October, pp. 323-30: 'Backstage at the Windmill'; 'Ten minutes to the show. Once inside the theatre, you breathe electric air. The lights are brighter, the shadows darker, than in the world outside. A lost hairpin becomes high comedy. A second of time becomes important as an hour. Brandt catches all this eager tension in these photographs of back-stage scenes.' Brandt was paid £15, and one picture, 'Waiting for the cue', was subsequently re-used.

December, pp. 473-82: Shelter pictures, by Brandt and by Henry Moore, introduced by a Brandt portrait of the artist; 'One of the great artists of our day – Henry Moore in his studio', under a drawing of horn-like rocks.

1943

He did less for *Picture Post* in 1943, although this was the year of 'The Threat to the Great Roman Wall', 23 October, and of 'Portraits in the Servants' Hall', 24 December. *Lilliput* began to publish the work of Peter Rose-Pulham, 'Surrealist Artists' in October, and in September Brandt began to publish in *Harper's Bazaar* in a style half way between fanciful Beaton and murderous Hitchcock.

January, p. 62: 'What's all this about reconstruction?'; a pig with stacked chimney pots.

February, p. 98: 'The Attic Room'; formerly 'Top Floor', no. 44 in *A Night in London*.

March, p. 182: 'Alice'; the barmaid at 'The Crooked Billet', facing an article by Basil Nicholson, 'The truth about pubs'.
March, pp. 239-46: 'What our artists look like'; Walter Trier, Osbert Lancaster, Anthony Gilbert, David Langdon, Victoria, Mervyn Peake, Haro Hodson, Fix Kelly; his second portrait essay. Walter Trier, an artist from Prague, had been represented

in *Das Plakat*, the Berlin poster journal to which Brandt's family subscribed in his childhood. Trier's career was surveyed by Tom Hopkinson in *Picture Post*, 20 December 1947.

April, pp. 308-9: 'Exhausted journalist – tired out filly'; a pairing of a figure on a station platform at Maidstone East, and a flattened foal on the Hungarian plain.
April, p. 314: 'Prior Park, Bath'; an urn in a landscape, subsequently used in 'The Forsaken Garden', *Harper's Bazaar*, June 1944.

May, pp. 344-45: 'Hesitation'; two Parisian racegoers looking right towards two girls, backs turned: 'Indifference'.
May, p. 347: '... and Peace'; figures in a punt, opposite 'War', as an aircraft carrier.
May, p. 362: 'The White Poppy'.
May, p. 389-98: 'The Cathedrals of England'; Canterbury, Oxford, Salisbury, Ely, Westminster, Winchester, Southwark and St. Albans, photographed for Easter.

June, p. 482: 'The first woman on the moon'; a swathed bather on a beach, under rocks.
June, p. 493: 'English sporting scene. The Flyfisher'; above an idyll poem by Alfred Cochrane.

July, pp. 60-61: 'Figure-head on cliff ... Nymph in cave'; pictures from the Scillies, in the early 1930s.
July, p. 71: 'The Avenger'; a hawk on a wicker chair with a lamp in a window.

August, p. 116: 'The Booksy Girl'; 'Human Types', by R.W. Firth.
August, p. 156: 'Dreaming Couple'; prone on grass.
August, p. 162: 'Anti-invasion outpost'; the Scillies, a stone head in shrubbery.

September, p. 195: 'Wasn't that fellow in our regiment'; from a *Picture Post* article on Colonel Blimp, 'Cartoonist's joke becomes a film hero', 19 December 1942.
September, p. 230: a woman standing ankle-deep in a country pool in a swimming costume, taken in connection with 'Holiday Camp for War Workers', *Picture Post*, 26 September 1942.
September, pp. 239-46: 'The Garden of England'; pictures of statuary and garden architecture from Stonyhurst (Lancashire), Plas Newydd (Denbighshire), Bowood (Wiltshire), Garsington (Oxfordshire), Highcliffe Castle (Hampshire), Stowe (Buckinghamshire).

September, p. 282: a head in water; c.f. 'The first woman on the moon'.

September, p. 308: 'The voice that breathed o'er Eden' (John Keble, *Poems. Holy Matrimony*); Salvatore Buccalini, as taken at Glyndebourne in 1936, and as used, in reverse, in *The Bystander* and in *Weekly Illustrated*.

1944

On 22 January 1944 *Picture Post* published 'A Year's Work by the National Trust', and on 1 January 1944 some of Brandt's pictures were used in 'We Plan a valley in South Wales', but otherwise he did little for *Picture Post*. Portraiture for *Harper's Bazaar* took up some of his time, and in December he began to show fashion pictures in that magazine. In *Lilliput* he is unusually miscellaneous.

January, p. 60: 'A dish fit for a ...'; of a cook sampling.
January, p. 71: 'And drive like hell!'; of an old coachman.

February, pp. 155-62: 'Odd corners of museums'; eight tableaux from museums of science, costume, natural history and the applied arts.

March, p. 221: 'The happy pig'; solitary, in a misty landscape.

June, pp. 491-98: 'Animal portraits'; polar bear, grecian ibex, night heron, wart hog, sea lion, coypu, llama, American bison, for which he was paid £20.

July, p. 14: 'The girl from occupied Europe'; a beautiful portrait.

August, p. 116: 'Barcelona harbour'; moored barques from the early 1930s.
August, pp. 137-46: 'Chelsea photographed'; including Dylan Thomas, John Davenport and the painter-photographer Peter Rose-Pulham.
August, p. 162: 'Memory'; a nude in profile in the style of Man Ray.

October, p. 265: 'So have we'; lovers opposite a picture of a horse and dog: 'We've fallen for each other'.

November, p. 412: 'Utility model'; children in a toy car.

December, p. 430: 'The girl who worked hard'; a schoolgirl at a desk.
December, pp. 491-98: 'A small town in autumn sunlight';

Bradford-on-Avon taken like Halifax and Hampstead, for the sake of abrupt recessions.

1945

As the war came to a close European photographers began to reappear in *Lilliput*, notably Blumenfeld in August, and payment for work began to rise slightly. Brandt's contribution to *Picture Post* was muted, although it did include his 'surreal' 'Frosty morning in the park', 20 January 1945, and 'The Magic Lantern of a Car's Headlights', 31 March 1945. This was a busy year, portraits and fashion, with *Harper's Bazaar*, and the year in which he went to work as a fashion photographer in advertising, for Rima's Model Gowns Ltd. (wholesale only), of 25 Bruton St., London, W.1. It was also the year of his triumph in the Brontë country.

March, p. 196: 'Studio'; a criss-cross pattern of brushes.

April, p. 330: 'Neglected beauty: the great arch of St. Pancras'.

May, pp. 407-14: 'Bill Brandt visits the Brontë country'; in the final pairing of churchyard and street he rhymes tombstones and paving stones; paid £20.

July, p. 55: 'Dangling'; a gnome at a garden fishpond.

September, pp. 239-46: 'Brighton: the home of the English seaside'; a quasi-conceptual piece, ending with a neatly divided oceanscape; Brandt was paid £21, Anthony Gilbert 15 gns. for the drawing; and Miss Antonia White £6 for the text.

October, p. 260: 'Yes, it was Bloomsbury'; 'Top Floor' or 'The Attic Room' reprinted without mistletoe.
October, p. 263: 'Not so lonely'; a frame from 'A simple story about a girl', from September 1941. This was the 100th issue of *Lilliput*, and these were among the magazine's achievements.
October, p. 308: 'Dahlia'.

November, p. 391: 'Tenant's reality'; a back-to-back street, and perhaps a brief reflection in *Lilliput* of the domestic and social issues which had taken increasing space in *Picture Post* during the 1940s, e.g. 'Beveridge: the fight is on', 6 March 1943.

1946

This was not quite the end of Brandt's career in documentary, but his main report for *Picture Post*, on 'The Doomed East End',

9 March 1946, was twelve to three the work of the action photographer Charles Hewitt. He was becoming a specialist in abandoned, romantic sites, such as Fountains Abbey, *Picture Post*, 28 September 1946. Prices were on the increase, up to £2 for a single picture. His career at *Harper's Bazaar* came to an end, apart from advertising work for Rima.

February, pp. 155-62: 'Hampstead under snow'; eight experiments in blocked, barred and excavated space, for which he was paid 30 gns.

March, p. 180: 'Introvert'; a gesticulating statue from 'Daybreak at the Crystal Palace', *Picture Post*, 11 February 1939; opposite 'Extrovert' – a dancer.

March, pp. 239-46: 'Below Tower Bridge'; eight spatial experiments by the river: Wapping, Bermondsey and Limehouse.

April, p. 308: 'I'll give it another fifty years'; a boy at a chess book.

May, pp. 411-18: 'Thomas Hardy's Wessex'; Lulworth, Shaftesbury, Egdon Heath, Stonehenge, Salisbury Cathedral, Maiden Castle, Tess's Cottage, Corfe Castle.

June, p. 486: 'The Watcher'; the first of his Hitchcockian nudes for *Lilliput*; these seem to have been developed in tandem with the mysterious and dark fashion pictures which he undertook in 1945 and 1946 for Rima.

August, p. 116: 'Private enterprise'; moored fishing punts on a river, £3.

September, p. 228: 'But soft ...'; a part-figure holding a dog disappearing through a door beyond panelling; opposite '... we are observed', at an opening door.

September, pp. 239-46: 'English composers of our time'; Benjamin Britten, Constant Lambert, Michael Tippett, Bernard Stevens, Antony Hopkins, Alan Rawsthorne, William Alwyn, Elisabeth Lutyens.

December, p. 476: 'Just a line to let ...'; a master cook writing with his left hand, in a reversed image, opposite the grand mufti, '... you know what's cooking'. Brandt was paid 4 gns. for this one picture, up from 2 gns. the year before, and 1 gn. in 1944.

1947

This was the year of 'The day that never broke', a melancholic masterpiece in four images for *Picture Post*, 18 January 1947; he

contributed little else to that magazine, and nothing to *Harper's Bazaar*. In *Lilliput* there was increasing competition from the French, such as Doisneau and Brassaï (again), and the task of reporting on the British was being taken up, in colour, by such painters and illustrators as James Boswell, James Fitton, Edward Burra and Ronald Searle.

March, p. 210: 'Hide ...'; a chorus girl in a fancy hat half hidden by a curtain, from 'Backstage at the Windmill', October 1942.
March, p. 237: 'Brief encounter'; a nude, body to body with a mirror.
March, pp. 265-76: 'The beauty and sadness of Connemara'; this is the first case in which a commentary is credited to the artist.

April, p. 311: 'Memorial to an old friend'; a stuffed terrier in a glass case.

May, p. 468: 'Blue-stocking'; a Sickertian nude reclining in a carved chair against a background of cultural books, shelved.

August, pp. 155-60: 'A day in Dublin'; includes a portrait of the poet Patrick Kavanagh, theatrically placed on a bare staircase.

November, pp. 389-96: 'Over the sea to Skye'; photographs and commentary credited to the artist; with '... the Brontë country', his most famous essay; three of its eight images were subsequently used in *Literary Britain* in 1951.

December, p. 508: 'Strength'; tree roots in snow.

1948

This was the year of his farewell to documentary in *Picture Post*, with 'The Forgotten Gorbals', 31 January 1948, where the greater part (ten from thirteen) of the published piece was by Bert Hardy, and with 'The night watch on crime', 1 May 1948, which looks back to the hieratic, Victorian style of *Weekly Illustrated*. 'The horizon of Richard Jefferies', 6 November 1948, contains his most expansive landscapes to date.

February, pp. 151-56: 'Hail, Hell and Halifax'; six pictures, like those in 'Below Tower Bridge', February 1946, on vertiginous urban spaces.

March, pp. 77-84: 'The poet's crib'; Elizabeth Barrett-Browning, Tennyson, D.H. Lawrence, Tom Moore, Oscar Wilde, John Clare, Sir Philip Sidney, Thomas Hardy. Surprisingly, only three of these were used in *Literary Britain*.

June, pp. 37-42: 'Six Artists'; Henry Moore, James Fitton, Ivon Hitchens, John Piper, Feliks Topolski, Graham Sutherland, and, as in March, a text by Geoffrey Grigson.

June, pp. 77-84: 'The Borough'; eight pictures set in Aldeburgh, the scene of Benjamin Britten's opera *Peter Grimes*. The captions are taken from George Crabbe's poem, *The Borough*, 1810.

July, p. 84: 'Woodman's Daughter'; by a picture of a schooner, one of four independent indoor nudes of this period, beginning with 'The Watcher'.

August, pp. 63-68: 'History in rocks'; extraordinary geologies taken on his recent coastal travels, introduced by the geographer L. Dudley Stamp.

September, pp. 77-84: 'Painter's country', Van Gogh's Provence photographed and described by Bill Brandt; a return to an inhabited landscape, with a complex spatial interplay in the pairings.

November, p. 95: '5 Photographers in Search of a Portrait'; the subject was Josephine Stuart, and the artists were Rosemary Gilliat, Michael Peto, Laelia Goehr, Bill Brandt and Angus McBean; each contributed an explanation.

December, p. 36: 'Bronze idol'; squatting opposite the Red Dean.

1949

Brandt's farewell to the photo-essay was 'The Vanished Ports of England', *Picture Post*, 24 September 1949, a view of the land as a geometry abandoned by giants. At *Picture Post* Brandt was beginning a new career as a fashion photographer, which had been launched on 24 July 1948 with 'Fashion-on-sea'; in 1949 he completed eight fashion features, including 'Her hair is a fashion asset', 24 September 1949. His essay form of the 1940s, showing landscape in a poetic relation to architecture, had been adopted and adapted by Eric de Maré and Douglas Glass. One of *Lilliput*'s best pieces in 1949 was Eric de Maré's 'English canal-side', May, pp. 95-102. *Lilliput*'s editors were interested in change, and increasingly preferred *risqué* illustrations from the nineteenth century along with a new emphasis on contemporary illustration. Walter Trier's monopoly on covers was ended. Brandt's severe style was beginning to look anachronistic.

February, pp. 59-66: 'Nervy Birds in a Gilded Cage'; David Lean, Charles Crichton, the Boulting twins, Carol Reed, Anthony Asquith, Alberto Cavalcanti, Ronald Neame, Robert Hamer; captions by Richard Winnington give ages, and dwell on the vagaries of success and failure in the film industry.

March, p. 38: 'Reflection'; the fourth and last of his indoor nudes to appear in *Lilliput*.

August, p. 51: 'Cold storage'; stone maidens in a vaulted store, supervised by a Highland hunter, Prince Albert; c.f. 'Odd corners of museums', February 1944.

November, pp. 49-56: 'An Odd Lot'; E.M. Forster, Norman Douglas, Ivy Compton-Burnett, Robert Graves, Edith and Osbert Sitwell, Elizabeth Bowen, Evelyn Waugh, Graham Greene; with a commentary by Alan Pryce-Jones, and an odd, apologetic title.

1950

Brandt was still very intermittently occupied with work for *Picture Post*, which used some of his pictures in 'Street Play and Play Streets', 8 April 1950. His only fashion project of the year was 'Raincoats are promoted to fashion', *Picture Post*, 14 January 1950. His solitary, and last, article for *Lilliput* looks like a sequel to 'Nervy Birds ...', February 1949. He may have been involved at this time in preparatory work for *Literary Britain*.

December, pp. 51-58: 'Box-office boys'; Henry Sherek, Harold Fielding, Michael Standy, Emile Littler, Tom Arnold, Val Parnell, Bernard Delfont, E.P. Clift (by John Gay); imposing gaze-of-the-father images.

Picture Post features illustrated by Brandt's photographs; the numerals following the title refer to story no. and vol./issue respectively. Complete details are not available for every feature.

1938

3 December, pp. 53-55: 'Buskers of London', 52, 1/10.

1939

28 January, pp. 34-37: 'A Day in the Life of an Artist's Model', 2/4.

11 February, pp. 54-55: 'Daybreak at the Crystal Palace', 2/6.

4 March, pp. 29-34: 'Nippy. The Story of her day ...', 2/9.

1 April, pp. 54-57: 'Enough of all This!', 2/13.
8 April, pp. 19-23: 'A Barmaid's Day', 345, 3/1.

29 July, pp. 43-47: 'The Perfect Parlourmaid', 4/4.

1940

30 March, pp. 28-29: 'A Plea for Mothers', 266, 6/13.

1941

4 January, p. 20: 'New Britain must be planned', 10/1.
4 January, p. 22: 'Plan the Home', 10/1.

10 May, pp. 18-21: 'Spring in the Park', 722, 11/6.

21 June, pp. 20-23: 'I Look at Bournemouth by J.B. Priestley', 791, 11/12.

5 July, pp. 14-17, 'This was the war-time Derby!', 792, 12/1.
'Where Britain's airmen are refitted, 813, 'killed'.
12 July, pp. 12-15: 'A Day on the River', 822, 12/2.

23 August, 16-17: 'What are all these children laughing at?', 837, 12/8.

20 September, 'The Tay Bridge Disaster' (film), 878, 12/12.

4 October, pp. 24-25: 'Picture Medley – Meeting in Trafalgar Square', 13/1.
25 October, pp. 13-15: 'We Want More Nursery Schools', 903, 13/4.

8 November, pp. 8-11: 'The Life Story of a British General', 901, 13/6.
'Glynis Johns', 927, 'killed'.
8 November, pp. 12-13: 'When Britain Fought Europe' (film), 936, 13/6.

17 December, cover: 'Chorister in King's Chapel of Savoy', 13/13.
'Choirboys', 976, 'killed'.
27 December, pp. 21-22: 'What I believe about ghosts' by Robert Graves, 982, 13/13.

1942

3 January: 'Farming the Basis of a Healthy Countryside', 14/1.
24 January, pp. 22-23: 'The Archbishop of Canterbury (Most Revd. Cosmo Gordon Lang)', 1006, 14/4.
'Empty Houses', 1048, 'killed'.
'Army Suitability Tests', 1095, 'killed'.

28 February, p. 7: 'February Brings Snow to St. James', 14/9.

11 April, p. 25: 'Portrait of Ezra Pound', 15/2.

4 July, pp. 20-21: 'Bath: What the Germans mean by a "Baedeker Raid"', 1173, 16/1.

12 September, p. 17: 'Saving Britain's Plum Crop', 1235, 16/11.
26 September, pp. 11-15: 'Transport: Key to Our War Effort', 1245, 16/13.
26 September, p. 16: 'Holiday Camp for War Workers', 1254, 16/13.

3 October, pp. 16-17: 'A town that takes care of its troops', 1253, 17/1.

14 November, pp. 11-13, 'Fire guard on the House of Commons', 1276, 17/7.

19 December, pp. 14-15: 'A Cartoonist's Joke Becomes a Film Hero' (Colonel Blimp), 1239, 17/12.
'The Stirling Bombers', 1243, 'killed'.
'Nativity Play', 1302, 'killed'.
'One Man Newspaper', 1331, 'killed'.
26 December, pp. 7-9: 'The first wartime Christmas to bring a vision of peace', 1333, 17/13.

1943

2 January, cover: 'The child who has never known peace', 18/1.
2 January, p. 14: 'Social Security: the New Ideal', 18/1.
2 January, p. 17: 'Are we planning a new deal for youth?', 18/1.

6 March, p. 8: 'Beveridge: the fight is on', 1347, 18/10.

24 April, pp. 20-21: 'Should the church keep out?' by the Archbishop of York, 19/4.

23 October, pp. 12-15: 'The Threat to the Great Roman Wall', 1562, 21/4.

24 December, pp. 22-24, 'The Portraits in the Servants' Hall', 21/13.

1944

1 January, pp. 6-7: from 'We Plan a valley in South Wales', 1448, 22/1.
1 January, pp. 8-11: from 'The Story of the Swansea Valley', 22/1.
22 January, pp. 13-17: 'A Year's Work by the National Trust', 1622, 22/4.

27 May, p. 7: 'The Empire's Capital Awaits the Issue', 23/9.

1945

20 January, pp. 13-15: 'A Frosty Morning in the Park', 26/3.

17 February, pp. 24-45: 'Religion goes on the air', 1919, 26/7.

10 March, p. 19: 'Women's Struggle for Economic Freedom', 26/11.
31 March, pp. 13-15: 'The Magic Lantern of a Car's Headlights', 1936, 26/13.

19 May, pp. 2-15: 'This Was V.E. Day in London', 1991, 27/7.

17 December, p. 24: 'Waiting – Evacuated Statues', 29/7.

1946

9 March, pp. 8-11: 'The Doomed East End', 3092, 30/10.

22 June, p. 23: 'Ruins for Remembrance – Christchurch, Newgate St., London', 31/12.
29 June, p. 7: 'Inside Spain', 4101, 31/13.

6 July, p. 14: 'Just Another English Summer', 32/1.

10 August, p. 24: 'A Nest of Singing Birds' (Dylan Thomas), 4156, 32/6.

28 September, pp. 11-13: 'Fountains Abbey: should it be restored', 4220, 32/13.

9 November, p. 22: 'The Great Park of Windsor', 33/6.

1947

18 January, pp. 30-33: 'The Day That Never Broke', 34/3.

19 April, p. 15: 'Where Stands Britain – How did we get into this mess?', 35/3.

24 May, p. 7: 'A First Breath of Summer', 35/8.

22 November, p. 10: 'The Man Who Designed the Dress – Norman Hartnell, 37/8.

13 December, pp. 15-18: 'The Arts of India', 4493, 37/11.
20 December, pp. 10-11: 'The Ghost Castle of Ravensworth', 37/12.
27 December, p. 18: 'The Reader in the Cell', 37/13.

1948

31 January, pp. 11-16: 'The Forgotten Gorbals', 4499, 38/5.

28 February, pp. 24-25: 'The Gibson Girl 1948', 38/9.

27 March, pp. 20-21: 'The Craven Fault' (Malham Cove), 38/13.

1 May, pp. 19-21: 'The Night Watch on Crime', 39/5.

24 July, pp. 22-23: 'Fashion-on-sea', 4593, 40/4.

2 October, p. 24: 'The Climate of Britain', 41/1.

6 November, pp. 11-13: 'The horizon of Richard Jefferies', 4663, 41/6.

1949

2 April, pp. 14-17: 'A Lady of Elegant Leisure', 43/1.

25 June, p. 29: 'Cottons with a Difference', 4821, 43/13.

30 July, p. 29: 'Two for Travel', 4845, 44/5.

20 August, pp. 32-33: 'Fashion in bras', 4869, 44/8.

24 September, pp. 40-41: 'Her Hair is a Fashion Asset', 4883, 44/13.
24 September, pp. 16-19: 'The Vanished Ports of England', 4887, 44/13.

5 November, pp. 33-34: 'Thoughts on Necks', 4915, 45/6.

3 December, pp. 44-45: 'How Britain Adapts Paris Fashions', 4934, 45/10.

Harper's Bazaar (UK): a check-list of features and advertisements
incorporating photographs by Bill Brandt

17 December, pp. 39-41: 'Paris Designs for the Small Purse',
4945, 45/12.
31 December, p. 20: 'New Jerseys are made of jersey', 4953,
45/14.

1950

14 January, pp. 20-21: 'Raincoats are promoted to fashion',
4959, 46/2.

8 April, pp. 30-33: 'Street Play and Play Streets', 5005, 47/2.

1951

3 March, pp. 16-17: 'The Mad Woman of Chaillot, 5216, 50/9.
24 March, pp. 38-39: 'Spring Goes to the Head', 5234, 50/12.
31 March, pp. 25-27: 'A Few Lines From Paris', 50/13.

14 April, p. 39: 'Afternoon and Evening', 5236, 51/2.

5 May, pp. 11-15: 'From Mud to Festival', 51/5.
26 May, pp. 12, 24: 'Special "All London" Issue', 5309, 51/8.

Brandt worked for *Harper's Bazaar* in Britain for roughly two
years, opening with the Duchess of Kent in September 1943 and
closing with Pablo Casals in October 1945. Contact with the
magazine introduced him to the world of fashion and he worked
for Rima Fashion Gowns from May 1945 until December 1948.
His Rima pictures appeared in *Harper's Bazaar* on alternative
months, often on p. 1 of the magazine's advertising section.
These pictures, uncredited and unmentioned in any of the
literature on the artist, have a rather melancholic elegance which
connects them with the indoor nudes printed in *Lilliput* from
June 1946; in some cases they are taken in London's streets,
against backgrounds reminiscent of 'The Day That Never Broke',
Picture Post, 18 January 1947. He brought cultural *savoir faire* to
the magazine but was never, it seems, able to photograph models
as such; they always emerge with more presence than is good for
the product.

1943

September, pp. 24-25: 'Summer at "Coppins"'; pictures of the
Duchess of Kent, and of Prince Edward, the Duke of Kent,
driving a tractor (Prince Edward was nearly eight years old).
September, p. 40: Françoise Rosay. 'In this remarkable picture of
the famous French actress, Bill Brandt has captured something of
the spirit of her unhappy country. Françoise Rosay looks out
from a London window, after her escape from France. Defying
the Germans to the last, she refused to return to Paris to make
films for them. For many of us, she stands for the era of great
French films; her performances in *Pension Mimosas*, *Gens de
Voyage* and *Carnet de Bal* are unforgettable. She is making her
first British film, playing the part of a bereaved mother in
Michael Balcon's *Halfway House*.' She had been photographed by
Blumenfeld, and had appeared in his 'Modern masterpieces of
photography', *Lilliput*, September 1938, p. 333.

October, p. 23: 'London Designers'; Edward Molyneux,
Norman Hartnell, Peter Russell, Charles Creed, Hardy Amies (in
military uniform).

1944

January-February, p. 45: 'Iya Lady Abdy, who recently escaped
from France'; under her maiden name, the painter Iya Gaye.

May, p. 1 in the preliminary advertisements: a flash picture of a
woman talking on the telephone; Rima Model Gowns.

June, p. 23: 'Welsh garden'; a picture of sprouting topiary under the heading, 'In these times', with this extract, from Galsworthy: '"'Just say, if you must", they would tell him, "just say: 'In those times – because of the vegetables there was no time for topiary.'"'

June, pp. 42-43: 'The foresaken garden'; the lake at Stowe, Bowood in Wiltshire, Highcliffe Castle, Prior Park; 'Our war-neglected gardens have a sad poetic beauty'.

June, pp. 54-55: 'Champagne Charlie'; eight pictures of the film being made by Alberto Cavalcanti. In 1941 he had photographed the making of 'The Tay Bridge Disaster' for *Picture Post*, 20 September 1941, the first of three such assignments for that magazine.

July-August, p. 45: 'Countess Karolyi paints the railings of her house in Hampstead'; this was under 'Documentary London', and the Countess was wife of Count M. Karolyi, leader of the free Hungarians. Eva Rakos, Brandt's wife, was Hungarian.

September, p. 46: 'Natasha Litvin, wife of the poet and writer, Stephen Spender'; a pianist, under 'Art, Stage and Screen'.

November, 28-29: 'Taking a long view'; three fashion pictures; 'John Nash took a long view when he designed these imposing blocks of terraces in Regent's Park. Today, over a century later, with their surrounding colonnades, roads, paths, trees and grass as well, they conform with the finest modern conception of town planning.'

November, pp. 46-47: 'The Countess of Pembroke and Montgomery has just been elected Mayor of Wilton for the third year in succession'; five pictures on the Pembrokes and their home, including one of 'Lord and Lady Pembroke with Bannock and Brownie in the library'. Bannock and Brownie were dogs, and this was as close as Brandt ever came to the style of Beaton.

December, pp. 30-31: 'England's sense of humour'; George Belcher, Osbert Lancaster, David Low; c.f. 'What our artists look like', *Lilliput*, March, 1943.

December, pp. 42-43: 'Sir Kenneth and Lady Clark'; their house in high Hampstead, with studio portraits in the home; Lady Clark was known to dress elegantly.

December, p. 52: a woman in a long dinner dress playing a harp with broken strings: a mysterious fashion feature (editorial).

1945

January-February, pp. 56-57: 'You'll rejoice in a long dinner dress again'; a hostess gown from Rima faces a two-piece crêpe dinner dress by Koupy, at Dickins & Jones. Both gowns and their models are spectrally lit; the Rima woman fingers book-shelves, and the Koupy counterpart acts the role of a spy in a panelled room.

May, p. 1 in the opening fashion section: a Rima advertisement of a woman seen from behind fondling books on shelves.

May, pp. 48-49: 'Player and playwright'; Terence Rattigan opposite Lynn Fontane 'in a georgette teagown designed by Molyneux', standing in an open door, theatrically lit and handling the woodwork; 'Lunts chose *Love in Idleness* as their first English play'.

June, pp. 43-44 and p. 71: 'The common reader and the modern poet'; T.S. Eliot, Louis MacNeice, Stephen Spender, Alun Lewis, Dylan Thomas and C. Day Lewis reading a newspaper.

July-August, pp. 45-47: 'The Albany'; J.B. Priestley on a balcony, Clifford Bax at a window, Patrick Hamilton – author of *Rope*, G.B. Stern by a telephone, Eric Hesketh Hubbard – a painter, Margery Sharp ('in private life Mrs. Geoffrey Castle, is well known in America for her brilliant story writing') and a view of rooftops. 'Within a stone's throw of Piccadilly Circus is the quaint old-fashioned Albany, the earliest of all London flats'.

September, p. 50: 'Newcomers to Westminster'; R.H.S. Crossman, working on papers at a table. Portraits in this series were also done by Felix H. Man.

October, p. 39: 'Above the crowd'; Pablo Casals, playing his cello and smoking a pipe at once. After a very prolific opening this was Brandt's final piece, apart from advertising, for *Harper's Bazaar*.

THE RIMA SERIES IN *HARPER'S BAZAAR*.

1945

November, p. 3: a tall figure melodramatically lit.

December, p. 1: by piled chairs.

1946

March, p. 1: a woman in a very stiff dress leaning on a table; compare the figures of Otto Dix.

April, p. 1: a surreally lit back view with seamed nylons and heavy shoes.

May, p. 1: the model holds her hands to her head and stands behind a large white mound.

June, p. 1: hands to head and armpit, in a long black dress, with a shadow on a paper backdrop.

June, p. 8: a model in pastel shades, full length down to her shoes, with St. Paul's in the background; Bon Marché, £20.

November, p. 1: leaning on a podium under a plant, shadow on paper.

December, p. 1: looking down and leaning on a settle.

1947

March, p. 1: a giant standing figure with her hands in her pockets and fog in the background.

June, p. 1: a model with bangles and a street-corner look and flowers on the ground, against shadows on paper.

September, p. 1: a tall, standing figure, hand to head, and the head aligned with a shell niche.

November, p. 1: the Rima woman at the top of stairs by a door, with a pheasant's feather in her hat.

December, p. 1: leaning on stairs under a chandelier; the whole series invites comparison with Patrick Kavanagh on a melodramatic staircase in Dublin, in 'A day in Dublin', *Lilliput*, August 1947.

1948

March, p. 1: Atrima, designed by Rima; now at 59 Grosvenor St., W.1.

June, p. 1: a woman watching a bowl on a column.

September, p. 1: a woman peeping around the edge of steps opposite the Houses of Parliament.

December, p. 1: Rima at Jay's, Regent St., W.1; at an open door. Rima advertising then vanished until December 1949 when their models reappeared in a hazy beauty which was not Brandt's.

1. BOOKS AND CATALOGUES

The English at Home, introduction by Raymond Mortimer, London, 1936.

A Night in London, the story of a London night, London, Paris and New York, 1938.

Camera in London, introductory essay by Bill Brandt, commentary by Norah Wilson, London, 1948.

Literary Britain, introduction by John Hayward, London, 1951.

Perspective of Nudes, preface by Lawrence Durrell, introduction by Chapman Mortimer, London, 1961. (Issued as *Perspective sur le nu*, Paris, 1961.)

Shadow of Light, a collection of photographs from 1931 to 1966, introduction by Cyril Connolly; notes on the plates by Marjorie Becket, London and New York, 1966. (Issued as *Ombre d'une île*, Paris, 1967.) The second edition has an additional introduction by Mark Haworth-Booth, London and New York, 1977.

Bill Brandt: Photographs, introduction by Aaron Scharf, Arts Council of Great Britain, London, exhibition catalogue, 1970.

Bill Brandt, introductory essay by Norman Hall, 'Bill Brandt/True Londoner', Marlborough Gallery, New York, exhibition catalogue, 1976.

Bill Brandt: Nudes 1945-1980, introduction by Michael Hiley, London and New York, 1980.

Photographs by Bill Brandt, introduction by Mark Haworth-Booth, Washington, D.C., 1980.

Bill Brandt: A Retrospective Exhibition, introduction by David Mellor, The Royal Photographic Society, National Centre of Photography, Bath, exhibition catalogue, 1981.

Bill Brandt: Portraits, introduction by Alan Ross, London and Austin, 1982.

Bill Brandt: Portraits, introduction by Richard Ormond, National Portrait Gallery, London, exhibition catalogue, 1982.

Bill Brandt: War Work, The Photographers Gallery, London, exhibition catalogue, 1983.

Literary Britain, introduction by John Hayward, edited and with an afterword by Mark Haworth-Booth, Victoria and Albert Museum, London, 1984.

Bill Brandt: London in the Thirties, London, 1984; also published with an introduction by Mark Haworth-Booth, New York, 1984.

Les Grands Maîtres de la Photo: Bill Brandt, a collection of 49 pictures with a foreword and an afterword by Mark Haworth-Booth, no. 11 in a series, Paris, 1984.

Bill Brandt: Behind the Camera, introduction by Mark Haworth-Booth and an essay by Dr. David Mellor, Oxford and Philadelphia, 1985; published in connection with the exhibition 'Bill Brandt: Behind the Camera, Photographs 1928-83', presented by the Philadelphia Museum of Art.

Bill Brandt, biography by Patrick Roegiers, in the series 'Les grands photographes', Paris, 1990.

2. ARTICLES AND REVIEWS

'Bill Brandt's Landscapes', by Tom Hopkinson, *Photography*, London, April 1954, pp. 26-31.

'Presenting the Work of 12 Great Photographers', a profile and statement by Brandt, *Popular Photography*, New York, July 1958, p. 21 and pp. 32-33. The other photographers included Ansel Adams, Richard Avedon, Henri Cartier-Bresson, Cecil Beaton and W. Eugene Smith.

'Art, Pornography or merely Shocking', a review of *Perspective of Nudes* by the editors of *Popular Photography*, New York, March 1962.

'Bill Brandt Today ... and Yesterday', a statement by the photographer, *Photography*, London, June 1959, pp. 20-33.

'The Photographs of Bill Brandt', by Robert Doty, *Infinity*, the journal of the American Society of Magazine Photographers, January 1964, pp. 6-9.

Portfolio with text by Peter Lacy, *The History of the Nude in Photography*, New York, 1964.

A portfolio and special feature, by Bill Jay, *Creative Camera*, August 1967, pp. 160-69.

A portfolio, *Photo*, Paris, August 1969, pp. 30-37.

A portfolio by Brandt and an essay by Jan Olsheden, *Popular Fotografi*, Copenhagen, 10 October 1966, pp. 31-46.

'Landscape Photography', fifty pictures selected by Bill Brandt for a circulating exhibition originated by the Victoria & Albert Museum, London, 1969.

'Bill Brandt', a biography and an appreciation by Tom Hopkinson, *The Daily Telegraph Magazine*, 10 April 1970.

'Bill Brandt', a portfolio with a text by John Szarkowski, *Album*, no. 1, London, 1970, pp. 12-28.

A statement by Bill Brandt, *Album*, no. 2, London, 1970, pp. 46-47.

'Bill Brandt', a review of the Hayward Gallery exhibition, by Ainslie Ellis, *The British Journal of Photography*, London, 15 May 1970, pp. 472-79.

'Bill Brandt', an interview with Ruth Spencer, *The British Journal of Photography*, 9 November 1973.

'Living Masters of Photography', a portfolio and statement by the artist, *Camera*, Zurich, May 1972, pp. 14-23.

'Bill Brandt', a portfolio of nudes, *Photo*, Paris, November 1980, pp. 104-11.

'Bill Brandt in Perspective', by Trevor Gett, *Australian Photography*, April 1981, pp. 56-59.

'The Land: Twentieth Century Landscape Photography', selected by Bill Brandt for the Victoria & Albert Museum, London, 1976.

1904

Born, Hermann Wilhelm Brandt, 3 May, Hamburg; one of four brothers, of whom Walter, the eldest, became a banker, and Rolf, b. 1906, became an illustrator. August, the youngest, was an aviator, killed during the Second World War.

1920

Suffering from tuberculosis, he began a six-year cure at a sanatorium in Davos.

1927

Followed his brother Rolf to Vienna, where he came into contact with the circle around Dr. Eugenie Schwarzwald, a leading light in Vienna society; through Dr. Schwarzwald he made contact with Ezra Pound, who referred him to the Man Ray studio in Paris and to René Crevel, the Surrealist writer; in Vienna he was subject to analysis at the clinic of Dr. Wilhelm Stekel.

1929

Attached to the Man Ray studio in Paris for a three-month period; visited England, and photographed in the Caledonian Road Market.

1931-33

Settled in England, although in 1932 he spent a considerable time in Barcelona, Toledo and Madrid in the spring, before visiting Hungary during the summer; in the autumn of 1933 he returned to Vienna and to Hungary; in Barcelona, in February 1932, he had married the Hungarian, Eva Boros.

1934

Minotaure, the Parisian Surrealist magazine, published an image of two mannequins in a flea market, with a text by René Crevel.

1936

In the spring, Brian Batsford published Brandt's first book, *The English at Home*; at the same time he began to work for *Weekly Illustrated*, and for *The Bystander*.

1937

Largely on the strength of *The English at Home*, and of the Spanish pictures of 1932, his pictures begin to appear in *Lilliput*, founded in August 1937; went north, on a formative journey, probably at the behest of *Weekly Illustrated*.

1938

A Night in London, with 64 images, published jointly by Country Life in London, Arts et Métiers Graphiques in Paris and Charles Scribner's Sons in New York; in the December of 1938 he began to contribute to the newly-founded *Picture Post*.

1940

Employed by the Ministry of Information to take pictures of Londoners in air-raid shelters during the Blitz.

1941

The National Buildings Record employed him to photograph endangered buildings, including Canterbury Cathedral.

1942

During January he went north to photograph in Edinburgh.

1943

In the early autumn he took pictures of the Roman Wall, which confirmed his interest in northern landscape; in September he began to photograph, largely as a portraitist, for *Harper's Bazaar* in England.

1944

Contributed miscellaneous photo-journalism to *Lilliput*, and portraits to *Harper's Bazaar*.

1945

With the ending of the war, European photography began to re-emerge in *Lilliput*; he worked hard at fashion, and at six- and eight-piece essays for *Lilliput* – romantic sites, such as the Brontë country.

1946

The first of his sequestered female nudes began to appear in *Lilliput*; took pictures of 'The Doomed East End' for *Picture Post* – one of his last documentary surveys.

1947

Travelled widely in Ireland and in the Hebrides, for articles published in *Lilliput*.

1948

Focal Press published his first retrospective, *Camera in London*, preceded by a long statement of his own; six photo-essays by Brandt appeared in *Lilliput*, but his work for *Picture Post* was dwindling; a survey of literary sites in the north, 'The poet's crib', led finally to *Literary Britain* in 1951.

1949

Lilliput used two series of portraits, but Brandt's connection with that magazine was coming to an end.

1950

Asked by Cassell and Co. to continue his work on literary sites for *Literary Britain*.

1951

Publication of *Literary Britain*; from 1951 he worked increasingly on his series of outdoor nudes, taken in Normandy and on the Sussex Coast; these eventually appeared in *Perspective of Nudes* (1961).

1960s

As Brandt became more celebrated he was increasingly called on to provide retrospective portfolios for photography magazines and for the illustrated supplements of broadsheet newspapers; he was featured in the *Sunday Times Magazine*, 11 September 1966, and then among 'The World's Greatest Photographers' in the *Observer*, 14 June 1968; his reputation had been established internationally by the publication of *Shadow of Light* in 1966, and was endorsed by an exhibition of his pictures at the Museum of Modern Art, New York, in 1969; that exhibition was subsequently shown at the Hayward Gallery, London, in 1970; during the 1960s and 1970s he completed a series of boxed collages containing marine and seashore elements.

1970s

Brandt continued to take celebrity portraits intermittently for the *New York Times Magazine*: John Le Carré, 8 September 1974, and V.S. Naipaul, 26 December 1976; in 1975 the Arts Council of Great Britain toured an exhibition of his early photographs, 1930-1942, with an introduction by Peter Turner; at the same time he was asked by Mark Haworth-Booth to curate a major exhibition of landscape photographs, 'The Land', for the Victoria & Albert Museum, London; he continued his project in nude photography and in November 1980 a portfolio of the later nudes was published by *Photo* magazine in Paris.

Subject to diabetes from the early 1940s and for a long time in bad health, he died on 20 December 1983.

Photographic Acknowledgments

Noya Brandt © Brandt Estate: pages 2, 42, 44, 45, 46, 47, 48, 49, 51, 52, 53, 54, 56, 57, 58, 59, 60, 61, 62, 63, 65, 66, 67, 68, 70, 71, 72, 73, 74, 86, 87, 88, 89, 99, 118, 119, 120, 122, 123, 124, 125, 126, 127, 130, 131, 132, 133, 134, 135, 137, 138, 139, 140, 141, 142 ,143, 148, 150, 151, 153, 154, 155, 156, 157, 159, 160, 166, 167, 168, 169, 170, 171, 172, 173, 174, 175.

Hulton Deutsch Collection: pages 50, 64, 69, 75, 76, 77, 78, 79, 80, 81, 82, 83, 84, 85, 96, 97, 98, 100, 101, 102, 103, 104, 105, 106, 107, 108, 109, 110, 111, 112, 113, 114, 115, 121, 136, 144, 145, 146, 147, 152, 158, 162, 163, 164, 165.

Imperial War Museum: pages 90, 91, 92, 92, 94, 95.

RCHME Crown Copyright for Royal Commission on the Historical Monuments of England: pages 116, 117.